Kaṭṭaikkūttu

FORMS OF DRAMA

Forms of Drama meets the need for accessible, mid-length volumes that offer undergraduate readers authoritative guides to the distinct forms of global drama. From classical Greek tragedy to Chinese pear garden theatre, cabaret to *kathakali*, the series equips readers with models and methodologies for analysing a wide range of performance practices and engaging with these as 'craft'.

SERIES EDITOR: SIMON SHEPHERD

Badhai: Hijra-Khwaja Sira-Trans *Performance across Borders in South Asia*
978-1-3501-7453-5
Adnan Hossain, Claire Pamment and Jeff Roy

Cabaret
978-1-3501-4025-7
William Grange

Classical Greek Tragedy
978-1-3501-4456-9
Judith Fletcher

The Commedia dell'Arte
978-1-3501-4418-7
Domenico Pietropaolo

Liyuanxi – Chinese 'Pear Garden Theatre'
978-1-3501-5739-2
Josh Stenberg

Modern Tragedy
978-1-3501-3977-0
James Moran

Pageant
978-1-3501-4451-4
Joan FitzPatrick Dean

Romantic Comedy
978-1-3501-8337-7
Trevor R. Griffiths

Satire
978-1-3501-4007-3
Joel Schechter

Tragicomedy
978-1-3501-4430-9
Brean Hammond

Kaṭṭaikkūttu

A Rural Theatre Tradition in South India

Hanne M. de Bruin

methuen | drama

LONDON • NEW YORK • OXFORD • NEW DELHI • SYDNEY

METHUEN DRAMA
Bloomsbury Publishing Plc
50 Bedford Square, London, WC1B 3DP, UK
1385 Broadway, New York, NY 10018, USA
29 Earlsfort Terrace, Dublin 2, Ireland

BLOOMSBURY, METHUEN DRAMA and the Methuen Drama logo
are trademarks of Bloomsbury Publishing Plc

First published in Great Britain 2023

Library of Congress Cataloging-in-Publication Data
Names: Bruin, Hanne M. de, author.
Title: Kattaikkuttu: A rural theatre tradition in South India / Hanne M. de Bruin.
Description: New York: Bloomsbury Publishing Plc, 2024. | Series: Forms of drama |
Includes bibliographical references and index.
Identifiers: LCCN 2023005873 (print) | LCCN 2023005874 (ebook) | ISBN
9781350236615 (hardback) | ISBN 9781350236608 (paperback) | ISBN
9781350236622 (ebook) | ISBN 9781350236639 (pdf)
Subjects: LCSH: Kattaikkuttu–India, South–History. |
Kattaikkuttu–Production and direction–India, South. |
Kattaikkuttu–Social aspects–India, South.
Classification: LCC PN2884.5.K38 B78 2024 (print) | LCC PN2884.5.K38
(ebook) | DDC 792.0954/8–dc23/eng/20230530
LC record available at https://lccn.loc.gov/2023005873
LC ebook record available at https://lccn.loc.gov/2023005874

ISBN:	HB:	978-1-3502-3661-5
	PB:	978-1-3502-3660-8
	ePDF:	978-1-3502-3663-9
	eBook:	978-1-3502-3662-2

Series: Forms of Drama

Typeset by Integra Software Services Pvt. Ltd.
Printed and bound in Great Britain

To find out more about our authors and books visit www.bloomsbury.com
and sign up for our newsletters.

To P. Rajagopal, my anchor and inspiration.
To all girls and young women who imagined
becoming a performer but could not.

CONTENTS

ILLUSTRATIONS

SERIES PREFACE

The scope of this series is scripted aesthetic activity that works by means of personation.

Scripting is done in a wide variety of ways. It may, most obviously, be the more or less detailed written text familiar in the stage play of the Western tradition, which not only provides lines to be spoken but directions for speaking them. Or it may be a set of instructions, a structure or scenario, on the basis of which performers improvise, drawing, as they do so, on an already learnt repertoire of routines and responses. Or there may be nothing written, just sets of rules, arrangements and even speeches orally handed down over time. The effectiveness of such unwritten scripting can be seen in the behaviour of audiences, who, without reading a script, have learnt how to conduct themselves appropriately at the different activities they attend. For one of the key things that unwritten script specifies and assumes is the relationship between the various groups of participants, including the separation, or not, between doers and watchers.

What is scripted is specifically an aesthetic activity. That specification distinguishes drama from non-aesthetic activity using personation. Following the work of Erving Goffman in the mid-1950s, especially his book *The Presentation of Self in Everyday Life*, the social sciences have made us richly aware of the various ways in which human interactions are performed. Going shopping, for example, is a performance in that we present a version of ourselves in each encounter we make. We may indeed have changed our clothes before setting out. This, though, is a social performance.

The distinction between social performance and aesthetic activity is not clear-cut. The two sorts of practice overlap

and mingle with one another. An activity may be more or less aesthetic, but the crucial distinguishing feature is the status of the aesthetic element. Going shopping may contain an aesthetic element – decisions about clothes and shoes to wear – but its purpose is not deliberately to make an aesthetic activity or to mark itself as different from everyday social life. The aesthetic element is not regarded as a general requirement. By contrast a court-room trial may be seen as a social performance, in that it has an important social function, but it is at the same time extensively scripted, with prepared speeches, costumes and choreography. This scripted aesthetic element assists the social function in that it conveys a sense of more than everyday importance and authority to proceedings which can have life-changing impact. Unlike the activity of going shopping the aesthetic element here is not optional. Derived from tradition it is a required component that gives the specific identity to the activity.

It is defined as an activity in that, in a way different from a painting of Rembrandt's mother or a statue of Ramesses II, something is made to happen over time. And, unlike a symphony concert or firework display, that activity works by means of personation. Such personation may be done by imitating and interpreting – 'inhabiting' – other human beings, fictional or historical, and it may use the bodies of human performers or puppets. But it may also be done by a performer who produces a version of their own self, such as a stand-up comedian or court official on duty, or by a performer who, through doing the event, acquires a self with special status as with the *hijras* securing their sacredness by doing the ritual practice of *badhai*.

Some people prefer to call many of these sorts of scripted aesthetic events not drama but cultural performance. But there are problems with this. First, such labelling tends to keep in place an old-fashioned idea of Western scholarship that drama, with its origins in ancient Greece, is a specifically European 'high' art. Everything outside it is then potentially, and damagingly, consigned to a domain which may be neither

'art' nor 'high'. Instead the European stage play and its like can best be regarded as a subset of the general category, distinct from the rest in that two groups of people come together in order specifically to present and watch a story being acted out by imitating other persons and settings. Thus the performance of a stage play in this tradition consists of two levels of activity using personation: the interaction of audience and performers and the interaction between characters in a fictional story.

The second problem with the category of cultural performance is that it downplays the significance and persistence of script, in all its varieties. With its roots in the traditional behaviours and beliefs of a society script gives specific instructions for the form – the materials, the structure and sequence – of the aesthetic activity, the drama. So too, as we have noted, script defines the relationships between those who are present in different capacities at the event.

It is only by attending to what is scripted, to the form of the drama, that we can best analyse its functions and pleasures. At its most simple analysis of form enables us to distinguish between different sorts of aesthetic activity. The masks used in *kathakali* look different from those used in *commedia dell'arte*. They are made of different materials, designs and colours. The roots of those differences lie in their separate cultural traditions and systems of living. For similar reasons the puppets of *karagoz* and *wayang* differ. But perhaps more importantly the attention to form provides a basis for exploring the operation and effects of a particular work. Those who regularly participate in and watch drama, of whatever sort, learn to recognize and remember the forms of what they see and hear. When one drama has family resemblances to another, in its organization and use of materials, structure and sequences, those who attend it develop expectations as to how it will – or indeed should – operate. It then becomes possible to specify how a particular work subverts, challenges or enhances these expectations.

Expectation doesn't only govern response to individual works, however. It can shape, indeed has shaped, assumptions

xviii SERIES PREFACE

about which dramas are worth studying. It is well established that Asia has ancient and rich dramatic traditions, from the Indian subcontinent to Japan, as does Europe, and these are studied with enthusiasm. But there is much less wide-spread activity, at least in Western universities, in relation to the traditions of, say, Africa, Latin America and the Middle East. Secondly, even within the recognized traditions, there are assumptions that some dramas are more 'artistic', or indeed more 'serious', 'higher' even, than others. Thus it may be assumed that *noh* or classical tragedy will require the sort of close attention to craft which is not necessary for mumming or *badhai*.

Both sets of assumptions here keep in place a system which allocates value. This series aims to counteract a discriminatory value system by ranging as widely as possible across world practices and by giving the same sort of attention to all the forms it features. Thus book-length studies of forms such as *al-halqa*, *hana keaka* and *ta'zieh* will appear in English for perhaps the first time. Those studies, just like those of *kathakali*, tragicomedy and the rest, will adopt the same basic approach. That approach consists of an historical overview of the development of a form combined with, indeed anchored in, detailed analysis of examples and case studies. One of the benefits of properly detailed analysis is that it can reveal the construction which gives a work the appearance of being serious, artistic and indeed 'high'.

What does that work of construction is script. This series is grounded in the idea that all forms of drama have script of some kind and that an understanding of drama, of any sort, has to include analysis of that script. In taking this approach books in this series again challenge an assumption which has in recent times governed the study of drama. Deriving from the supposed, but artificial, distinction between cultural performance and drama, many accounts of cultural performance ignore its scriptedness and assume that the proper way of studying it is simply to describe how its practitioners behave and what they make. This is useful enough, but to

leave it at that is to produce something that looks like a form of lesser anthropology. The description of behaviours is only the first step in that it establishes what the script is. The next step is to analyse how the script and form work and how they create effect.

But it goes further than this. The close-up analyses of materials, structures and sequences – of scripted forms – show how they emerge from and connect deeply back into the modes of life and belief to which they are necessary. They tell us in short why, in any culture, the drama needs to be done. Thus by adopting the extended model of drama, and by approaching all dramas in the same way, the books in this series aim to tell us why, in all societies, the activities of scripted aesthetic personation – dramas – keep happening, and need to keep happening.

I am grateful, as always, to Mick Wallis for helping me to think through these issues. Any clumsiness or stupidity is entirely my own.

Simon Shepherd

ACKNOWLEDGEMENTS

I have presented earlier versions of some material used in this book in other venues and publications and gratefully acknowledge the permission from the publishers to expand on those writings here. The material in the section on Performance Spaces in Chapter 1 has been discussed in greater detail in a collaborative essay together with Sue Rees that appeared in *Performance Research*, 25 (6–7) (2020) (de Bruin and Rees 2020: 89–107), and is reproduced by permission of Taylor & Francis (https://www.tandfonline.com).

The idea of art as labour discussed in Chapter 1 was first put forward by P. Rajagopal in 2017 in a musical discussion between him and Karnatic vocalist T.M. Krishna, which formed part of the collaborative production *Karnatic Kattaikkuttu* produced by First Edition Arts. I investigate the historical and social implications of this idea in greater detail in a chapter in the forthcoming publication *Creative Economies of Culture in South Asia: Craftspeople and Performers* edited by Anna Morcom Anna and Neelam Raina and to be published by Routledge (de Bruin forthcoming a).

The concept of *vēṣam* as a basic unit of Kaṭṭaikkūttu and the theatre's practice-based, embodied knowledge which I discuss in Chapter 3, were first presented at the international conference *Dynamics of Interweaving of Performance Cultures* held in Berlin in 2018. Subsequently, these ideas have been reworked for a chapter in *Performance Cultures as Epistemic Cultures*, Vol I, edited by Erika Fischer-Lichte, Torsten Jost, Astrid Schenka and Milos Kosic published by Routledge (de Bruin 2023), whilst the concept of *vēṣam* will appear as an entry in *The Routledge Companion for Performance-Related Concepts in Non-European Languages*

edited by Erika Fischer-Lichte, Torsten Jost and Astrid Schenka and published also by Routledge) (de Bruin, forthcoming b).

The description of the traditional training process of a young performer in Chapter 3 draws on an essay published in the *Handbook of Education Systems in South Asia, Global Education Systems* edited by P.M. Sarangapani and R. Pappu and published by Springer, Singapore (de Bruin 2020).

All translations from the original Tamil texts into English, and any flaws these may contain, are mine. I thank all the performers for allowing me access to their knowledge, performances and opinions. I thank the Kattaikkuttu Sangam for allowing me time to write and the International Research Center 'Interweaving Performance Cultures', Berlin, for stimulating discussions prompting me to re-engage with academic writing.

NOTES ON TRANSLITERATION

Tamil words used in this book follow the transcription conventions of the *Tamil Lexicon* ([1924–36]1982). Sanskrit terms follow the transcription found in Monier-Williams's ([1899] 1976) *A Sanskrit-English Dictionary*. I use a Tamil word the first time it occurs in transliteration in italics and with diacritics, e.g. *vēṣam*; in subsequent uses the italics and diacritics are omitted to facilitate readability, e.g. vesam. To indicate that a word is plural I have at times added an -*s* to indicate this, even though the plural in the original language would be expressed differently. The names of epic characters are given in their Sanskritized transliteration (instead of in their Tamil forms) with which readers are likely to be more familiar, e.g. Bhīma instead of pīmaṉ; upon subsequent uses the diacritics are omitted.

Titles of plays from the Kattaikkuttu repertory are given in their Tamil transliteration and, on first occurrence only, with diacritics, followed by an English translation of the title in brackets, e.g. *Pakaṭai Tukil (Dice and Disrobing)*. In subsequent instances I refer to these plays by their English titles (with a few exceptions where such translations are difficult). Place names, proper names and names of theatre forms and genres, as well as Indian words that are already familiar to English readers in their Anglicized forms, have been spelled without diacritical marks.

Introduction

This book provides an introduction to Kaṭṭaikkūttu (கட்டைக்கூத்து), the name I will use to refer to a rural South Indian theatre form. It is based on and expands on my earlier study *Kaṭṭaikkūttu: The Flexibility of a South Indian Theatre Tradition* (de Bruin 1999). In addition, I use material and quote from several different essays I have written since (de Bruin 2000, 2006, 2019, 2020, 2021, de Bruin and Rees 2020, de Bruin 2023, forthcoming a, b).

Kattaikkuttu is a Tamil-language-based, physical and vocal form of open-air ensemble theatre and is also known as Terukkūttu (or Therukoothu) or simply Kūttu (Koothu).[1] It uses different types of song, music, articulated prose, acting, movement, facial make-up and elaborate costumes to produce all-night, narrative performance events. Most performances are based on the pan-Indian epic, the *Mahābhārata,* and to a lesser extent selected episodes from the *Purāṇas*.[2] Through introducing you to the electrifying world of Kattaikkuttu, I hope to contribute to a revision of the recent social and cultural history, or histories representing multiple perspectives, of the Tamil stage. I argue that these histories are incomplete without acknowledging the contribution of popular performance forms, such as Kattaikkuttu, to the development of Tamil theatre.[3]

I became interested in Kattaikkuttu when I realized that this was 'Mahabharata in action' at locations where I expected

it least: rural Tamil Nadu.[4] As a student of Indology, I had read parts of the Mahabharata text in Sanskrit, but I was never really able to figure out who was who: the epic did not come alive for me. Seeing a rural audience of 2000+ sitting spellbound, watching an all-night Kattaikkuttu performance on the occasion of a festival for the goddess Draupadī Ammaṉ was a mind-blowing experience. Draupadi, who is married to the five Pāṇḍava-brothers, is the heroine of the Mahabharata. In the northern and central districts of Tamil Nadu she is worshipped as a village goddess (Hiltebeitel 1988). That first performance took me on a long journey of discovery of the epic (in its rural Tamil dramatic version) and of Kattaikkuttu: what the theatre is and what, ideally, it could be, and what it means to be a Kattaikkuttu performer. During this journey I met my husband, P. Rajagopal, who is a Kattaikkuttu actor from a family hereditary involved in Kattaikkuttu. Later in his career Rajagopal began directing and writing plays for his students. He was instrumental in establishing the Kattaikkuttu Sangam (est. 1990), an association of rural, professional performers and the Kattaikkuttu Gurukulam (2002–20). The Gurukulam was a residential theatre school. It offered rural children and young people from disadvantaged backgrounds the possibility to learn Kattaikkuttu without having to give up formal education, as Rajagopal did when he joined his father's company at the age of ten. The Gurukulam had to close its doors in March 2020 because of the Covid-19 pandemic and a subsequent lack of funding.

What's in a name?

With its introduction to an urban, primarily Chennai-based, performing arts scene probably somewhere in the 1950s,[5] Kattaikkuttu became part of a wider *field of the performing arts*.[6] This field encompasses rural and urban governmental stakeholders operating in the formal and informal sectors

of the cultural economy. These interested parties and individuals lay claims to the limited material and symbolic power generated by the field. The symbolic power of the arts is evident, for instance, in the naming and validation of performances and their classification into 'folk', 'classical' and 'modern'. My bracketing of these terms is deliberate for these labels are contested, political constructions that reflect the power dynamics within the Indian field of performing arts (de Bruin 2019: 51). According to historian Partha Chatterjee, the invention of the classical was an ideological response to the colonial power's denunciation of Indian culture and Indian traditions as barbaric and irrational (Chatterjee 1993: 118–27; Ebeling 2010: 16–19 with reference to nineteenth-century Tamil literature). Kamala Ganesh sees the existence of the domain of the classical and its ambivalent relationship with the popular as a part of the project of modernity (Ganesh 2018). Classical traditions derive their authority primarily from Sanskrit textual sources. These sources were used to define a classical aesthetics as the yardstick with which the validity and authenticity of Indian cultural expressions could be measured.[7] In the case of Tamil culture, attempts have been made to trace the origin of indigenous Tamil performative expressions to the Sangam (*Caṅkam*) times (100 BCE and 250 CE) and the poetic literature that flourished during this period. The rediscovery of Sangam poetry in the last decades of the nineteenth century and its nationalist reassessment established the Tamil language as ancient and its classical literature as a valuable heritage (Ebeling 2010: 18). However, it is virtually impossible to know what performances described in the Sangam literature looked and sounded like. Attempts to trace the origin of today's performance genres to the Sangam times are based mostly on vague associations not substantiated by concrete data (Seizer [2005] 2007: 50). After India's independence, the central government played a pivotal role in solidifying the distinctions between folk, classical and modern in order to establish the cultural identity of the young nation-state (Cherian 2007; Cherian 2009). Far from being neutral, these

divisions continue to be political and involve the dynamics of class and caste – with the classical being dominated by India's highest, yet numerically small caste of Brahmins – in addition to differences in taste, aesthetics and economics.

Kattaikkuttu performers are active participants in the field of the performing arts. They compete not only for patronage of regular rural audiences, but also for patronage from the bureaucracy, private organizations and individuals. They hope that the latter will help them secure non-traditional performance opportunities at urban cultural festivals and gigs in which their dramatic medium is used to spread a didactic or political message.[8] Representatives of Kattaikkuttu companies, including company owners, principal actors and company financers, have lobbied with varying degrees of success for recognition and rewards with bureaucratic and private institutions. Urban-based stakeholders have collaborated with rural performers and used Kattaikkuttu's vocabulary and repertory to create new forms of modern, urban theatre (e.g., Ahuja [2007] in conversation with K.S. Rajendran). Finally, several performers have set up their own organizations and training (schools) and organized their own cultural festivals.

One of these organizations is the Kattaikkuttu Sangam based in Punjarasantankal Village about 8 kilometres out of Kanchipuram town.[9] The Kattaikkuttu Sangam is a not-for-profit association that aims to uphold the prestige and quality of the Kattaikkuttu theatre (www.kattaikkuttu.org). As a democratically representative body, the Sangam unites a number of rural professional performers across company boundaries and regional styles. Membership of the Sangam is on an individual basis. While some performers decided to become a member, others did not. For some performers geographical distance is an obstacle; others may perceive the Sangam as a threat to their existing clientele and patronage or as unable to represent their specific performance styles. On the occasion of the Sangam's establishment, the performer-founders asserted the right to name the theatre on their own terms as Kattaikkuttu instead of Terukkuttu in the conviction that this

name was more appropriate, identifying the theatre by its visibly distinctive characteristic – the *kaṭṭai* ornamentation. They also felt that Kattaikkuttu carried greater dignity as compared to Terukkuttu. The latter term has negative connotations in Tamil,[10] in addition to being associated with a low caste status, in particular for performers coming from a hereditary performance background. Since then, many performers in my core area of work have started referring to their profession as Kattaikkuttu instead of Terukkuttu while rural spectators appear to have accepted the name unquestioningly.[11] However, during a workshop in 1993, the name of the theatre became a topic of contestation. The Sangam had invited urban theatre workers and intellectuals to the workshop. Some of the urban representatives felt that the name Terukkuttu should not be tinkered with, in particular not by a foreign scholar, implying that the name change was on my instigation.[12] This led to a split between performers preferring to call their performances Kattaikkuttu and others adhering to the name Terukkuttu, to refer to what in fact are the same all-night, narrative performances in which the principal, male actor-singers wear kattai ornamentation (de Bruin 2000). The naming debate reflects the dynamics of the field of the performing arts and the conflicting forces and vested interests at work within this competitive arena.

Tamil theatre histories

In my earlier work I have outlined the rural dramatic scene as I encountered it during my fieldwork in the late 1980s and 1990s, describing the interlinkages between different rural performance forms and Kattaikkuttu's place therein (de Bruin 1999: 94–110). Being grounded in orality for its transmission and performances, Kattaikkuttu lacks an archive of written documentation and material artefacts that would help us trace the theatre's history, because performers had no need to establish

such an archive.[13] In addition, the existing powers – whether the colonial administration, colonial educators or a Tamil middle class emerging in the beginning of the twentieth century – did not consider Kattaikkuttu worthwhile documenting. Lacking specific detail, scholarly descriptions of the popular Tamil stage and autobiographic accounts of respected actors make it difficult to identify the exact nature of the performances they speak of. Kattaikkuttu's dramatic repertory has never entered the syllabi of Tamil literature courses and, with a few exceptions (de Bruin 1998; Frasca 1998), its performances have not seen critical editions and commentaries. Tamil Nadu has no officially recognized institution or recognized course where one could train as a Kattaikkuttu actor or musician. And as far as I know, Kattaikkuttu's characteristic musical soundscape, including the *mukavīṇai* (a high-pitched wind-instrument), has never made it into a soundtrack of a Tamil film.

Historically, the distinctions between what we now recognize as independent performance genres, such as Kattaikkuttu and its local competitor, the popular Ṭirāmā or Drama (from the English 'drama'),[14] appear to have been less well determined. Rural performance forms were never static, homogeneous entities nor did they respect administrative and linguistic boundaries between States established as recent as 1956–7. Adjacent performance forms bleed into each other, just like languages do when they are in contact, resulting in the exchange of performance elements and practices. This bleeding is visible, for instance, in the blending of costume elements that Kattaikkuttu borrowed from the Drama genre. Theatres and repertoires, encapsulated in the bodyminds of their non-elite practitioners and spectators, travelled wide and far for a variety of reasons, including famines, heterodox mobile religious cults open to lower, marginalized castes (de Bruin 1999: 75, 180) and commerce. Tamil forms of theatre accompanied labourers who were part of the Tamil diaspora migrating as far as La Réunion near the African coast and Trinidad and Tobago and Guadeloupe in the Caribbean during the British and French colonial administration.

Outside its core performance area, Kattaikkuttu is not a well-known theatre. Members of the urban upper- and middle classes, including those involved in the performing arts, may not even have heard of its existence. Kattaikkuttu's lack of visibility contrasts with that of other South Indian performance genres, such as Kathakali, Kutiyattam and Yakshagana found in the neighbouring states of Kerala and Karnataka. The latter genres are considered classical, involve high(er) caste practitioners and audiences and enjoy a higher social and cultural status. While sharing performative elements, repertories and practices with these neighbouring genres, Kattaikkuttu differs from them in one important respect: Kattaikkuttu performers have retained their own voices. This determines Kattaikkuttu's soundscape and the unique nature of the theatre's multimediality in which the singing actor needs to be an all-rounder ready to lend her/ his body to be a character to the fullest degree possible. In contrast, in Kathakali, Kutiyattam and Yakshagana singing has been delegated to a separate vocalist, who becomes the voice of the character (Zarrilli 2000: 61). This frees up the facial muscles and eyes of the actor-dancer for the creation of more elaborate, stylized and codified facial expressions that usually are considered more classical.

Within the Indian landscape of the performing arts, Kattaikkuttu and other similar rural folk art forms remain marginalized in terms of cultural prestige and economic validation, but not in terms of audience attendance. Given the frequency of rural shows during Kattaikkuttu's high season drawing audiences from anything from 50 to 2000+ spectators, I estimate rural theatre to entice many more rural viewers than urban, contemporary Tamil theatre events. Kattaikkuttu exists primarily in the performance event itself, which is disappearing while being produced. Outside the moment of their production, Kattaikkuttu performances live on as memories of individuals and as communal cultural memory. Performance scholar Diana Taylor refers to these individual and cultural memories as the *repertoire* and contrasts it with a written or artefact-based *archive* (Taylor [2003] 2007).[15] As a consequence,

writing about Kattaikkuttu performances almost always involves remembering and writing about the past. Such writing per definition is selective and unable to entirely bridge the gap between the *real live event* and what we remember (Canning & Postlewait 2010: 13). I have tried to trace (selected) parts of Kattaikkuttu's history on the basis of experiences and memories as reported by my informants, most of them professional Kattaikkuttu practitioners, my own experiences of watching many overnight performances since the 1980s, conversing with spectators, observing Kattaikkuttu's praxis in all its facets being taught to the students of the Kattaikkuttu Gurukulam and being involved in new productions of the school. This makes such a reconstructed history extremely personal, intimate and (emotionally) subjective. For the performers, as well as for me, remembering involves experiential moments of elation, as well as negation and sometimes humiliation. It also means that any kind of generalization as to what Kattaikkuttu was, is or ought to be, is not possible nor do I think would it be desirable.

Discourse of contempt

Influenced by Western, colonial ideas of what counted as legitimate theatre, members of the Tamil intelligentsia blamed what they perceived as the deterioration of the popular Tamil stage on village-based actors without considering their economic and social circumstances. Tamil theatre historian N. Perumal in his book *Tamil Drama: Origin and Development* (1981) highlights the corporeality and viscerality of 'street dancers' (a possible reference to Terukkuttu, which translates as street theatre). He describes the performers in demeaning terms as shouting, hooting, hopping, leaping and begging for food the morning after the performance (Perumal 1981 as quoted in de Bruin 1999: 94–5). According to noted lawyer, playwright and theatre person V.C. Gopalratnam a drama in

the Tamil country in the eighties and nineties of the nineteenth century was something to be looked down upon 'not only for its lack of any intrinsic value, but also for the lack of character, respectability and purity in those who were connected with it' (Gopalratnam [1956] 1981 as quoted in de Bruin 2019: 56).[16] I have referred to these biased, value-laden descriptions of the popular Tamil stage as a *discourse of contempt* (de Bruin, forthcoming a). This discourse was perpetuated until well into the 1980s by a Tamil cultural and intellectual elite unwilling to interrogate its own colonialization and consider the unique richness of its own theatre heritage.[17]

At the beginning of the twentieth century, male members belonging to the urban middle classes – many of them high-caste lawyers, businessmen and salaried government employees – initiated the first modern bourgeois Tamil theatre. This theatre used Western proscenium stage conventions, a European (Shakespeare and Molière) and Sanskrit (Kalidasa) repertoire to present modern theatre productions, in addition to disciplining its audiences through instituting official starting and end-times of performances at indoor performance venues with proper seating arrangements. Juxtaposing the deteriorated popular stage to the modern, bourgeois Tamil theatre they were in the process of crafting, members of this urban elite proudly referred to themselves as *amateurs* as against the *professional* folk performers. The amateur-professional distinction emphasized the fact that these urban-elite actors were involved in theatre for the sake of art, whilst their professional counterparts performed in order to make a living (de Bruin 2019: 56).

In the first English monograph about Terukkuttu, Richard Frasca observes that the theatre often is described as dead or dying (Frasca 1990: xii). As a consequence, Terukkuttu/ Kattaikkuttu is perceived to be in need of salvation. The myth of Kattaikkuttu as a dying theatre form has been perpetuated by the Tamil and English media invoking the voices of selected folk actors who say they are unable to make a living out of this dying art form.[18] While it is true that Kattaikkuttu

did experience a dip as a result of the competition of the commercial Drama genre (Hollander 2007: 168) and, later on in the 1930s, as a result of the emerging Tamil cinema with sound, it definitely made a comeback outlining its heroic nature and specific performance style in contrast to that of the Drama. My figures reveal that Kattaikkuttu remains immensely popular. In my core area of work professional companies performed between 100 and 160 all-night shows annually, while an average performer roughly earned anything between Rs. 1,00,000 and Rs. 2,00,000 per year in 2019 (that is prior to the pandemic). In the absence of an (official) survey, we lack consistent data with regard to the number of performers, audiences and performers' incomes.[19] This makes it easier to perpetuate the idea of Kattaikkuttu being dead or dying.

The exact boundaries of Kattaikkuttu's geographical spread and performance territory are not easy to establish because it is not always clear where a theatrical performance ceases to be Kattaikkuttu and becomes a different form. Kattaikkuttu is prevalent in different formats and styles in the Tiruvannamalai, Vellore, Tiruvallur, Kanchipuram, Chengalpat, Krishnagiri, Dharmapuri, Salem, Vilupuram and Cuddalore Districts of North and Central Tamil Nadu, the Union Territory of Pondicherry and the Chittoor District of Andhra Pradesh; the play *Hiraṇya Nāṭakam* (*Hiranya's Play*, also known as *Hiraṇya Vilācam* or *Śrī Pakta Pirakalātā*, *The Devotee Prahlāda*) performed by amateur actors as a form of community theatre is found in several different villages around Tanjavur where it appears to have been inspired by the Bhagavata Melam (de Bruin 1999: 219–21; Kaali 2006). However, further down south in Tamil Nadu people seem to be no longer familiar with Kattaikkuttu and the theatre's elaborate Mahabharata repertory. Possibly Kattaikkuttu's role in these southern districts is fulfilled by other ritual performance traditions, such as Villupāṭṭu or Bow Song, which is popular in the Tirunelveli District (Blackburn 1988).

Alternative views

While rural Kattaikkuttu lacks recognition and symbolic capital and has been criticized for a lack of aesthetic subtility, not everybody in the urban arts establishment entertains a negative view with regard to the theatre and its artistic scope. C.P. Aaryaan works as a creative director for an advertising company in Chennai. He described Kattaikkuttu to me as follows:

> (it) is not just the voice of the marginalized, it is the preservation of our history and the celebration of our dignity. Through our *Kattaikoothu*,[20] the voices of our ancestors, the wisdom from our journeys we learned and unlearned over time, the grace of our Gods who walked amongst us and much more are brought to life, stirring a myriad of different emotions in different individuals. *Kattaikoothu* that way is a participative, experiential art that can instantly strike strong chords, shake conventions or harmonize with anyone who is looking for answers beyond the mundane and routine and hence foster life and inspire generations across the world. In short, when experienced even once, for any individual it is life before and after the *Kattaikoothu* experience.

> (Fragment of a written statement by Mr. C.P. Aaryaan, 21 April 2021)

In the mid-1970s, Tamil playwright and theatre director Na. Muthuswamy (1936–2018) was one of the first theatre persons to recognize the inherent qualities of Terukkuttu/ Kattaikkuttu when he happened to witness a performance at the Music Academy in Chennai. Inspired by the theatre's idiom, repertory and village performance contexts, Muthuswamy began creating new work and a new, modern aesthetics in close collaboration with hereditary Terukkuttu actor Purisai Na. Kannappa Thambiran (1915–2003) and, after he returned

to the theatre, Kannappa's son Sambandham (Hollander 2007: 168; Gopalakrishnan 2014). Actors acting in these plays received their theatre training at Koothu-p-pattarai, which Muthuswamy established in Chennai in 1977. This theatre ensemble-cum-training space has been using Kattaikkuttu elements, skills and repertory, in particular movement and sound, to help create a new, contemporary Tamil theatre language as envisaged by Muthuswamy.[21] Muthuswamy's experimental plays were a reaction against the dull, politically non-engaging and aesthetically unexciting, urban modern Tamil theatre landscape of the 1970s. This landscape was dominated by a popular genre, known as Sabha Natakam (*capā nāṭakam*) performed and consumed predominantly by urban Brahmins, in addition to grand-scale historical and mythological plays that addressed, in terms of caste and social status, somewhat wider urban audiences.[22] Muthuswamy wanted to go back to the roots to retrieve traditional Tamil theatre as an authentic expression of the Tamil (language) voice. This search for authenticity and a true modern Tamil theatre provided, at least initially, patronage and dignity to one particular style of Terukkuttu/Kattaikkuttu, which sometimes has been presented as the most genuine one (Frasca 1990: xii), but not to the tradition as a whole. This biased urban patronage introduced yet another dimension to the existing competition between regional theatre companies and styles.

If the naming debate is an indication, there clearly is a gap between rural and urban perceptions of what Kattaikkuttu is.[23] Julia Hollander has noted the alienation of urban spectators from Kattaikkuttu's theatrical practice and rural contexts. According to her, Kattaikkuttu performances situated in rural, emotive, sacral performance contexts with which urban middle classes are no longer familiar represent an almost exotic experience to urban viewers (Hollander 2007: 166).[24] Such alienation works both ways: rural audiences have little chance to partake of urban contemporary theatre performances, such as the ones made by Muthuswamy, while most of them have never attended a live classical Karnatic concert or a

Bharata Natyam dance performance. This raises the question as to whether Kattaikkuttu really counts as a legitimate and authentic form of Tamil indigenous expression and culture. If so, one wonders why such recognition has not been translated into greater support for Kattaikkuttu, for instance by setting up training facilities on a par with those available to classical art forms, which can help keep up the quality and transmission of the theatre and the dignity of its exponents.

Personal note

Before embarking on a description of the elements that I believe constitute Kattaikkuttu's core, a personal note is in place. My involvement in initiating changes and innovations as a co-founder, co-traveller, facilitator, conceptualizer and dramaturg/costume designer of the Kattaikkuttu Sangam and the Kattaikkuttu Gurukulam, and my long-standing relationship(s) with some of its performers and students, makes this book and the findings and opinions expressed herein personal and subjective. One of these performers is my husband P. Rajagopal. His extensive knowledge of Kattaikkuttu and his vast experience of more than fifty years in the profession pervade this book. I was able to access this knowledge because of our intimate working relationship. Therefore, this book is as much Rajagopal's as it is mine.

1

Kaṭṭaikkūttu:
Aesthetic characteristics
and historical and
socio-economic contexts

What is Kaṭṭaikkūttu?

Based on its visual appearance and movement vocabulary, Kattaikkuttu has been termed dance and dance-drama. However, movement is just one of the many media through which Kattaikkuttu expresses itself. In addition to being dancers, Kattaikkuttu performers are incredibly strong vocalists, actors and co-creators of the all-night narratives they present. Given Kattaikkuttu's emphasis on vocalizing and embodying the theatre's musical and linguistic performance texts, total theatre or perhaps multi-media ensemble theatre would be a better description.

In the following I discuss different, interlinked elements that go into the making of an overnight performance. Two caveats are in place here: Firstly, within the scope of this book it is impossible to treat all these elements elaborately and equally. In fact, I believe that some of them, such as make-up, ornaments, costumes, music and movement/choreography, would be better documented in a medium other than writing. Secondly,

my data are specific, pertaining – unless mentioned otherwise –
to the Perunkattur style (*Peruṅkaṭṭūr pāṇi*) of which Rajagopal
is an exponent. The Perunkattur style represents a traditional
way of performing and a performance discipline as developed
and transmitted by Rajagopal's ancestors, who lived in the
village of Perunkattur. In my area of work there were a number
of companies which performed in the Perunkattur style.
While I place the Perunkattur style within a broader outline
of the Kattaikkuttu tradition, I do not have the knowledge to
comment in detail on other styles with which I am less or not
at all familiar.

The elements

Kaṭṭai vēṣams and other characters

Kattaikkuttu's distinctive kattai ornamentation – crowns,
shoulder and breast ornaments made out of wood – defines
the theatre's visual appearance. Characters who wear kattai
ornaments are called *kattai vesams* or kattai characters. The
presence of kattai ornaments goes together with an elaborate
mask-like make-up and a spectacular fashion of costuming.
It also requires an entry routine behind a hand-held curtain
and a presentational style that emphasizes the heroic. The
foundational make-up colour and the decorations drawn on
top of it are associated with specific character traits; the colour
helps to differentiate between different male kattai characters
and identifies their distinctive nature. Kattai vesams wear wide
skirts and underskirts – traditionally starched saris which
nowadays have been replaced by stiff plastic petticoats – over
trousers and a long-sleeved top or 'coat'.[1]

In contemporary Kattaikkuttu performances, kattai
vesams occupy a central place. They represent superhuman
divine and demonic warriors, who are the main agents in the
mythological battles around which much of Kattaikkuttu's

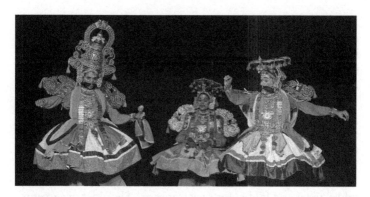

FIGURE 1 *Kattai vesams in P. Rajagopal's* Dice and Disrobing *wearing characteristic kattai ornaments, make-up and costumes. Left: P. Moorthy as Duryodhana with large crown or* kirīṭam; *right: K. Radhakrishnan as Sakuni with a small crown or* cikarēk *and in the middle: V. Logeshwari as Karna, Performing Arts Festival of the Kattaikkuttu Sangam, Punjarasantankal, 13 March 2013. (Photo by A. Prathap © 2013 Kattaikkuttu Sangam.)*

repertory is built (de Bruin 1999: 89).[2] The kattai ornaments they wear symbolize power, royalty, manliness and heroism. The heroic (*vīram*) comes in shades varying from composed (*cāntam*) in the case of Dharmarāja (Yudhiṣṭhira) to berserker ferocious (*rauttiram*) for a character such as Duḥśāsana. With reference to Kathakali, Phillip Zarrilli has described the heroic as an idealized state of being/doing marked by the hero's sacrificial acts of blood-letting and killing. According to him, such killings are the prerogative of the emblematic good king who, through these violent acts, orders and empowers the cosmic order in which the demons are always lurking to take over power (Zarrilli 2000: 5–6). In the case of Kattaikkuttu, the ambivalence that lies hidden in these of acts of sacral killing is both destructive and energizing. Kattaikkuttu performances create conflictious, violent situations within which the heroic kattai characters – and sometimes inspired spectators too – operate. Being communal in nature, rural

Kattaikkuttu performances transform their audiences into a
royal court (capā < Sankrit sabhā) in which the assembled
kings witness Draupadi's marriage and Duhsasana's attempt
to disrobe her, or into the battlefield of Kuruksetra where
Arjuna kills Karṇa.

Kattai ornaments include two types of crowns. The large
pointed one with a halo is known as kirīṭam or muṭi and the
smaller one as cikarēk [Figure 1]. The kiritam is worn by
important kings, such as Hiraṇya, Dharmaraja, Bhīma and
Duryodhana.[3] The cikarek is used by minor kings and princes,
for instance Karṇa, Arjuna, Duhsasana and Kīcaka. It can be
taken apart and folded for easy transport. Shoulder ornaments,
called puja kīrtti or pujam (< Sanskrit bhuja, 'arm'), additional
head ornaments (talai cāmāṉ), ear ornaments (kātu kaṭṭai)
and a breast ornament (mārpatakam), are other important
kattai worn together with both the kiritam and cikarek. The
kattai are made out of wood of the kalyāṇa muruṅkai tree
(Erythrina variegata or Indian coral tree).[4] Even though this
is a light sort of wood, a complete set of kattai ornaments
still represents a substantial weight – the large crown weighing
about 2.5 kilos – demanding considerable physical stamina on
the part of an actor wearing the ornaments in an all-night's
performance. After a carpenter has shaped a piece of wood
into the required form for a particular ornament, a dedicated
kattai craftsperson does the rest of the work. The various
kattai are painted and inlaid with small pieces of glass or, in
the case of some styles, decorated with coloured paper and
glitter. The ornaments display regional and stylistic variations.
Their making and design, with their vivid red, deep green,
white and gold colours, its traditional motifs of bands of
curved lines (māl), (lotus) flowers and green parakeets (paccai
kiḷi) executed with mirrorwork in relief, resemble that of the
Tanjavur painting and gold work, but then in a poor man's
version. Even though being material objects, the kattai are
believed to be animated with a certain sacral power, which
they transfer to their wearers, the kattai vesams. This can be
deducted from the eye-opening ceremony which the crafts

person carries out for the big crown before it is used for the first time (de Bruin 1999: 86–9).

The make-up and costumes of women characters in Kattaikkuttu do not have the grandeur of their male kattai counterparts, nor do they feature any kattai ornaments. In fact, the attire of principal female characters often lacks any sign of royalty. Their costumes are rather realistic, resembling that of ordinary village women dressed in (nylon) saris and their best finery. Most women characters wear a pinkish or light yellowish base make-up as a light skin colour is associated with beauty and a higher caste. Exceptions are unconventional female characters, such as the forest temptress Kāṭṭupēraṇṭi (in the play *Arjuna's Penance*) who wears a black make-up and Draupadi in the disguise of a Kuratti[5] who wears a green foundational make-up. Minor female characters, such as the maid servants (*tōḻi*) of queens and princesses, are dressed accordingly. It is possible that (kattai) elements of the women's costumes and ornamentation have been lost perhaps because they became unpractical to transport when the mobility of performers increased or went out of vogue. However, bereft of any form of kattai ornamentation that visually amplifies the appearance of a character, leading female characters definitely look diminutive next to their royal, male counterparts.

In addition to male kattai characters and female characters, Kattaikkuttu has a category of characters that on the basis of their attire is known as *ṭires vēṣam*. *Ṭires*, derived from the English word 'dress', is a tunic-like outfit the breast part of which may be decorated with bead-work. The tunic sometimes has a detachable mantle (*oṭṭu*), epaulets and a raised collar and is worn on top of tights and trunk hoses, while the actor may wear a small, bead-trimmed crown in the shape of a crescent (for such a dress vesam, see Figure 6). Most probably this costume entered Kattaikkuttu through the Drama or Natakam, pointing to the historically close interactions between these two locally popular theatre genres.[6] The dress costume may have been influenced by Elizabethan theatre costumes but

further research on costumes and ornamentation is required to establish this. Krishna and his brother Balarāma are tires vesams; Śakuni can be a kattai vesam or a tires vesam depending on the conventions followed by a particular theatre company.

Sound scape and movement

Besides the impressive visual appearance of the kattai vesams, what strikes one in Kattaikkuttu's performances is their high energy level and characteristic sound scape. Kattaikkuttu is grounded in Karnatic music, a system of classical South Indian vocal and instrumental concert music. Karnatic music has been adapted to suit Kattaikkuttu's open-air dramatic performance contexts.[7] Kattaikkuttu performers use Karnatic music's basic

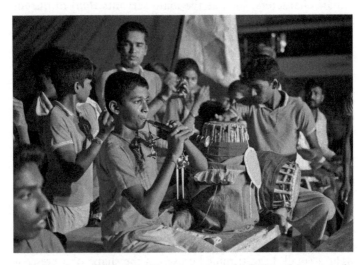

FIGURE 2 *Kaṭṭaikkūttu orchestra (*mēḷam*) with P. Sasikumar on the* mukavīṇai *and A. Selvarasu on the mridangam/dholak. The peddle harmonium is not visible in the photograph. All-night performance of* Disrobing of Draupadi *by the Kattaikkuttu Young Professionals Company, Marutam Village, 24 September 2016. (Photo by A.R. Sumanth Kumar © 2016 Kattaikkuttu Sangam.)*

musical concepts, such as *śruti* (pitch), *rākam* (raga or melody), *tāḷam* (rhythm) and *kālam* (tempo). However, they do so in an intuitive and pragmatic manner without the deep analytical understanding of a classically trained Karnatic musician.

The quality and timbre of voice and audience expectations with regard to how a voice should sound are entirely different for Kattaikkuttu theatre and Karnatic concert music. Kattaikkuttu's singing is open-throated and, in the case of the Perunkattur style, high-pitched, in particular for a male voice.[8] Kattaikkuttu performances generally are unamplified. A high-pitched voice carries further in the stillness of the night, giving it a distinctive, emotional and raw quality enhanced by the musical repetition of the mukavinai, Kattaikkuttu's characteristic oboe-like wind instrument.[9] Furthermore, in contrast to Karnatic concert music, Kattaikkuttu's music supports dramatic action, sometimes with a rapid tempo allowing performers to move vigorously expressing

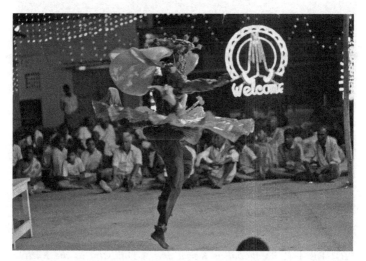

FIGURE 3 *Tuḷḷal or jump (S. Haribabu as Śalya) in an all-night performance of* Karṇa Mōkṣam, *Takkolam Village, 18 August 2019. (Photo by PeeVee © 2019 Kattaikkuttu Sangam.)*

their heroism and bravery through choreographed dance steps (*aṭavu*) and foot patterns accompanied by arm/hand movements, half and full jumps (*tuḷḷal*) and spins (*kirikki*) (de Bruin 2019: 58–60).

Comedy

The seriousness of the epic narrative is interspersed with comedy. Comedy is the domain of the Kaṭṭiyakkāraṉ who acts as the intermediary between epic characters and rural spectators. As indicated by his name, the formal duty of the Kattiyakkaran is that of 'praise (*kaṭṭiyam*) maker/doer (*kāraṉ*)' or herald (Frasca 1998: 41, fn 13). The Kattiyakkaran also guards the king's court and precedes him to announce his arrival. He combines the roles of herald and guardian with

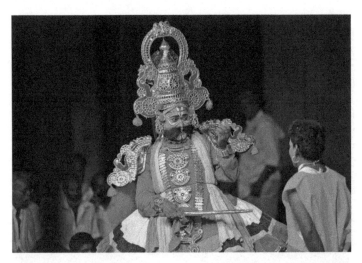

FIGURE 4 *P. Rajagopal as Karṇa and A Dillibabu as the Kattiy-akkaran in an all-night performance of* Karṇa Mōkṣam, Takkolam Village, 18 September 2019. *(Photo by PeeVee © 2019 Kattaikkuttu Sangam.)*

that of comedian. Most theatre companies employ a single Kattiyakkaran, who is on stage – and if not on stage, on call – for the entire duration of the performance.[10] He may engage another actor, who is not in role at that moment, to act as his buddy. Comedy allows performers to comment on local society and, often obliquely, on current politics; it is also an instrument to (re)engage rural audiences when their attention fades and sleep threatens to overtake them (de Bruin 1999: 301–13; de Bruin 2019: 54).

The creation of comedy is one of the least documented and least researched aspects of Kattaikkuttu.[11] Except for the standard prose passages and introductory songs of the Kattiyakkaran in his formal role of herald and royal guardian, his interactions with a multitude of characters and his arsenal of entertaining songs and intermezzos do not find a place in any of the written or printed performance scripts. The contribution of the Kattiyakkaran is pivotal to keeping an all-night performance going and up to date for his audiences through his ludic and critical interventions. Performing this role is a traditional way of getting to know the roles of your opposite numbers.

Performance duration

A typical Kattaikkuttu performance in a Tamil village or provincial town commences around 10 or 11 pm and lasts until 6 or 7 am the next morning. An overnight performance is a continuous, yet undulatory event. There is no division into separate scenes; instead, dramatically and ritually heightened episodes alternate with less loaded parts, humorous intermezzos and the relaxed banter of a comedian. As a result, the attention of audience members weaves in and out of a performance depending on what is happening on the stage. It is not unusual for rural spectators to have a quick nap in between episodes in order to be woken up by a neighbour when the dramatic or comic action intensifies.

Their long duration makes Kattaikkuttu performances a challenge for scholars who want to understand how they work. On average an overnight play features, in addition to the leading male and/or female character, between eight to fifteen other main and minor characters. While some performers specialize in male, female or comic roles, ideally a well-trained performer in the Perunkattur style is able to perform all these parts. Such a versatile performer is an asset for a theatre company enabling it to keep its members at a minimum and the share paid out to its performers at a maximum. Given the fact that most Kattaikkuttu theatre companies have a running repertory of about twenty to twenty-five all-night plays, the total number of roles a Kattaikkuttu actor can perform adds up to about 160 to 300 roles – an incredibly high volume of dramatic material. Most of this material is memorized and recalled orally; that is, it is not available in books, but is part of the practice-based knowledge that is owned and embodied by Kattaikkuttu performers and, to a lesser extent, by the spectators.

Performance spaces[12]

In a hierarchical Tamil village set-up not every empty space (Brook [1968] 1996) qualifies as a performance space fit for Kattaikkuttu, nor do performances happen just somewhere in the street (teru) as the name Terukkuttu would suggest. Performances usually take place at customary locations. Power relations in the village and the fact that performances have a sacral purpose determine the choice of these performance spaces. Such performance spaces comprise three different areas: the performance space or stage proper facing either west or north, a (seating) area reserved for spectators and the greenroom [Figure 5]. Some villages have a permanent raised, concrete platform for performances, but most performances are at ground-level. Cross-roads of village streets, an open area

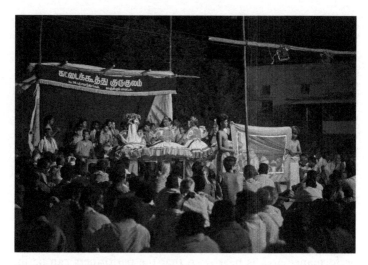

FIGURE 5 *Village audience watching a curtain entrance of a group of kattai characters during an all-night performance of* Disrobing of Draupadi *by the Kattaikkuttu Young Professionals Company, Marutam Village, 24 September 2016. (Photo by A.R. Sumanth Kumar © 2016 Kattaikkuttu Sangam.)*

opposite or adjacent to a village temple, a *tōppu* (tope or orchard with an open space), a piece of farmland just harvested, the street along which the house of a patron is situated or a (narrow) street in a provincial town lined on both sides with houses (and sometimes gutters) serve as temporary performance spaces. Their dimensions vary from 20 by 20 feet to about 15 by 15 feet or even smaller. Performers have little say in the dimensions of the performance area or its surface. This can make overnight performances demanding events for the performers, both physically and in terms of diplomacy and collaboration between themselves and between them and their patrons.

Spectators sit on the ground along three sides of the performance area as well as on elevated places such as doorsteps or roofs of nearby houses – women often separate from men, while children occupy the front rows and young

men stand or hang around the outer edges of the spectators' seating area. Elderly people may bring a chair to sit on and watch the performance, while patrons and higher ranking-guests might sit for some time onstage, either on a bench meant for the actors or on a plastic chair that has been brought in for them. Most of the times there are no proper toilet facilities, and performers and spectators use the areas that are not well-lit and outside direct view as a public toilet. The backside of the performance area leads into the greenroom, where the actor-singers prepare for their performance by putting on the make-up and getting into costume. The greenroom is created for the occasion out of thatch or, nowadays increasingly, discarded plastic sheets used for billboards and banners. In some villages, the panchayat building, a classroom of the local school or a corner of a village temple serve as greenroom provided that the performance area is nearby so that the performers can be in constant auditory contact with what happens on the stage. The greenroom has a single, low-hanging bulb and a small oil lamp to provide actors with sparse light to put on their facial make-up. This space is reserved for the performers, but patrons and other curious spectators often drop in to participate in the pre-performance puja (worship), get a glimpse of the make-up or the process of actors getting into costume.

The lighting of the stage generally consists of two 500-Watt bulbs or focus lights suspended between two poles at the front of the stage by the local electrician, who often wires the lights directly into the main overhead line. Lights may include also a few fluorescent tubes attached to the poles on the front or back of the stage. The greenroom at the back of the performance area is separated from the stage by a curtain brought along by the theatre company. Suspended across the upstage area is a banner, which states the name of the company, its location, the name of its principal performer(s) and proprietor and their mobile telephone numbers. Centre back stage there are two wooden benches, one for accompanying musicians to sit on and one for the actors, in addition to a chair (wood or plastic) for the harmonium player.

Rural spectators' ownership of the performance

The stage is not exclusively reserved for the performers, nor is it sacrosanct, in spite of the fact that performances often take place on sacral-religious occasions. The set-up of a typical, rural performance area facilitates an intimate relationship between performers and spectators that contributes to the latter's sense of collective ownership of a performance. For not only do they, or a group of village people on their behalf, pay for a performance, they also set up the performance area and offer local hospitality to the visiting actors and musicians. Most importantly, the performance is theirs because it takes place on their *soil*. Anthropologist Valentine E. Daniel has highlighted how in Tamil culture the soil of one's birth village contributes to defining personhood. According to him personhood is never isolated nor individuated, but always understood in context. A person absorbs into her/his being the substance or quality of the soil of her/his *conta ūr*, that is, the village of her/his birth, as do other village members, contributing to their being an interconnected and interdependent community (Daniel [1984] 1987: 61–104 as quoted in de Bruin and Rees 2020: 97).

Ownership of the performance manifests itself in other ways too, varying from patrons having a say into which play will be performed to spectators walking into the performance space while the performance is in full swing to present an actor, or the entire theatre company, with a monetary gift or a shawl. Such a gift or *aṇpaḷippu* is announced publicly by the Kattiyakkaran or another company member who at that moment is not in role. The first donation during an all-night performance customarily is one on behalf of the village, therewith underlining the hierarchical and interdependent relationship between performers and patron-spectators. The leader or *Vāttiyār*[13] of a company, if not yet in role, will appear on the stage to announce this collective gift. Rajagopal does so through a conventional *viruttam* or eight-line recited-verse, which he learned from his father. The viruttam

is followed by a prose passage in which each sentence begins with the word *cupōjeyam*, 'auspicious victory' (< Skt. *śubha-jeya*), announced loudly whilst the actor raises his hand with the donation. In formulaic prose he thanks all persons holding different offices in the village, including traditional ones, such as the village headman and village accountant, in addition to more modern functions, such as the police, panchayat president and members. To this list he can add members of the festival committee that has extended the invitation to perform and, depending on the context, other important guests (de Bruin and Rees 2020: 96–8).[14]

Off-stage performances

The boundaries of the Kattaikkuttu performance area are porous. While patrons and spectators may walk into the performance space, conversely performers from time to time may step into the crowded audience arena. Peeling off her sari(s) and carrying them with him, Draupadi's opponent Duhsasana moves into the audience therewith visualizing an infinite stream of saris which the God Krishna has granted her to protect her modesty. Similarly, another Mahabharata character, Arjuna, leaves the stage and proceeds to the centre of the village in order to climb a huge (60–100 feet tall) pole or *tapacu maram* after an all-night performance to obtain a divine weapon from the god Shiva (Śiva). The pole symbolizes Mount Kailasa on top of which Shiva resides. The off-stage performance of *Patiṉeṭṭām Pōr* (*The Eighteenth Day*) takes place on the last day of a *Pāratam* or Mahabharata festival. It is another example of performers leaving the performance area at the end of an all-night performance. Moving through the village to its centre, they transform the village space into the battlefield of Kuruksetra where Duryodhana, represented by an actor *and* a huge, lying mud-statue in the village commons, finally gets killed.

Performances on the occasion of Paratam festivals connect epic space with physical locations beyond the area delineated for the performance proper to encompass the entire village, therewith imbuing the performance and these spaces with additional meaning and life. In this complex process of interweaving, the physicality of the *ūr* never entirely loses its specific characteristics. Rather its very substance feeds into the substance of performance, making every performance event unique as well as locality-specific and endowing rural spectators, on whose behalf the performance has been commissioned, with ownership of the performance and its patrons with (a limited) agency to curate it in the way they want (de Bruin and Rees 2020: 98–9).

Performances

Performers distinguished between two different kinds of performances: presentations of a single-night duration or *taṇi nāṭakams* and performances that took place as part of Paratam festivals. Paratam festivals feature a cycle of Mahabharata performances – usually between eight and twelve depending on the budget of the organizers – which are dedicated to the village goddess Draupadi (or Tiraupatiyammaṉ). Paratams are extremely complex, layered events that display a range of local specificities. At a performative level, they interweave the recitation and extrapolation of a Tamil version of the Mahabharata and a series of overnight Kattaikkuttu performances with temple rituals that include the procession of the icons of Draupadi, her multiple husbands and their guardian Pōttarājā/Pōttu Rāja (Hiltebeitel 1988: 139–40). The long duration of these festivals allows performers to develop, within the overarching framework of the Paratam, a narrative continuum into which they infuse carefully built-up, predictable moments of sacral tension, which are further

reinforced by complementary narratives and festival rituals (de Bruin 1999: 112).

Performances of a single-night duration are put on for a variety of deities, including pan-Indian gods of higher status, such as Ganesha (Gaṇeśa), Shiva (Śiva) and Vishnu (Viṣṇu) (also called Perumāḷ in Tamil), in addition to localized village goddesses referred to as *ammaṉ* with or without a name prefix (e.g. Poṉṉiyammaṉ, Paccaiyammaṉ, Puliyatāmmaṉ, Tīppāñcammaṉ). Another important context for a single-night performance is the conclusion of the funeral rites for a deceased individual. On such an occasion, relatives of the person who has died commission the performance of the Mahabharata play *Karṇa Mōkṣam* in the hope that the deceased will attain *mōkṣa* or liberation from the cycle of rebirths, just like Karna in the play (Frasca 1990: 135; de Bruin 1998 and Chapter 2).

Kattaikkuttu performances are freely accessible to everyone. While performances of Karna Moksam on the occasion of a death are paid for by individual families, most other performances are sponsored collectively by a village, a street or a town's quarter. Sometimes this is done by requiring each household to contribute a fixed amount (*talaikkaṭṭuvari*). At other times a performance or an entire festival is financed from the sales of a village's common produce or through finding sponsorship.

Performance as sacrifice

India's oldest treatise on drama, the *Bhāratīya Nāṭyaśāstra* (150 CE to 350 CE), describes a performance as a visual sacrifice (*yajña*). Also today, Kattaikkuttu performances are considered sacrificial offers to a deity, who often is a local goddess (De Bruin 1999: 124–6; Zarrilli 2000: 20). At the end of her parade through the village, the processional icon of the goddess is parked in front of or near the performance area so that she can witness the performance. Kattaikkuttu performers are hired not only for their artistic expertise,

but also for their ritual competence and their ability to handle sacral power epitomized by the deity and generated during the performances. Their professional knowledge and low caste status made hereditary performers experts par excellence to evoke and manage ambivalent sacral power, that is, to contain its dangerous and polluting effects and channel its beneficial and life-giving forces for the benefit of the village community.

Many Hindu-religious village festivals on the occasion of which Kattaikkuttu performances happen, and in particular festivals for ferocious village goddesses, are non-Brahminical in nature. Village goddesses and other local deities are said to invoke both *bhaya* and *bhakti* or fear and devotion in their devotees. They demand to be worshipped through blood sacrifices and other impure substances that necessarily need to be handled by non-Brahmin, low caste priests or directly by the devotees themselves. In addition to the slaughter of a cock, goat or buffalo, worship may include practices of self-mutilation and possession. Sacral power becomes visible at moments when performers and members of the audience fall prey to possession-like states (*āvēcam* from the Sanskrit *āveśa*). Such states are predictable and usually connected to real or dramatic acts of violence, bloodshed, killing and injustice that are pivotal to the way Kattaikkuttu performers (re) create, interpret and embody the Mahabharata and puranic narratives in the here and the now. Rural audiences perceive the occurrence of avecam in a character or a member of the audience as a visible sign of the success of the performance and its sacral efficacy: a specific performance segment or character has run its/his course, neutralizing or dispersing the demonic, which is inherent in all of us and in society, until the next festival and the next performance (de Bruin 2023: 85).[15]

Generally, Paratam festivals provide, more so than single-night presentations, a heightened sacral atmosphere that fosters the occurrence of possession-like states in performers and members of the audience.[16] Such an atmosphere is altogether

absent from performances that take place on secular occasions, for instance cultural festivals, which are mostly confined to urban contexts. On such occasions, performances tend to be of a much shorter duration – usually between one and two hours – while their purpose is not community or sacrality oriented, but exclusively artistic and aesthetic.

The performance season

Kattaikkuttu's performance season starts on Kaṉṟu (Kaṇṇu) Poṅkal, that is, the third day of the Pongal Festival, falling on the third day of the Tamil month *Tai* (around 16 or 17 January). Customarily, it closes on the fifth Saturday of the Tamil month *Puraṭṭāci* (mid-September to mid-October) (de Bruin 1999: 53).[17] In between these two dates, the season has a first peak in the hot summer months of April and May when most of the Paratam festivals take place. A second peak falls in the Tamil months of *Āti-Āvaṇi* (mid-July to mid-September), which coincides with the planting season of paddy. During this second peak single-night performances are commissioned for the Goddess Māriyammaṉ (or Māriyattā) and a variety of other local goddesses. Mariyamman is associated with fertility and rain – and hence with a bountiful harvest – as well as with disease, in particular small pox (Beck 1981; Srinivasan 2010: 83). At the end of the season, on all Saturdays during the month of Purattaci, performances are commissioned in honour of Perumal/Vishnu. Towards the second part of October or the beginning of November the onset of the northeast monsoon makes outdoor performances unlikely, though occasional performances do happen.[18]

Paratams provide a theatre company with a number of guaranteed performances. When I did my field work in the late 1980s and 1990s, Paratams constituted about one-third of the total annual number of performances by the Peruṅkaṭṭūr Poṉṉucāmi Nāṭaka Maṉṟam, then one of the leading companies (de Bruin 1999: 112). Even though

tani natakams may fetch a slightly higher price, Paratams
are in demand as a source of reliable income. In addition,
the number of commissioned Paratams is evidence of a
company's standing in the professional field. Some Paratams
are particularly well known for their grandeur, artistic
quality and critical spectatorship. One of these is the Arcot
Paratam, held once in a decade. Rajagopal performed
at the 1978 Arcot Paratam for fifteen nights with a large
company of twenty-five actors and musicians, which he had
arranged especially for the festival following the demand of
the patrons; his father C. Ponnucami led the performances
of the 1958 Arcot Paratam. The public acclaim Rajagopal
received as a twenty-five-year-old actor from the organizing
Chettiars, a well-to-do business community in Arcot,
conferred on him a star status. Looking back, he considers
the Arcot Paratam a turning point from which his career as
a leading Kattaikkuttu performer took off.

Performers

Like many other traditional performing arts forms in India,
Kattaikkuttu used to be a hereditary and, consequently, caste-
based occupation that was transmitted from father to son or
another close male relative. Historically, the theatre appears
to have been the prerogative of male members of the Tamil-
speaking Vaṇṇār (Washerman or Dhobi) and Paṇṭāram
(flower garland-makers and priests in non-Brahmin temples)
castes, at least in the northern districts of Tamil Nadu where
most of my research and work have been based (de Bruin
1999: 61–76).[19] Within these hereditary performing castes, it
was usually a core group of four to five male kinsmen who
were involved in performances, while other family members
carried out the regular caste occupation.[20] Family lineages of
Vannars and Pantarams based in the villages of Perunkattur
and Purisai, both situated in the Cheyyar Taluk of the

Tiruvannamalai District, have provided some of the most
well-known exponents of two distinct styles of Kattaikkuttu.
I have assumed that these performance styles originated
and developed as a result of the feudal system of hereditary
performance rights-cum-obligations that I will outline below.
Initially these styles – that is, their performance practices and
(textual) interpretations, repertoires and professional secrets –
appear to have been in the hands of closely related family
lineages of performers holding locality-specific hereditary
performance rights. When Kattaikkuttu opened up to other
castes these styles were transmitted to, copied and at times
modified by non-hereditary performers.

Since I completed my fieldwork now almost thirty years
ago, the presence of hereditary performers in Kattaikkuttu has
diminished considerably. Knowing the hardships of life as a
performer, hereditary actors and musicians did not encourage
their sons to follow in their footsteps.[21] In my fieldwork area
Kattaikkuttu today is dominated by Vanniyar performers for
many of whom Kattaikkuttu is a first- or second-generation
occupation (de Bruin 1999: 76–8 and 151–4). The growing
interest of Vanniyars to perform Kattaikkuttu and form their
own theatre companies appears to be linked to their caste's
political and religious emancipation. Vanniyars are a caste
of agrarian labourers and (small) landowners. The 1871
Census classified Vanniyars as Shudras (yet stationed above
Vannars and Pantarams in the caste hierarchy),[22] but already
since the nineteenth century the caste has been involved in
trying to gain upward mobility by laying claims to a heroic
Kshatriya-warrior status.[23] Kattaikkuttu's heroic nature and
its Mahabharata repertory allow Vanniyars to publicly express
their political aspirations to a Kshatriya status and so does
their identification – supported by the caste's mythology –
with the heroic characters of the Mahabharata (de Bruin
1999: 77, 84).

Some of the newly emerged Vanniyar companies began
as an amateur pastime, when a group of male Kattaikkuttu
enthusiasts in a village decided they wanted to learn an all-

night play. Hereto, a professional performer – often a Vattiyar from a hereditary Kattaikkuttu background – would be hired to teach them. With the acquisition of a few more plays and invitations to perform outside their own village such a group might eventually decide to begin performing professionally, that is, against payment, as an ensemble. Passion for the theatre was stated as an important motivation to become a Kattaikkuttu performer, as in the case of Mr C. Sitaraman, a Vanniyar by caste from Siruvanchippattu village. Today Mr Sitaraman is one of Kattaikkuttu's leading actors in my area of work.[24] Other performers quoted poverty as a reason to join a professional theatre company at a young age because it offered them access to food and a degree of safety.[25] In yet other instances a desperate parent would drop off a young boy with a Vattiyar, requesting him to teach the child a useful skill because of its perceived inability to learn or his unwillingness to go to school.

In addition to a large number of Vanniyar performers, Kattaikkuttu has also opened up to Dalits, which is the other numerically dominant caste group in north Tamil Nadu. While Dalits appear to never have been entirely excluded from theatre companies (including those run by hereditary performers), their presence appears to have been minimal. In my fieldwork area there was a single company composed exclusively of a kin group of hereditary Dalit performers. They had settled quite recently in a place called Kalavai Kutroad, near the town of Kalavai in Vellore District, indicating that earlier they might have led a more nomadic existence. The performance style of this Dalit company differed considerably from that of other theatre companies to the extent that it did not qualify as Kattaikkuttu proper in the eyes of most non-Dalit Kattaikkuttu performers.[26] Today Kattaikkuttu counts a number of young Dalit actors and musicians, some of whom got access to the theatre thanks to the training offered by the Kattaikkuttu Gurukulam. These Dalit performers operate as individuals and are part of non-Dalit, usually Vanniyar-dominated theatre companies. A woman performer from a

Dalit background and alumna of the Kattaikkuttu Gurukulam has established her own performance ensemble.

The māmūl system

In contrast to other performing art forms, such as the high-status Devadasi dance tradition attached to Agamic temples or Kathakali dance drama, Kattaikkuttu never seems to have enjoyed royal patronage or Brahminical temple patronage (Frasca 1990: 38).[27] Instead Kattaikkuttu was part of a feudal village set-up that was regulated by the agrarian season and the need to maintain a socio-economic and cosmological equilibrium. Both Vannars and Pantarams are non-agrarian (and non-landowning) service castes rendering services that were, and to some extent still are, indispensable for the functioning of an agrarian society (Brubaker 1979: 129).[28] My informants referred to these services constituting both a right and an obligation as *mamul*s or *mirācus* (de Bruin 1999: 62–3; for a description of miracu or mirasi-tenure in nineteenth-century Tamil Nadu see Jayashree [1989], 580–7). Potters, barbers, carpenters, blacksmiths, non-Brahmin priests, female performers dedicated to local goddesses, shepherds and certain sections of the Dalit community are examples of such non-agrarian, service-rendering castes. In addition to occupational tasks, mamuls included duties of a sacral and a performative nature. Different kinds of services were distributed among different family lineages and different castes in patterns that varied from village to village forming together a complex and highly locality-specific system of occupational, ritual and performance rights-cum-obligations. The mamul system regulated the interdependent, yet unequal, interactions between the dominant, usually landowning cultivator castes, on the one hand, and, on the other hand, agricultural labourers and service and artisan castes. In return for rendering their (obligatory) services, members of the service and artisan castes received a specified share of the paddy

harvest, which would be set apart for them on the threshing floor (de Bruin 1999: 42–3; de Bruin 2007: 54).[29] When the rural agrarian economy shifted to a market economy, this payment in kind came to include, and eventually was replaced entirely by, cash.

Terukkūttu

One of the mamuls of the Vannar kin group in Perunkattur was the performance of Terukkuttu on the occasion of festivals (*yāttirais*) for the goddess Mariyamman.[30] Such festivals would take place during the months of Ati and Avani, that is, mid-July to mid-September. A Vannar officiant would carry the *karakam* or pitcher decorated with flowers and embodying the goddess Mariyamman on his head taking it in procession through the streets of the village over three subsequent days. On the afternoon of the second day the karakam procession would be accompanied by a Terukkuttu ensemble that would be preceded at the head of the procession by a group of Dalit (*paṟai*) drummers (de Bruin 1999: 63–70).[31]

Terukkuttu literally means street (*teru*) theatre (*kuttu*). As noted in the Introduction, the term has been used to refer to the same all-night narrative performances that I call here Kattaikkuttu. However, Rajagopal, who is a Vannar by caste, distinguished the practice of Terukkuttu as performed by his family members from these overnight Kattaikkuttu performances.[32] According to him overnight performances have a narrative structure, are demarcated by a well-defined performance space and need three musicians and ten to twelve actor-singers. In contrast, Terukkuttu is mobile, has no specific narrative and takes place during the daytime (de Bruin 1999: 70–1). The practice of Terukkuttu requires two actors – a male, kattai character and a female character – a *mirutaṅkam* (< Sanskrit *mṛdaṃga*) player and a leader or Vattiyar who plays the hand cymbals.[33] The karakam procession, including the Terukkuttu ensemble, would stop in front of every house where

its inhabitants would perform a light-offer for the karakam. Thereafter a householder or an onlooker could request the Terukkuttu actors to perform one or more well-known song and dance sequences from the Kattaikkuttu repertory, usually involving sung debates (*tarkkams*) between illustrious male and female epic characters, that would be rewarded with small monetary gifts.

For Vannar performers, the performance of a Terukkuttu was a prerequisite to secure an overnight performance – the Kattaikkuttu proper – on the third and last night of the Mariyamman festival. The Terukkuttu had no remuneration other than voluntary gifts; the overnight performance would be paid for by the village community and, consequently, was pivotal to sustain hereditary Vannar performers' precarious livelihoods. The Terukkuttu practice was physically exhausting and the monetary rewards small and unpredictable. The obligatory nature of the practice and the absence of a proper remuneration, in addition to the display of subservience to their benefactors and the fact that some of the onlookers might have been drinking (and the performers sometimes too), made this caste-based practice a demeaning experience (de Bruin, forthcoming a). In the long run, Terukkuttu performances were abandoned in favour of the more prestigious and economically attractive Kattaikkuttu performances, which placed a greater emphasis on the narrative contents and their dramatic enactment.[34]

Art as labour

In a recent production Rajagopal equated, somewhat sarcastically, Kattaikkuttu with *uḻaippu*, that is, hard labour, physical effort, toil or exertion (de Bruin 2019: 64–6; also, Pandian 2009: 162–3 and, with reference to several different rural occupations, Karthikeyan 2019, xiii and *passim*).[35] Coming from a Vannar lineage of hereditary Kattaikkuttu

performers, for him ulaippu has both a physical and a social-emotional side. When in existence, the Terukkuttu custom required performers to transverse the entire village during the heat of the day. Kattaikkuttu's heavy kattai ornamentation, high-energy movement vocabulary and open-throated singing during overnight performances place great physical demands on the bodies of the performers. Additionally, Kattaikkuttu's epic Mahabharata repertory focuses on sacrificial battles that often result in the violent killing of one of two battle contestants and may give rise to possession-like states in performers and spectators alike (de Bruin 1999: 124–42). During the process of recreating these violent confrontations, the performers lend their bodies and minds to become each other's heroic opponents. In doing so, they take upon themselves the risk of becoming the potential sacrificial victims of these sacral battles if they were to fail to monitor their violent nature appropriately; that is, if their play would erupt into reality, minimizing – or perhaps eliminating altogether – the fine line that distinguishes play from real and self from character. Being of low caste, Kattaikkuttu performers are thought to be particularly competent to handle the potential danger and impurity posed by these battles, adding a dimension of personal vulnerability to their labour of performance (de Bruin, forthcoming a).

Flexibility and the rule of 'kirāmattiṉ iṣṭam'

The subservient position of hereditary Kattaikkuttu performers required them to attune their performances to the expectations of their patrons and spectators. This has imbued Kattaikkuttu with a flexibility that is reflected in the unwritten practitioners' rule that every performance should be *kiramattin istam* ('according to the wish of the village') (de Bruin 1999: 56–7). For instance, the decision as to which play will be performed is left to the sponsors of the event and performers are careful not to interfere in this process. Requests for minor adaptations in costumes (e.g. a demand that Karna wears a big crown instead

of the customary smaller cikarek) are agreed to immediately. Similarly, the mood of a performance can be set by allowing the Kattiyakkaran to expand or reduce his comedy and slapstick. Observance of the rule of flexibility is necessitated by the artists' dependence on an intricate network of sponsors and audiences of mixed political and social composition, with whom they maintain relationships over time. Performers, in particular when they belong to a low/no caste group, thus cannot afford to antagonize their audiences. In the next chapter I will discuss how flexibility is operationalized in actual performances.

Theatre companies

Kattaikkuttu depends on a group of actor-singers and musicians to realize a show. In everyday parlance such an ensemble was called a *kāmpeṇi* (from the English 'company') in my fieldwork area. In other districts the word *jammā* was used.[36] However, stage banners and printed performance invitations usually carried the more formal terms of *capā* (< Skt. *sabhā*), *(nāṭaka)* *maṉram*, 'assembly', 'court', 'meeting place', '(performance) place' or *kuḻu*, 'band', 'troupe' to refer to a theatrical ensemble.

A regular theatre company needs between twelve and sixteen performers to present Kattaikkuttu's principal epic and puranic narratives. For Paratam festivals one or two additional stage-hands may be hired. As a practical rule it is said that a company is operational when it is able to perform the Mahabharata play *Pakaṭai Tukil* (*Dice and Disrobing*), which requires the fullest cast of performers. Companies often rely on one or two star performers, who act the principal male and female characters in all plays opposite each other. These star performers are pivotal to securing performance invitations referred to as *tāmpūlam*s.[37] Tampulams are oral performance contracts which are sealed by the exchange of betel leaves and areca nut and, nowadays, an advance payment (de Bruin 1999: 46).

In my area of work, theatre ensembles employed three musicians to accompany eight to twelve actor-singers: a player of the pedal-harmonium ('*kāl* box'), a drummer who played the mridangam and *ṭōḷak* (< Skt. *ḍholak*) and a player of the mukavinai, a high-pitched reed instrument [Figure 2]. The mukavinai appears to have been part of the orchestra accompanying Satir dance performances by rural Devadasis, but is found nowadays only in Kattaikkuttu. Outside my area of work not all companies had a mukavinai and some employed a simpler version of the harmonium requiring one hand to play and one hand to operate the bellows. Other companies had two sets of mridangam/dholak with the percussionists seated opposite each other on an elevated platform placed centre-back of the performance area. In addition to these musical instruments, each of which are the domain of professional musicians, theatre companies used two sets of hand cymbals or talams played by those actor-singers who are not in role. Kattaikkuttu performances in the region around Vilupuram-Gingee-Pondicherry were stylistically different from the Perunkattur style. While the mukavinai was absent in these southern companies, the talam players occupied a central place. They were often seated on or stood prominently at both sides of the actors' bench centre back stage, whereas in the Perunkattur style the cymbal-players stood behind the bench on which the musicians were seated, somewhat hidden from public view. The combination of metals that the cymbals are made of, and therefore their sound quality, differs from style to style to match the pitch of the actor-singers of an ensemble.

From māmūl to negotiated performances

Abandoning Terukkuttu performances in favour of all-night Kattaikkuttu performances was part of a larger development begun during the first half of the twentieth century or perhaps already earlier. This development involved the gradual erosion

of the mamul system. Initially, cracks in the system appeared at an economic level when the customary remuneration in kind or cash no longer was worth the performance of the service. Liberating oneself from the oppressive, interdependent social relationships that the mamul system involved took much longer and attempts to do so could have far-reaching social consequences. I have described elsewhere how in the mid-1960s Rajagopal's father, C. Ponnucami Vattiyar (1915–71), refused to perform the customary Terukkuttu – and therewith brought the entire procession of the deity to a halt – because a village headman offered him a ridiculously small amount of money. His refusal led to a panchayat involving several different villages (de Bruin, forthcoming a; also, de Bruin 1999: 144).

Multiple reasons underlie the attrition of the mamul system. These include socio-economic and political changes as a result of the introduction of general franchise, access to formal education, a relaxation of the caste system, an increased commercialization and expansion of the (agrarian) village economy and the emergence of a local performance market. All these factors together affected the organization and power-structures of rural villages, or conglomerates of villages, which until then had been governed by a variety of hereditary occupational, ritual and performance rights and privileges allotted to family lineages representing different castes.[38] As a consequence of these changes, in combination with state interventions and greater political awareness and organization, members of the lower and lowest caste groups, in particular Vanniyars and Dalits, became more vocal and acquired land of their own, with Vanniyars now owning 50 per cent of the lands in my area of work.[39] In the longer run, these economic, social and political transformations impacted severely on the caste composition of villages, intercaste relationships and on the Kattaikkuttu profession itself. At the level of performance, the transition from mamul to negotiated, sponsored performances resulted in the tradition opening up to newcomers, Vanniyars and Dalits in particular, and a

commercialization and professionalization of the theatre (de Bruin 1999: 143–54).

Competition: Drama performances and the emergence of a local performance market

The erosion of the feudal mamul system coincided with the entry of Drama, a popular, commercial theatre genre already alluded to in the Introduction, on the rural performance scene. Drama is a form of musical and theatrical entertainment found with stylistic and operational differences and under different names across Tamil Nadu. It is unclear how exactly Drama penetrated into the rural hinterland of Tamil Nadu (then part of Madras Presidency) and how it was absorbed within the existing performance landscape. With regard to the Special Drama, Susan Seizer has proposed that this theatre genre, akin to Drama, entered the rural theatre scene through visiting 'special' actors from well-established (and perhaps urban-based) companies. These performers were hired on a freelance basis to augment the popularity of Special Drama companies while the management structure and ownership of the latter remained intact (Seizer [2005] 2007: 47–8). In northern Tamil Nadu, handbills of upcoming Drama performances displayed the cameos of well-known actresses, some of them from the Tamil film, who may have been employed as specials (de Bruin 2001: 73). However, further research is needed to reconstruct the history of Drama in my area of work.

Commercial Drama companies operated independently of the mamul-based village hierarchies of which hereditary Kattaikkuttu practitioners were a part. Their performances were financed through ticket sales – at least initially – while caste appears not to have been a bar for someone wanting to join a Drama company. Drama's hybrid performance style and operational practices were inspired by the Parsi theatre and other travelling theatre companies that visited urban

centres in the region during the last decades of the nineteenth and the beginning of the twentieth century. The commercial Parsi theatre combined elements, repertories and performance structures of indigenous expressive genres with melodramatic performance conventions and proscenium stage techniques gleaned from the Western Victorian theatre (de Bruin 2001: 2; Seizer [2005] 2007: 52–3). The hybridity of the Parsi theatre found further regional translation when this theatre style came into contact with local performance traditions. In my area of work this appears to have been the locally popular musical and dance tradition of rural female Devadasis, some of whom joined the early Drama scene, and Kattaikkuttu (de Bruin 2001: 56–74; Seizer [2005] 2007: 22, 47–9; Hansen 2021: *passim*).[40] Drama's display of novelty made it into a harbinger of modernity for non-elite audiences and the most popular form of entertainment in the region, a role that was taken over by the popular Tamil cinema when it emerged in the 1930s.

Hybrid performance styles and hybrid repertoires

Catering to the same rural spectators as Kattaikkuttu, Drama's rapid rise to popularity required hereditary Kattaikkuttu performers to rethink and strengthen their position and that of their theatre within a nascent rural performance market. Initially they appear to have done so by copying successful elements of Drama's presentational style and operational practices. A photo of Rajagopal's father's and grandfather's theatre company taken in the 1930s prominently features an actor in dress costume, an element which, as we saw already, was borrowed from the Drama genre [Figure 6]. According to Rajagopal, the Perunkattur troupe also used painted backdrops, wings and a device called 'drop scene', which it had copied from Drama performances and which were part of the framing conventions of a proscenium arch introduced by the Parsi theatre (Kapur 1993: 86; Seizer [2005] 2007: 52)).

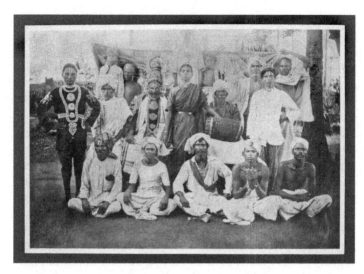

FIGURE 6 *Restored photograph of P. Rajagopal's father's and grand-father's company. In the middle his father C. Ponnucami in the female role of Kalantāri; next to him with the mridangam Rajagopal's grand-father, C. Chandiran. The character on the left (C. Balakrishnan) is a dress vesam and the single kattai vesam is Duryodhana (M. Muttusami). The Kattiyakkaran is Vayalur Rattinam. The other members of the cast could not be identified. The play is* Pulēntiraṉ Kaḷavu, *early 1930s. (Photo personal collection P. Rajagopal © P. Rajagopal).*

From about the 1920th onwards, or perhaps already earlier, both Kattaikkuttu and Drama appear to have been in close contact with each other. Complex processes of competition, imitation and convergence between Kattaikkuttu and Drama resulted in a syncretic performance style in which the same group of hereditary Kattaikkuttu performers creatively used elements from both theatre forms.[41] For instance, in the opening scenes of the Mahabharata play *The Royal Sacrifice* King Jarasandha (Carācaṇṭaṉ) and Bhima appeared as kattai characters. However, in these same scenes Jarasandha's father, Makatarājaṉ (or Pirakatattaṉ/Brihadratha), featured as a dress vesam and so would Yudhisthira, Nārada, Krishna and Śiśupāla appearing in the second segment of the play. The

presentational style of dress vesams differed from that of
Kattaikkuttu, in particular with regard to their body language,
stage entries (no curtain) and use of space (no steps or atavus).
Rajagopal's father Ponnucami Vattiyar began incorporating
new plays into the existing repertory of the company as a
survival strategy. In 1932 he premiered *Nāḷāyiṇi Carittiram*
ascribed to Kaṅkātaraṇ Vattiyar from Tiruppulivanam
near Uttiramerur. The entire play was presented in Drama
style.[42] Based on information from the late M. Kanniyappan
and late M. Ponnurangam, senior hereditary performers
of the Perunkattur style, half of the plays in the repertory
of Rajagopal's father's and grandfather's company were
presented in Drama style or in a hybrid style mixing elements
from both Kattaikkuttu and Drama, while the other half were
performed in Kattaikkuttu style.[43] A similar development
appears to have taken place in Purisai, another important hub
for Kattaikkuttu. Here, too, hereditary Pantaram performers
were forced to diversify and expand their skills (Hollander
2007: 168). Kannappa Thambiran Vattiyar, a celebrated actor
and director belonging to the Purisai style and a contemporary
of Ponnucami Vattiyar, describes in an interview how he began
staging plays in Drama style in order to weather what he
saw as a temporary decline in the popularity of Terukkuttu
(that is Kattaikkuttu) (Swaminathan 1992: 38 as quoted in de
Bruin 1999: 102). He attributed these plays to T.T. Sankaradas
Swamikal (Caṅkaratās Cuvāmikaḷ, 1867–1922), a well-known
playwright and author of the majority of plays in the dramatic
repertory of the Special Drama.[44]

Emergence of Kaṭṭaikkūttu
as a distinct genre

Extensive borrowing and syncretic matching and mixing
were followed by a process of distinction and separation,
which ultimately led to the evolution of Kattaikkuttu and

Drama into two separate genres. Where the Drama operated outside the feudal mamul system and offered a form of secular entertainment, in addition to creating a sense of novelty and modernity, Kattaikkuttu continued to be bound to sacral performance contexts.[45] These contexts required epic and puranic themes in addition to the performers' expert know-how to handle sacral power embedded in these contexts.

From storytelling to fully fledged dramatization

In order to create a niche for themselves in the emerging rural performance market, Kattaikkuttu performers began emphasizing the theatre's heroic nature as embodied by its kattai vesams. Furthermore, performers specialized in a Mahabharata repertory enabling them to monopolize Paratam and other sacral village performance contexts. While older performances featured a single kattai character and appear to have been set predominantly to a storytelling mode, the style of acting now moved toward fully fledged dramatization. Today's performances feature a much greater number of kattai vesams in a presentational style that demands a fuller degree of identification with the dramatic character and a greater corporeality on the part of the performer. Not only have kattai vesams become emblematic of Kattaikkuttu's heroic performance style, their high-energy stage behaviour is an attraction for contemporary spectators. Thus, companies may feature the five Pandavas, or Duryodhana, Duhsasana, Karna and Sakuni in full kattai attire during an impressive, collective stage entry behind a curtain.[46] In the stories themselves the focus turned towards these heroic kattai vesams, who have become the central characters in almost every performance and who are the most important dramatic agents to evoke sacral power. The pace of performance increased considerably by speeding up the songs (or rendering them in a fast and a slower mode).[47] Symbolic fights turned into more physical ones to

provide greater scope for the presentation of *vīra* rasa. These developments may have been detrimental to the portrayal of leading female characters and their importance in a play. In present-day performances in my area of work, kattai vesams are visually as well as verbally portrayed as superhuman beings, whereas their female counterparts – irrespective of their royal or divine descent – tend to be shown as more or less realistic prototypes of contemporary Tamil village women.[48] Although they often fulfil pivotal and even militant roles in the narrative plots and although their traditional verbal text remains strong (as we shall see in Chapter 3), their stage behaviour frequently carries the message of conformation to socially accepted norms of female subservience and compliance. Perhaps this is not surprising given the fact that Kattaikkuttu remains, with a few exceptions, a theatre form in which female roles are embodied and interpreted by men. As a corollary of relinquishing their mamul rights and increased competition of the Drama, Kattaikkuttu performers had to become more professional in their outlook, responding quickly and adequately to the social and economic changes in Tamil society and concomitant changes in audience demands and preferences.

Increasing commercialization: Agents, advances and the debt trap

With the monetization and commercialization of the rural stage, intermediaries or agents made their entry, in addition to an advance system. Agents broker the commissioning of some performances, in particular of new or below-grade theatre companies that have not (yet) built their own clientele network. However, well-known and well-run companies often refuse to use the services of these agents as they believe this to be below their dignity and a sign of a lack of performance quality. Rather than approaching potential patrons or using the services of an agent, they expect sponsors to approach them to commission a performance, and in fact this is what continues to happen.

An ensemble theatre such as Kattaikkuttu requires a solid economic base to be able to maintain troupes of twelve to sixteen professional artists for the duration of a theatre season. In addition to the remuneration paid for performances, Kattaikkuttu's economics are determined by the number of performances a troupe can secure and, of late, by an advance system. An advance – the English term is used by the performers – basically is a loan extended to a performer by a sponsor or financer (who may or may not be a performer himself), often against a high rate of interest (estimated to be between 12 per cent and 25 per cent). Theatre companies function on the basis of shares (*paṅkus*) paid out to performers at the end of each performance. In addition to their performance fee, the share can include a payment for the assets that an individual performer brings in. This may be a musical instrument, a set of kattai ornaments, the attire for female characters (usually including several saris, a petticoat, jewellery and wigs) or the screen cloth hung to cover the backside of the performance area (*paṭutā* or *partā* < Urdu *partā*) (de Bruin 1999: 49–52).

Performers negotiate the volume of their share(s) before agreeing to join a company for the duration of a season. Nowadays these negotiations include the payment of an advance to a performer. A percentage of the advance plus the interest on the principal, that is, the original loan, is deducted from a performer's total amount that s/he will receive at the end of each performance. In the period 1987 to 1990, the Perunkattur Ponnucami Nataka Manram, which was the subject of my research, used to divide the total amount received for a performance into twenty-five shares; this company of hereditary performers had not yet embraced the advance system (but gradually did so in the following years). Today's companies work on average with forty shares of which ten to fifteen shares go to the financer(s) to account for the total advance amount provided to the troupe members.[49]

Kattaikkuttu appears to have borrowed the practice of advance from the Drama genre, which in turn must have copied

it from the commercial Parsi theatre and its regional off-spring. Initially Kattaikkuttu actors-cum-company owners would lend a small monetary amount to co-performers in order to keep them in the company and help them bridge the lean season. However, with high returns on a high-risk, informal investment that does not require any bureaucratic paper work, Kattaikkuttu began to attract financers from outside the profession. Begun somewhere in the 1980s, the practice of advance has become so widespread among Kattaikkuttu performers that today there hardly is a professional performer who has not taken out an advance. The amounts of advance have increased considerably with some individual performers becoming more indebted every year. Rather than a financial bridge to transcend the lean season, these advances are now considered to represent the worth of a performer. The intricacy of this informal financial system speaks from the fact that financers are not interested in recovering the principal amount they invested originally. The advance system drives up the number of performances, sometimes irrespective of the quality of performance and the well-being of performers. Thanks to increased mobile phone ownership, it has become much easier to inform company members about upcoming performances; earlier somebody had to make the rounds in person to inform co-performers or communicate the dates of upcoming performances by postcard. A greater volume of performances allows financers to recover the principal amount already during or soon after a performer completes his first season. Thereafter, all additional interest recovered by the financer(s) is profit.[50] By not repaying or not being able to repay the principal amount, many performers wittingly have become bonded labourers. Their indebtedness prevents them from switching companies at the end of the season, as used to be established practice (de Bruin 2020: 8). This in turn prevents the circulation of artistic knowledge and skills and the transmission of conventions within the profession, which is showing its impact on the quality of today's performances.

Summary

In this chapter I have traced Kattaikkuttu's trajectory from a dramatic form of caste-based labour embedded in a rural feudal performance economy to an independent total-theatre genre. This transition involved a replacement of obligatory performance rights by performances the remuneration and conditions of which are subject to negotiation between performers and patrons. Confronted with the competition from Drama companies and, more recently, from modern mass media, Kattaikkuttu performers have highlighted the heroic element in their performances through a focus on the theatre's distinct kattai characters and a Mahabharata repertory. This enabled them to monopolize sacral performance contexts, in particular Paratam festivals (de Bruin 1999: 150).

Newcomers of different castes have entered the profession to the extent that only a small number of hereditary performers are still involved in the tradition. With the majority of performers now being Vanniyars, caste identities have begun to play a more important role in the commissioning of performances. Better transport and communication facilities have increased the mobility and action radius of performers, who are able to accept performance invitations further away and at novel locations. The total volume of performances has grown during the last five decades – and seems to have stabilized now at between 100 and 200 performances per year – while also the payment for performances has increased. Patrons and audiences are no longer destined to seeing the same mamul company, but can select a theatre company of their liking and affordability. In order to maintain old performer-patron relationships and cultivate new ones, Kattaikkuttu performers continue to have to satisfy the demands and expectations of audiences at large. In order to do so Kattaikkuttu's inherent flexibility remains pivotal to allowing performers to adapt each performance to the wish of the village and secure future performances.

2

Producing an all-night performance

Kattaikkuttu's long-duration performance events have an ephemeral existence, but they do not come out of nothingness. In my earlier work I have proposed the existence of blueprints, stored in the bodyminds of Kattaikkuttu's principal stakeholders, as underlying and prompting actual performances (de Bruin 1999: 163–5). In this chapter I will look at these conceptual blueprints, their actualization through performance and their fine-tuning to the local context using examples from a recorded performance of the all-night Kattaikkuttu play Karna Moksam. Before doing so I will briefly discuss the existence of handwritten and printed plays, their history and their relationship to Kattaikkuttu's texts in performance.

Performance texts

Handwritten personal scripts and printed chapbooks

Kattaikkuttu's performances are grounded in orality, yet are never entirely independent of written texts. The scripts of plays in Rajagopal's family's possession were inscribed on palm leaves. By the late 1980s, only a few of these had

survived, in a disorderly and incomplete state.[1] As palm leaves
are brittle and difficult to preserve in a hot and moist climate,
performers copied their content into notebooks when paper
became affordable. Such handwritten scripts or *pritis* contain
either the text of an entire play or the excerpt of a specific role.
In addition to handwritten notebooks, performers' collections
of plays almost always included a few printed chapbooks of
popular dramas. With standard woodcuts, a cheap paper-
wrapper and printed on low-quality paper, such chapbooks
were produced by small printing presses from the late
eighteenth century onwards. In contrast to the pritis, which
were closely guarded family possessions, the chapbooks were
generally accessible and sold at street corners, tiny bookstores
adjacent to temples and bazaar areas and, in rural areas, at
weekly markets and during festival fairs.

The chapbooks provide an extensive archive of popular
Tamil drama literature.[2] What strikes one in the chapbooks
is their high level of standardization, both in their layout and
language use. Most chapbooks lack genre-specific elements,
such as the routine sequence of songs that the curtain
entrance of a typical kattai character would require or the
Kattiyakkaran's interaction with other characters. Therefore,
it is impossible to tell from the chapbook texts whether these
were supposed to be presented in Kattaikkuttu style or Drama
style. In fact, printed chapbooks could serve as the play
texts for performances in either of these styles. Perhaps this
is not surprising because, as we saw in Chapter 1, this was
the time during which hereditary Kattaikkuttu performers
began straddling both these performance styles. The authors
of many of the chapbooks have passed in oblivion as more
recent reprints do no longer contain their names (Hiltebeitel
1988: 156–63). While attributing some of the plays in their
repertories to anonymous authors of chapbook dramas,
seasoned performers identified rural composers as the authors
of many other plays. La. Kumarasami Vattiyar (1847–1910?)
from Chennasamudram near Kalavai and his slightly older
contemporary A. Ramasami Vattiyar from Konametai village

near Perunkattur both authored a version of Hiranya Vilacam. Their competition gives us a sense of the artistic excitement that Kattaikkuttu performances of those days must have elicited.[3] Lastly, many plays contain songs of persons other than the author, who signed off with their names in the last line of their verses (de Bruin 1999: 177).

The standard format of chapbooks, the absence of genre-specific performance elements and the lack of obtrusive and sometimes risqué comedy point to a heavy editor's (or editors') hand. Of late, several scholars have drawn attention to the efforts of the colonial bureaucracy and an emerging Tamil bourgeois middle class to sanitize popular literature and dramatic expressions and even nineteenth-century classical Tamil literature.[4] The desire of the bourgeois elite for sanitization and rectification was grounded in its rejection of indigenous literature and indigenous forms of theatre and theatrical knowledge and a foregrounding of what it believed to be legitimate cultural expressions shaped by colonial education, modernity and a desire to create a respectable Tamil identity based on the language's ancient, classical sources. The idea that folk and other indigenous forms of culture had lost their pristine purity and morality and needed to be salvaged and sanitized is not new to the world of anthropology, or for that matter, the politics of culture (e.g. Clifford 1986: 103–21; Cherian 2009: 34). Such ideas have nurtured the discourse of contempt with regard to the status of the Tamil stage referred to in the Introduction.

In the past, theatre studies, unless concerned with ritual or orality, have tended to focus on written playscripts as the basis for performances and the source of semantic meaning. However, in the case of Kattaikkuttu, its handwritten and printed scripts are not at all congruent with the multimedia scores of actual performances. In fact, they do not play a role of importance in the creation of actual live performances. At most they serve as *aides-mémoire* refreshing a performer's memory of a role, the sequence of songs and the plot development of a play or help her/him memorize a particularly difficult poetic verse that, as an exception, needs to be learned word by word.

Multimediality

In the case of Kattaikkuttu's performance texts, the
relationship between the vocalized word and music and their
potential to create visual imagery is fluid and impossible to
pull apart. Kattaikkuttu shares this organic multimediality
with Tamil – the primary language through which this theatre
expresses itself. While in a Western perception words are
often thought to be the (most important) carrier of meaning
or semantic content, the Tamil language needs to be heard to
attain its full power (Kersenboom 1995). Words and music are
inseparable contributing equally to the creation of linguistic,
musical and emotional content and, subsequently, meaning
and mood. Kattaikkuttu's performance texts integrate music
with sung poetry and spoken prose, dance, body language,
facial expressions and acting, in addition to using an elaborate
range of costuming, ornamentation and make-up. In contrast
to the devised multimediality found in contemporary Western
performances, Kattaikkuttu's multimediality is a natural given
that local spectators take for granted (de Bruin 2019: 60).

The oral reservoir

In my earlier work I have tried to answer the question as to
how trained Kattaikkuttu performers are able to produce
repeatable performances of eight or more hours duration in the
absence of a written script and without memorizing the entire
performance text word by word, step by step and gesture by
gesture (de Bruin 1999: part II; de Bruin 2023: 81). Clearly,
Kattaikkuttu performances are not unpredictable, unstructured
or entirely improvised events. The stories are known.
Moreover, audiences have well-defined ideas of what a proper
Kattaikkuttu performance is or should be, in particular as they,
or patrons on their behalf, have commissioned and paid for such
performances. I have argued that a relatively stable *framework*
underlies each performance event. The framework provides

points of reference and informative cores that are essential for the initiation and realization of a live Kattaikkuttu event and the development of a narrative plot. It provides performers with a trajectory that allows them to know where they are in the overall performance and what to do next (de Bruin 1999: 191–209). The framework's points of reference prompt the use of a great variety of *multi-media building blocks* that performers have at their disposition to fill the basic structure provided by the framework (de Bruin 1999: 233–64). Blueprints, consisting of a framework and building blocks, allow performers to literally assemble long-duration dramatic events through the process of performance. The specific configuration of stable and variable elements of these blueprints provides Kattaikkuttu performances with a basic durability as well as an inherent propensity for flexibility and variation, through which, in the longer term, adaptation and change in the tradition are being recorded (de Bruin 1999: 164).

Additionally, I have proposed the concept of an *oral reservoir* to explain the location and circulation of Kattaikkuttu's dramatic material when *not* performed (de Bruin 1999: 164; de Bruin 2023: 81). Kattaikkuttu's oral reservoir is a hypothetical construct, a latent, communal, indigenous, expert knowledge base that I have assumed to be ingrained in the bodies and minds of people who own the tradition.[5] These are foremost the professional performers, who have imbibed knowledge and practices that define what they do as Kattaikkuttu, and not another form of theatre, from earlier lineages of performers. A second line of stakeholders are patrons and rural connoisseur-spectators or *racikars*. While usually not being able to actively perform themselves, these stakeholders have sufficient knowledge to critically evaluate Kattaikkuttu performances and commission future ones (de Bruin 2023: 81).

The oral reservoir is not a static or closed entity. While the core of the oral reservoir is relatively immune to change, its porous boundaries enable new material to enter into it. Material that is no longer actively used because its

subject matter has lost its relevance ultimately disappears from the oral reservoir. For instance, Kattaikkuttu's *Pālar vēṣams*, performed by two young child actors as part of the opening phase of a performance, were abandoned when performers shortened the preliminaries in order to accelerate the pace of performance and bring forward the commencement of the actual narrative.[6] Similarly, songs sung during the struggle for India's independence or the Tamil nationalist movement went out of vogue and were remembered only by some very senior performers (de Bruin 1999: 209–14). On the other hand, popular cinema tunes and a cinematic style of acting have penetrated Kattaikkuttu's performances. Ironically, many of the filmy tunes had their roots in the popular stage, were then adopted by the cinema and subsequently were recycled back into live popular, theatrical performances (de Bruin 1999: 163–5). Such a circular journey is facilitated by the oral reservoir, which allows dramatic material to be re-imagined and reshaped to fit new performance contexts and audience expectations. The porosity of the oral reservoir allows influences from other, adjacent performance forms, such as the Drama, and literary traditions to enter its storage and potentially be used in live performances. In Kattaikkuttu's performance economy, intertextuality and interperformativity, that is, referencing and interweaving narrative and performative elements and visual imagery belonging to other traditions, occur frequently (de Bruin 2023: 81). They create additional resonances and connect – as we shall see in the case of Karna Moksam often in ingenious ways – with other narrative repertoires to explain the behaviour of epic characters and their specific circumstances.

Framework of a performance

The framework underlying a Kattaikkuttu performance can be divided into an opening phase, a middle part in which the story is presented and a closing routine, each of which have their own subdivisions:

Opening phase

- *Mēḷakkaṭṭu* or musical introduction in which the musicians perform the five essential talams (talas) or musical meters used in Kattaikkuttu performances. These musical meters are *āti, aṭa, rūpakam, tirupaṭai* and *jampai*. The musical introduction is set to raga *nāṭṭai*. Phillip Zarrilli defines a raga (with regard to Kathakali) as 'a series of melodic modes built on a specific set of notes in the scale, and elaborated to bring together the musicians, performers and audience in the mood the raga is intended to evoke' (Zarrilli 2000: 59). This definition works for Kattaikkuttu's music too. Nattai raga is a heroic raga *par excellence* and an important contributor to Kattaikkuttu's characteristic sound scape. The musical introduction, performed in high tempo, announces that the performance is about to begin and calls spectators to the performance area.

- An opening song and invocatory verses to various deities. In the Perunkattur tradition, the opening song addresses Vishnu. It is followed by a *pāṭṭu* (or *taru*) and viruttam each for Ganesha, Sarasvatī (Kalaimakaḷ) and Murukaṉ; pattu and viruttam are two different modes of producing a poetic verse which I will discuss in the following section on building blocks.

Middle part

- Entrance (*pravēśam* or *tarpār* < Urdu *darbār*) of the Kattiyakkaran; this is followed by his announcement of the title of the play and the name of the theatre company and an introductory speech.

- Entrance of the first character or characters – usually a kattai vesam or group of kattai vesams using a curtain entry – followed by the entries of other characters as the story progresses; the curtain entrances are highly structured subdivisions within an all-night

performance. I will discuss Karna's curtain entrance in
the next chapter.

Closing routine

- Speech (*vacaṉam*) announcing that the play has
 reached its end.
- *Maṅkalam* or benedictory song with which every all-
 night performance concludes.

The actual performance is preceded by a puja for Ganesha,
the elephant-headed god who is thought to remove all obstacles.
The worship takes place in the greenroom where performers
light a small oil lamp, put out boxes with different colours of
make-up powder, mirrors and the large crown decorated with
flowers. The company's Vattiyar makes a drawing on the make-
up stone in front of which he places areca nut and betel leaves
and the two halves of a coconut together with the customary
donation (*dakṣiṇā*) from the sponsor(s) of the performance (de
Bruin 1999: 192–3). The Vattiyar then hands over one pair
of hand cymbals to another senior member of the company,
while keeping one pair himself. While they sound the hand
cymbals in a harsh, staccato rhythm in unison, the drummer
simultaneously sounds the mirutankam (a practice called *cāppu
pōṭutal*). As soon as this ceremony is over, the actors to appear
on stage first start putting on their make-up and costumes – a
process that can take between one and two hours. When an all-
night performance nears its end towards six or seven o'clock
in the morning, people start getting up and leaving for home
where another working day awaits them. There is no applause.
After the singing of a mankalam, the actors who were on
stage during the last segment of the performance return to the
greenroom. While they remove their make-up, their colleagues
pack up the costumes, ornaments and props, ready to return
to their individual homes or move on to a next performance
destination. The patrons of the performance appear to pay out
the negotiated remuneration for the performance; occasionally

they are nowhere to be found, sleeping off an overdose of alcohol, forcing the performers, who need some much-needed sleep too, to go in search of them.

Two levels of characters

A defining characteristic of the framework underlying Kattaikkuttu performances is the presence of two levels of characters. In actual performances these two levels represent the mythological world of the epics and puranas and the mundane world of everyday life. The first level is populated by royal and divine characters, including male kattai vesams, royal female characters, male dress vesams, such as Krishna, and sages, in addition to tolis in their roles of lady-friends and confidantes of queens and princesses and the Kattiyakkaran in his formal role of herald and guardian of the king's court. The epic characters are essential to the development of the narrative plot. In the performance of Karna Moksam, the royal-divine level features Karna and his wife Ponnuruvi, who are the two lead characters of the play, with Duryodhana, Sakuni, Arjuna, Śalya and Krishna in secondary roles. The second, mundane level consists of characters taken from everyday life. The latter comprises a variety of figures, such as Brahmin priests, astrologers, artisans, musicians, farmers, a midwife, hawkers and other village types. Some characters perform dual roles participating in both levels of the performance. For instance, in addition to being the hand maidens of queens and princesses, the tolis and the Kattiyakkaran in his role of menial servant of the court act out their own social dealings and conflicts in humorous asides. Draping a towel across one shoulder, the Kattiyakkaran sometimes plays the silly or obnoxious confidante of a toli. Such asides are presented in a more realistic acting style and include comments on everyday life situations, such as a comparison of the height of the salaries of the toli and the Kattiyakkaran (she earns more than him …), their treatment by the royals or their own hidden (erotic) desires.[7]

Kaṭṭiyakkāraṉ

The Kattiyakkaran is pivotal to linking the royal-divine level and the mundane level – and the sacral world of epic narratives and the everyday life world of rural spectators (also Frasca 1998: 41 fn 13). He is the conduit between the audience and the leading characters of the story and needs to be constantly at the disposal of his opposite numbers to answer questions and comment upon their actions. The Kattiyakkaran questions and often mocks royalty and divinity about their intentions obliging them to step down from their elevated positions of authority. He counteracts moments of heightened sacral power through down-to-earth comedy and intervenes when an actor-singer forgets his/her text or needs a rest (de Bruin 1999: 208).

Every Kattaikkuttu performance opens with the entry of the Kattiyakkaran. After his own introductory songs, he announces the name of the play and the theatre company through a standard, sometimes ridiculously 'learned', prose passage of which he has several at his disposition. In his introduction he requests noisy village audiences – often in vain – to be silent (using the English word 'Silence!'); he concludes his speech with a disclaimer of performance in which he apologizes for any mistakes that might occur in the upcoming show.[8] Below is the opening speech from a performance of Karna Moksam by the Perunkattur Ponnucami Nataka Manram, which I recorded in 1987 in the village Panrutti Kantikai:

Silence! Silence! Silence! Much beloved elders, members of this assembly, mothers, brothers, youth of tomorrow, I, the Buffoon bid you welcome. Let's have some applause (*oru ceken kuṭu* < English give a 'shake hand') – Not bad! Beaten to pulp–tamarind buds–nice show–tickles the ear–modern – Now what? – Silence! If you say 'town' it means only a particular town; if you say 'flower' it denotes the lotus; 'uncrowned monarch' is Nehru; 'Mahatma' means Gandhi; 'Kamar' means Kamaraj; a 'scholar' is Anna(durai); 'play' can only mean the kuttu we are going to perform here. It

is from kuttu that modern drama and cinema developed. This is the epic *Mahabharata* which has stood the test of time. Now what is the play we will perform tonight? *Karna Moksam*, an excellent part of the *Mahabharata* known as the fifth Veda. The play we have been asked to perform tonight is *Karna Moksam* and the Perunkattur Ponnucami Nataka Manram has come forward to stage this play for you. If there are any mistakes in wording, music, rhythm, or any errors made unknowingly, I beg you to forgive me and the other actors who will appear after me.

(de Bruin 1998: 12–13)

The nonsense words that the Kattiyakkaran uses – *Beaten to pulp–tamarind buds–nice show–tickles the ear–modern–Now what?* – are chosen for their rhyming qualities. The insertion of English words (including the Kattiyakkaran's self-reference as *Buffoon*, a title probably copied from Drama) is meant, according to the performer (Perunkattur K. Maheshwaran), to capture the attention of the spectators and bring them in a good mood. During the Kattiyakkaran's entry little kids and youngsters may come forward to present him with a garland of coloured pieces of pasta, fruit, paper or other rubbish.

The Kattiyakkaran is sometimes jokingly referred to as the *cirañjīvi* or eternal survivor – of the Mahabharata war and of the verbal attacks and beatings he receives from his royal masters (de Bruin 1999: 301–2). In The Eighteenth Day, for instance, he literally brings royalty down to earth providing the performance with a powerful subversive element. This play features Duryodhana and the Kattiyakkaran as the sole persons left on the side of the Kauravas on the final eighteenth day of the Mahabharata war. Inverting their power relationship, King Duryodhana asks the Kattiyakkaran how he can outlast this last day of the fraternal war promising to make him a Minister in his next government (de Bruin 2019: 67).

The Kattiyakkaran is one of the most contemporary and versatile characters in Kattaikkuttu, something that can be judged from his realistic manner of acting and the costumes he

wears. For instance, he may be dressed in loose, flowered and fringed pyjamas, a jacket and a ludicrous hat or a colourful, homey lungi, white banyan and a towel draped over his shoulder, tied around his waist (in deference) or tied around his head (as a menial worker),[9] or in jeans and a T-shirt with modern print or a reflecting safety jacket worn by people working on the road on top of loose shorts with suspenders stitched out of plastic fertilizer bags. His appearances and performance style differ from company to company and from actor to actor with some Kattiyakkarans being more verbal and verbose and others leaning more towards visual comedy, slapstick or pretended silence and disinterest. The Kattiyakkaran's comic repertory, including his introductions of plays, funny songs and intermezzos in the form of independent stories, is constantly being reshaped and refuelled by today's contexts. Being confined to a smaller number of performers specializing in this role, the Kattiyakkaran's repertory probably is the most oral and least researched part of Kattaikkuttu's extensive dramatic material.[10]

Building blocks and modes of production

Building blocks encompass an enormous and varied corpus of predominantly oral dramatic material. This corpus includes different types of poetic songs, fixed and ad hoc-constructed prose passages of varying length (such as the introductory speech of the Kattiyakkaran above), topical musical and comical interludes, different types of dance steps (atavus) and dance configurations for a solo performer as well as a group of performers, make-up patterns and costume practices. With the exception perhaps of Kattaikkuttu's make-up and costumes, it is difficult to discuss building blocks in isolation from their mode of production, which depends on a smooth collaboration between musicians, a solo actor-singer or a group of onstage

performers and the chorus. Below I will discuss examples of building blocks, their place and function within the overall performance and the unwritten conventions that govern their flexible or prescribed usage. For the discussion I have divided the corpus of multimedia dramatic material into songs, prose, music and movement, even though this is a simplification and all these elements cooperate, interweave and may be available simultaneously in an actual performance.

Songs

Songs, that is, poetic texts set to music produced in different modes, provide the backbone of a performance. They constitute its core textual and musical material while also providing the basis for the development of the plot, movement and choreography. For me, and I believe for many other spectators too, Kattaikkuttu's emotional-sensorial appeal lies in the inseparability and acting together of words, music and movement. Pattu and viruttam are the two dominant modes of singing; occasionally, other kinds of compositions and modes of rendering occur, such as *kantārttam* and *tokērā*.[11] A pattu may contain any number of lines and may be divided into *pallavi*, *anupallavi* and *caranam* sections. The lines of a song are sung by the actor-singer on stage, who is referred to as *munnani*; they are repeated by the chorus or *pinnani* (or *pinpāttu*), made up of actors who are not in role at that moment. Alternatively, the onstage actor may sing the first half of a line, while the second half is sung by the pinnani (as in the viruttam example below). In actual performances, each line of a pattu may be sung up to four times by the actor-singer and be repeated the same number of times by the chorus. A viruttam is a free-flowing musical production of a poetic verse that has melody, but no rhythm. In the Perunkattur style the most common approach to singing a viruttam is that an actor-singer, accompanied by the harmonium, sings the first two lines of stanza. These lines are then repeated by a single

voice form the chorus or, alternatively, by the mukavinai.[12] Thereafter the onstage performer takes up the same lines and connects them with the next ones. Each four-line stanza of a viruttam is followed by a *jati*. A jati is a musical interlude that, in contrast to the rendering of the viruttam verse, does have rhythm, allowing the actor-singer to perform a brief choreography.[13] In Karna's curtain viruttam below I have tried to make the collaboration between munnani [*mu*], pinnani [*pi*] and instrumentalists visible, as well as the repetition and the sharing of song lines between the onstage actor-vocalist and the chorus. Karna performs this gripping viruttam during his curtain entry. It provides a description of the battlefield on the eve of the sixteenth day of the Mahabharata war on which he has been made General of the Kauravas' armies and announces his intention to kill his arch enemy Arjuna, the bearer of the bow Kandipa, on the next, seventeenth day of the war:

Karna's curtain viruttam

pāṇṭavarkaḷum turiyōtaṇaṇ On the 16th day the forces of
paṭaikaḷum patiṇārām the Pandavas and
nāḷil [*repeated by pi*] Duryodhana [are]

[*switches to pattu mode*]

pala pala āyuta [*mu*] | armed with many, many
pāṇikaḷākavē [*pi*] weapons | and arrows

pala pala āyuta [*mu*] | armed with many, many
pāṇikaḷākavē [*pi*] weapons | and arrows

pala pala āyuta [*mu*] | armed with many, many
pāṇikaḷākavē [*pi*] weapons | and arrows

pala pala āyuta [*mu*] | armed with many, many
pāṇikaḷākavē [*pi*] weapons | and arrows

[*returns to viruttam mode*]

pala pala āyuta pāṇikaḷākavē armed with many, many
 weapons and arrows.

pāratappōr taṇilē In the Paratam war

[*jati performed by full orchestra*]

māṇṭaṉar maṉṉar aṉēkarkaḷ	enumerable kings have died,
māmuṭi malaimalaiyāyc	their huge crowns lay
citaṟa [*repeated by pi*]	scattered in heaps.

[switches to pattu mode]

maṇmicai nāynari [*mu*] \|	Carrion dogs and jackals \|
tiṉṟu koḻuttu [*pi*]	feast on the corpses
maṇmicai nāynari [*mu*] \|	carrion dogs and jackals \|
tiṉṟu koḻuttu [*pi*]	feast on the corpses
maṇmicai nāynari [*mu*] \|	carrion dogs and jackals \|
tiṉṟu koḻuttu [*pi*]	feast on the corpses
maṇmicai nāynari [*mu*] \|	carrion dogs and jackals \|
tiṉṟu koḻuttu [*pi*]	feast on the corpses
maṇmicai nāynari	carrion dogs and jackals \|
tiṉṟu koḻuttu	feast on the corpses
makiḻntu ulāviṭavē	and wander around merrily.

[jati]

tūṇṭiya turiyōtaṉaṉ	Seeing this the provoker of
itai kaṇṭu	the conflict,
tuṭittuḷḷam ēṅki niṟka	Duryodhana, stands there
[*repeated by pi*]	with heavy heart.

[switches to pattu mode]

turitamākavē [*mu*] \|	Agitated \| my eyes sparkling
iru viḻi taṉil poṟi [*pi*]	with fire
turitamākavē [*mu*] \|	Agitated \| my eyes sparkling
iru viḻi taṉil poṟi [*pi*]	with fire
turitamākavē [*mu*] \|	Agitated \| my eyes sparkling
iru viḻi taṉil poṟi [*pi*]	with fire
turitamākavē [*mu*] \|	Agitated \| my eyes sparkling
iru viḻi taṉil poṟi [*pi*]	with fire
turitamākavē iru viḻi	Agitated, my eyes sparkling
taṉil poṟi	with fire
tūḻela cilaikaḷ ēnti	I clasp my bow.

[jati]

kāṇṭīpantaṉṉaik kolluvēṉeṉṟu	Swearing to kill the bearer of Kandipa,
kaṭūramatāy eḻuntu [repeated by pi]	I rise in fury
kari pari cēṉaiyaik kūṭṭiyē vēkamāy	marching off my elephants and horses swiftly.
karṇaṉum kaḷariṉil vantaṉaṉ pārīr	Behold, here I come to the arena – Karna.

[jati]

Even though the above verse counts as a viruttam, the actor-singer sang it using a combination of pattu and viruttam modes, switching back and force to lend his rendering additional emotional force. The last two lines of the last stanza were performed in slow tempo with forceful diction as if to count the actual elephants and horses in Karna's army. In an all-night performance, viruttams stand out because they often have a slower pace and tend to be more reflexive. Not confined to a musical meter, viruttams allow an actor-singer to divide, lengthen or shorten the words of the poetry creatively, fitting them into the melodic outline provided by the raga. Viruttams offer scope for bringing out specific, raga-linked emotions, for instance of sadness, sympathy and longing, but also of valour and fury, and they often signal turning points in the narrative.

Some verses are extremely complex and need to be memorized in their entirety. An example is Prahlada's song in the play Hiranya Vilacam (composed by Kalavai Kumarasami Vattiyar). In this verse (as in the entire play) the child Prahlada proclaims Vishnu to be the greatest of all deities while refusing, in a polite and not at all childish manner, to acknowledge his father Hiranya as the supreme god. The complicated text of this verse is characterized by a series of rhyming consonants (referred to as yamuṉam; de Bruin 1999: 251–2) and requires the actor-singer (usually a senior performer physically thought suitable for this role and not a child actor) to pay careful attention to the diction of the text. The curuḷ of this verse is rendered in slow tempo, followed by a speeding up of tempo

before reverting again to the initial kalam.[14] The recurring consonants -kk- in the curul result in a typical rap-like rhythm that is part of the aesthetic attraction of this verse. While the words tend to blur when produced in high tempo, this contributes to the overall sense, and does not at all diminish Prahlada's intention, to show Vishnu's eminence:

(refrain): umakku nāṉōr | uṇmai colvēṉ[15]
ukappāy kēḷum eṉ | takappaṉārē
cumakkum āti | cētṉālum
colvāṉō iraṇ | ṭāyiram nāvinālum
[curuḷ] curarukkatipark kayaṉak araṉuk
koruvarkkariya paṭutarkaritām

I wish to tell you | the truth
Listen please | my dearest Father.
Even though he has 2000 tongues | (the snake) Ādiśeṣa[16]
Is not able | to express His (Vishnu's) greatness
[curul] Nor can it be grasped by anyone
Be they Indra, Brahma or Shiva.

Prose

Experiencing a Kattaikkuttu performance one is struck immediately by the alternation of sung verse and spoken prose (vacanam). Like the different types of songs, vacanam passages are in the Tamil language and, depending on who speaks, can have different degrees of formality. Kattaikkuttu is a living storehouse of Tamil where pivotal aspects of this ancient language[17] – its sounds and rhythms, vocabulary, metaphors, conventional visual imagery and poetry – are constantly being recycled, (re)produced, transmitted and reinvigorated. Tamil is also a language with a large oral residue and a high degree of diglossia, involving high and low registers (Smirnitskaya 2019: 3 and *passim*). Kattaikkuttu performances exploit these social and gendered linguistic registers as dramatic tools to characterize,

contemporize and satirize. Given Tamil's classical diglossia, these registers include the most exquisite literary expressions (*centamiḻ*), in particular in Kattaikkuttu's sung poetic repertory rendered by its principal characters, as well as colloquial speech (*koccaittamiḻ*). The Kattiyakkaran utilizes everyday slang to deliver verbal jokes. When a King praises the dancing skills of Rambha and Urvaśī, two celestial nymphs at Indra's court, the Kattiyakkaran[18] distorts these names in colloquial Tamil into *rompa* and *uravaicci*, 'a lot' and 'having soaked (it)', before completing the King's speech by adding *ruppi pōṭu*, '(now it needs to be) grinded', making it sound as if the King is speaking about ordinary village women preparing dough for itlis (a South Indian breakfast dish). Sages and Brahmins are mercilessly made fun of in Kattaikkuttu performances. The powerful streak of anti-Brahminism, which should be understood in Tamil Nadu's political context, is reflected in the Kattiyakkaran's jokes, gibes and uproarious imitations of Brahmin speech, in addition to his attempts at direct physical contact that sometimes amounts to violence (Swaminathan and de Bruin 1992: 102 as quoted in de Bruin 1999: 207). His vacanams may involve code-switching between standard Tamil and highly Sanskritized Tamil typically used by Brahmins, as when the Kattiyakkaran attempts to seduce a Brahmin character to eat *jala puṣpam*, 'flowers from the sea'.[19] This unknown delicacy turns out to be fish – a polluting, forbidden, food for a Brahmin.

Vacanam passages can be quite lengthy, providing a seasoned actor with the opportunity for elaboration of the narrative in the form of soliloquies. The oral reservoir contains a number of standard prose building blocks that serve as ready-mades to construct a (longer) vacanam. These building blocks consist of highly formalized prose passages that performers memorize integrally. Ready-mades are internalized and can be produced automatically buying an actor-singer time to decide what to do next. An example of such a formalized prose passage is the panegyric used by the Kattiyakkaran to announce the entry of a royal, male kattai vesam, in this case King Duryodhana:

> Behold the brave king of kings, the king unrivalled, the fierce king, the forceful king, the extravagant king, the ruler of Hastināpura, Duryodhana Maharaja entering the assembly hall.[20]

Using a set question, the king replies:

> Sentry, do you understand who has come – friend or foe?

To which the standard answer of the Kattiyakkaran is:

> If you explain, I'll know (or, we'll all know)!

This allows the king to introduce himself:

> My name is Lord Duryodhana, King adorned with a garland of *nantiyāvaṭṭa* flowers, liberal emperor who has never bowed his head to anyone, a man of big money.

The formulaic expressions, such as King-adorned-with-a-garland-of-nantiyavatta-flowers, are standard epithets of Duryodhana; the description 'a man of big money' prompts the Kattiyakkaran to ask what the king means by (the ambiguous term) big money. Formulaic expressions are characteristic of oral traditions and facilitate recall of oral material (Ong [1982] 1985: 26). Formulae include lists of synonyms found in traditional Tamil dictionaries or *nikaṇṭus* (Raman 2019), lists of names, weapons or genealogies. To show his eloquence, an actor may recite, for instance, the names of the fifty-six countries under Duryodhana's reign or the eleven names by which Arjuna is known. However, most vacanams do not consist of highly formalized repeatable phrases using instead a more free-flowing prose style. Such prose passages may take their cue from a question or a preceding poetic song providing a point of information which an actor-singer can elaborate upon to construct a topical prose passage. Building a vacanam is an important, yet difficult skill that every Kattaikkuttu actor-singer needs to master during his or her training.

While frequent repetition of lines characterizes Kattaikkuttu's sung poetry, the ability to expand a given narrative point or theme is pivotal for the development of Kattaikkuttu's prose portions. In the play Karna Moksam, Karna elaborates upon a reference found in Villiputtūr's *Pāratam*[21] – *eṭukkavō kōkkavō* – to convince his wife Ponnuruvi that Duryodhana is a good person who does not rush to conclusions. The actor-singer (P. Rajagopal) creates this expansion by recounting an earlier incident in which Karna, during a game of dice with Duryodhana's wife Bhānumati, accidently touches her pearl-waistband when she gets up to greet her husband. The waistband snaps, scattering the pearls all over the place. Duryodhana finds Karna and his wife in what looks like a compromising situation. Instead of coming to the wrong conclusion, he asks his friend what has happened. And to show that he is not angry with her, he asks Bhanumati whether he should pick up the pearls and string them back together (*eṭukkavō kōkkavō*) (de Bruin 1998: 160–3). In other instances, the story progresses because the Kattiyakkaran, or sometimes the character himself, asks pointed questions. When the Kattiyakkaran informs Karna that Duryodhana has requested his presence, Karna responds with the question 'Why?'. He answers this question himself later on in the performance, saying that Duryodhana has summoned him to put him in command of the seventeenth day of the war as all previous generals have been killed. Preceding his answer is a lengthy vacanam, a monologue with the Kattiyakkaran as listener and prompter. In this vacanam Karna/Rajagopal recounts in a nutshell the events that led to the war, in addition to what has happened on the previous sixteen days of battle. Such a summary helps the spectators stay on track, in particular when they are not entirely familiar with the finer details of the Mahabharata epic or have joined the performance at a later moment. Elaborating upon a specific point in the narrative is a performance strategy that is common to other southern performance traditions, too. In Kutiyattam, for instance, a hint or passing reference can be elaborated into several hours of performance (referred to as *vistāra*) (David

Shulman in Richman and Bharucha 2021: 223; also, Zarrilli 2000: 39–40 with regard to Kathakali). Such elaborations may open up new narrative windows, a strategy that, as we shall see, is often used in Kattaikkuttu's Mahabharata performances.

While vacanams represent a non-musical mode, they are frequently supported by the orchestra, and especially the percussionist who may accentuate the words of an onstage performer (de Bruin 1999: 225). Finally, the production of Kattaikkuttu's prose passages requires a specific pitch. While the term sruti or pitch normally is used in the context of music, according to Rajagopal it applies to spoken prose too. A vacanam derives its pitch from a preceding song's pitch. According to him using the same pitch to initiate a prose passage, in addition to being a stylistic feature, facilitates the retrieval of oral building blocks needed to create the vacanam.

Music and movement

Kattaikkuttu's non-amplified music is fine-tuned to the theatre's open-air circumstances. Music involves melody (raga or *meṭṭu*), musical meter or rhythm (tala) and tempo (kalam). Performers often identified a mettu on the basis of the first words of a well-known piece set in that particular tune (Frasca 1990: 88). For instance, when a song is labelled as having the mettu *colluvēṉ kēḷaṭi*, which is the tune of a familiar song occurring in Karna Moksam, performers will automatically select this particular tune, which is set to *kāmpōti* raga. Ragas are linked to the creation of specific moods or emotions, such as the heroic/valiant (nattai raga), heroic/majestic (*mōkaṉam*), pathos (*mukāri*), narrative/descriptive (kampoti), melancholy (*taṉyāci*), dignity/descriptive (*kalyāṇi*), devotional (*arikāmpōti* and *pairāvi*) and descriptive/reactive (*kētārakaulam*) (de Bruin 1999: 243). In contrast to classical Karnatic music, ragas are delivered in a straightforward fashion. The pace of Kattaikkuttu performances and the fact that the performers

need to tell a story make lengthy embellishments and elaborate (solo) musical improvisations by instrumentalists impossible.

Rhythmical organization is referred to as tala (talam in Tamil), which can be defined as a cyclical time span divided into segments by beats of the hand, hand cymbals or a percussion instrument. The players of the hand cymbals (also called talam) and the drummer can increase the frequency of the beats within a talam cycle from the first to the fifth tempo (kalam) to match the dance movements of an onstage performer; in comparison, Karnatic music uses only three tempi. Kattaikkuttu's characteristic half-jumps (*arai tuḷḷal*), levitating full jumps (*muḻu tuḷḷal*) [Figure 3] and spins or pirouettes (kirikki) require the fourth and fifth tempo. Musical meter (talam) occupies a strong position in Kattaikkuttu performances. It is a prerequisite for the dance and choreography and the coordinating element between musicians, background chorus and actors on stage.

Cymbal players often create rhythmical variation in order to – in the words of the performers – 'adorn' the music. In the Perunkattur style, performers handle the small hand cymbals delicately, though sometimes vigorously, to produce different rhythmical patterns. Again, this is a skill that is not taught in an analytical and systematized manner, but acquired by copying other performers. Finally, a frequently heard complaint from people unfamiliar with Kattaikkuttu's soundscape and theatrical vocabulary is that the high pitch and high pace of performance make the song lines unintelligible. While this is true, audibility is not always the primary goal of a specific musical rendering. When the words of a song, or a passage therein, are rendered as a curul the internal rhythm which the curul creates produces a staccato beat that sounds very much like present-day rap as in Prahlada's song above. Such virtuoso high-speed rhythmical renderings of a linguistic text privilege musical over semantic entities. They create a heightened atmosphere enhancing the impact of the song, but often make its words indiscernible (de Bruin 2021: 168).

Some musical building blocks do have a narrative function. A case in point is the *naṭai mēḷam*. The specific drum beat of the natai melam not only defines the embodied way a male or female character walks; it can also indicate, though not necessarily, that such a character moves from one place to another expressing a particular purpose or mood.[22] In The Eighteenth Day, Duryodhana during his entry uses a movement style known as *kulukka naṭai*. The characteristic bouncing steps of this walk are executed on the toes with heels off the floor, indicating Duryodhana's royal arrogance while perhaps also alluding to his mood-swings on this last day of the war. The *piyāṇṭu* is another example of a musical building block that signals a character moving in a furtive manner suggesting deceit or surprise; it is played, for instance, to illustrate the stealthy movement of Kāḷī out and about on one of her nightly cannibalistic rounds in *Rājacuyayākam* (The Royal Sacrifice). Specific music is used to signal auspicious events (*keṭṭi mēḷam*) as well as inauspicious events (*cāvu mēḷam*) or the entry of the snake Aśvasēṇa in Karna Moksam (marked by the raga *mōṭi* or *makuṭi*, more commonly known as snake charmers tune).[23] In addition to the jati connecting two stanzas of a viruttam and initiating choreographed movement, *tīrmāṇams* or drum flourishes are a pivotal and punctuating element of the Perunkattur musical and movement style. Tirmanams conclude a rhythmical cycle and are the basis for the finishing dance steps of an actor-singer. Each tala has its own specific tirmanam, the beats of which are rhythmically and verbally expressed through *colkaṭṭus* (syllables that mimic the rhythmical sound). Thus, the colkattus of ati talam, which is the most frequently used rhythm in Kattaikkuttu, are sounded as *takka timi takka juṇu – takka timi takka juṇu – takka timi takka juṇu*, while the tirmanam is *takatiṇattām – takatiṇattām – takatiṇattām* (de Bruin 1999: 244–5). Executing a tirmanam marks the completion of a choreography, making it visually precise and attractive. Unfortunately, many contemporary actor-singers are not or no longer able to execute perfect tirmanams, either because they do not have the required musical support or

because they have not learned how to identify and execute this musical-visual marking.

The scope of this book does not allow me to describe Kattaikkuttu's movement vocabulary in greater detail. Here it suffices to say that the different kinds of dance steps (atavu) basically are the same for all characters, whether a male kattai vesam, a female character or the Kattiyakkaran. The (gendered and social) differences between these characters are expressed through body language, position of arms/shoulders and hands, facial expressions and the use of voice and space. Female characters too perform a kirikki in fifth speed, but this pirouette movement is confined to a single location instead of covering the available performance space (as would be the case for a male character). Basic dance patterns for a single character or a group of characters are performed to the front as well as to the two other sides where spectators are seated; they include circular choreographies and the figure eight. As compared to other female characters, the Kuratti (Draupadi disguised as a woman of the Kuravar caste) has a more extensive movement repertory at her disposal, which involves backward steps as well as bending her upper body in diagonal directions to accentuate her dance.[24] Because of the Kuratti's energetic dance, *Draupadi Kuṟavañci* is an exceptionally popular play in today's Kattaikkuttu repertory, in particular when a company possesses a talented actor (male or female) to execute this role.

Make-up, costumes and props

Kattaikkuttu actors apply their own make-up using a small hand-held mirror.[25] Applying the make-up (powder or *vēṣam pōṭuvatu*) – or writing the face (*mukam eḻutuvatu*) – is an informal, leisurely process in which actor-singers get into the mood for their roles. The make-up is oil-based and most of the pigments used nowadays are chemical – something that has augmented the colour schemes and patterns. Most performers begin the make-up process by putting a small dot (*poṭṭu*) on

their forehead (a devotional gesture) before covering their entire face with the foundational make-up colour. They then daub their face with a layer of talcum powder that is washed off again with water to fix the foundational make-up and help it stay in place for an entire night, also when a performer begins sweating.

The colour of the foundational make-up is an indication of the nature and emotional state of a character. However, other than common observations about the base make-up colours, such as the notion that red indicates anger (*kōpam*), green courage (*tairiyam*) and a light rose colour composure (*cāntam*), performers found it difficult to articulate their ideas about the symbolism of the make-up colours and patterns (de Bruin 2006: 114). In the Perunkattur style, the shade of the foundational make-up colour of kattai vesams, such as Duhsasana or Arjuna, tended to be deeper when the dramatic intensity of the Mahabharata narrative increased with the deepest shades reserved for moments of bloodletting and killing. On top of the foundational make-up, decorative patterns and motifs are inscribed in contrasting colours, using predominantly black, white, orange, red and sometimes green. For kattai vesams the function of these decorations is to draw attention to the eyes. The power of the eyes is amplified and contained in particular through a decorative motif that the performers referred to as *māl*. A mal is a curved band consisting of two or three lines in different colours. The mal descends from the bridge of the nose or, depending on the character, the sides of the nose, to the centre of both the cheeks, and ascends again tapering into a thin line that almost meets the outer end of the accentuated eyebrows of the character. Lines consisting of tiny white dots underneath a curved mal and above the eyebrows complete the make-up.[26]

Colours and make-up patterns differ from performance style to performance style and sometimes from company to company. With the costumes for male kattai characters and female characters being more or less standard, make-up colours, shades and patterns and the two types of crowns

serve to distinguish the different kattai characters from each other. As part of their costumes, most characters wear ankle bells (*kajjai*). Other than simple attributes, such as wooden swords, a bow or mace, Karna's snake-weapon, a hand-held handkerchief, a stick for the Kattiyakkaran, Narasiṃha's mask (used in Hiranya Vilacam) and a rotating basket that the Kuratti wears on her head, Kattaikkuttu does not use other props. In some instances, the audience itself provides such props: the Kuratti may pick up a baby from a mother in the audience, or a bunch of young children may be invited on stage to serve as the pillars of a magnificent hall where Duryodhana will entice Dharmaraja to participate in a fraudulent game of dice (in the play Dice and Disrobing). Portability of the ornaments, costumes and props remains essential to this (semi-) itinerant form of theatre.

Performance conventions and recall strategies

I have repeatedly referred to Kattaikkuttu's inherent flexibility, or rather, the performers' skill to use building blocks in a flexible manner within the framework underlying a performance. This framework demands the use of specific types of building blocks at specific moments in the performance. While the tradition often leaves the choice of the actual building block from a category of similar building blocks to the actor-singer, this is not always the case. For instance, the entry of a kattai vesam behind a curtain (*tirai*) allows the actor-singer to sing a curtain song in praise of a deity of his/her choice (*tirai tūtippāṭṭu*). This devotional song bears no direct relationship to the story. However, in Dice and Disrobing Duhsasana's curtain song is prescribed. It addresses the goddess (referred to as Ambāḷ) imploring her help.[27] At surface level this may come across somewhat ironical as Duhsasana goes on to physically confront Draupadi who is considered a form of the goddess.

However, for a performer seeking her help makes sense because s/he is about to initiate and confront sacral power – ambivalent and therefore dangerous. In The Eighteenth Day, Duryodhana addresses Shiva in a prescribed curtain song asking him for support now that his power is crumbling and he is left all on his own. This composition in mukari raga has Duryodhana look back at his own actions and their effect on others, including the virtuous women of Hastinapura who have become widows:

Duryodhana's tirai tutippattu from *The Eighteenth Day*

Here I am,
Duryodhana, a wretched king.
Look at me – a king
who has caused his own lineage's death.

Ninety-nine brothers are dead.
My older brother Karna
and Droṇa too
have been killed.

My royal throne falters
and has become
a symbol of deception,
o God.

Perfumed, virtuous women
arc engulfed in grief
brought about by me –
a heinous man.

Left alone in this world,
who will come to my rescue
and comfort me,
o Shiva?

This curtain song is followed by a curtain viruttam.
Conventions as to which curtain song or viruttam should
to be sung may differ depending on the style or practice in
a company. While Karna's curtain viruttam quoted above
reflects the Perunkattur performance practice, performers
coming from a different lineage may sing a different viruttam
which they have inherited from their predecessors.[28]

In the case of the entry of female characters, Kattaikkuttu
frequently leaves the choice of the actual entrance song to
the actor-singer. However, Ponnuruvi's entrance in Karna
Moksam demands a specific verse that describes Ponnuruvi's
physical appearance comparing her to Rati (the beautiful wife
of the God-of-love Maṇmataṉ), in addition to recounting
that, as a Queen, she is surrounded by ladies-in-waiting.[29]
The rhythm of the song and its alternating speeds provide
scope for the execution of set choreographies. For some other
leading female characters, such as the Kuratti in *Draupadi
Kuravanci*, Draupadi in *Vilvaḷaippu* (*Bending of the Bow*
featuring Draupadi's marriage) and Draupadi in Pakatai Tukil
(Dice and Disrobing), the tradition also provides personalized
entry songs, which provide relevant information about these
principal female characters and their frame of mind.

The Kattaikkuttu tradition contains a number of strategies
for memorization and recall of specific building blocks.
We met already the formulaic expressions that have to be
learned by heart and rendered verbatim. Furthermore,
recall is facilitated by hints that are contained in the textual
material itself. When two or more performers interact on
stage, they often engage in a tarkkam. Such sung and spoken
debates may contain cues in the form of *toṭar eḻuttus*, literally
connecting letters or catchwords (a strategy also known by
its Sanskrit name *antāti*), which help actor-singers retrieve the
prerequisite text (de Bruin 1999: 260–1). In Karna Moksam,
for example, the catchword *poṟuppīr* occurs in the last line
of Ponnuruvi's song; it is the opening word of the first line of
Karna's response song, helping the actor-singer retrieve the
correct text:

Ponnuruvi's song

...

pōṟṟi pukaḻntiṭāmal tūṟṟi iruntēṉ pāvi	Sinner I was, praised you not but abused you
poṟuppīr poṟuppīr eṉ taṉ piḻai poṟuppīr eṉ nātā	Forgive me, please forgive me my faults, my Lord!

Karna's song

poṟuppīr poṟuppīr eṉṟu	Don't refuse to forgive me you say
curukkāy eṉ etir niṉṟu	standing before me impatiently.

Producing an all-night Kattaikkuttu performance depends on a combination of following the conventions set by a particular performance style or tradition and the performers' skilled application of a multitude of building blocks within the overarching frame underlying a performance. This allows them to adjust their performances to the expectations and demands of their spectators and their own physical conditions at the moment of performance. Kattaikkuttu's in-built flexibility, operationalized through its building blocks, has guaranteed the theatre its tenacity. It has allowed Kattaikkuttu as a form to adapt and retain its patronage and popularity among the rural, non-elite population over the last century, in spite of the fact that, as a folk tradition, the urban elite and urban media habitually have declared Kattaikkuttu dead or dying.

The play *Karṇa Mōkṣam*

Karna Moksam is a seminal play at Paratam festivals, recounting the events on the seventeenth day of the war. If performed in such a festival context, performers tend to emphasize the second part of the play highlighting the battle between Karna and Arjuna and Karna's killing. However, if Karna Moksam is performed as a stand-alone play on the sixteenth day after

the death of an individual, performers will foreground the first segment of the play featuring the relationship between Karna and Ponnuruvi and the latter's impending widowhood. At the end of the play, family members will come on stage to participate in the rites that mark Karna's, and simultaneously the deceased person's, passing on: here actual reality and reality created in performance coincide (de Bruin 1998: xiv; de Bruin and Rees 2020: 92). As part of my research, I recorded and translated into English an all-night version of Karna Moksam performed on the occasion of a death in 1987 (de Bruin 1998). The examples and translations in this chapter are borrowed from that translation.

The tragedy of Karna's life and defeat on the battlefield is one of the most sensitive and expressive episodes of the Mahabharata. The most striking innovation in the play is the introduction of Karna's wife, Ponnuruvi. Although such a figure is not found in the classical Tamil or Sanskrit sources, she does appear in the Indonesian Wajong Wong tradition (de Bruin and Brakel-Papenhuyzen 1992: 46). She is also known in other Tamil folk traditions and features in the 1964 Tamil film *Karnan* directed and produced by B.R. Pantulu with Sivaji Ganesan in the role of Karna. The central theme of the play is the confrontation between Karna and Ponnuruvi, who are not on speaking terms, and Karna's departure – against the wishes of his wife – for the battlefield after he has been anointed general of the Kaurava-army by Duryodhana. This is followed by the actual battle in which Karna is killed by the Pandava Arjuna, who is unaware of the fact that Karna is his half-brother.

Karna is the son of Princess Kuntī and the Sun God. He is born to Kunti prior to her marriage to the five Pandavas when she, as a teenager, tested one of the boons given to her to enable her to have a child by a deity of her choice. Ashamed of what people will say, Kunti abandons the baby and has her virginity restored by the Sun God. Set adrift in a basket on the river, the baby is found by a charioteer, who serves at the Kauravas' court, and his wife. The couple is childless and adopts the baby

FIGURE 7 *K. Venda as Karṇa's wife, Ponnuruvi. Backstage just prior to a performance of an excerpt of the all-night play* Karna Moksam *at Kalakshetra, Chennai, 23 December 2020, (Photo by A. Prathap © 2020 Kattaikkuttu Sangam.)*

calling it Karna because of the earrings and life-protecting armour with which it was born. Initially growing up in a lowly charioteer's family, Karna is considered a man of low caste. Later in his youth he is adopted by the Kauravas' father Dhritarashtra (Dhṛtarāṣṭra) who, at that moment in time, is still childless. Prior to the beginning of the war Kunti approaches Karna and discloses to him that she is his real mother. She attempts to make him change sides and join his half-brothers, the Pandavas. Karna refuses to sacrifice his loyalty for his friend King Duryodhana, who made him King of Aṅga supporting him when he needed it most, in favour of his blood ties. However, he promises his mother that, except Arjuna, he will not kill any of his other four half-brothers nor will he use his snake-missile more than once. In the upcoming war either Arjuna or he will die so that Kunti will still have five sons. Karna's perceived low caste and the fact that his mother abandoned him mark his

tragic life and determine his problematic relationship with his wife Ponnuruvi, who does not respect him as she feels she has been forced into a déclassé marriage. Ponnuruvi also objects against her husband's friendship with Duryodhana whom she considers a person of bad character.

Localization

Kattaikkuttu performers often elaborate beyond the epic story as we know it from the classical Sanskrit and Tamil written sources in order to adapt their performances to the local context.[30] They do so, for instance, by translating epic relationships into local family relationships, and by referring to local rites, customs and caste. In addition, women characters, such as Ponnuruvi and Draupadi and their specific circumstances and treatment at the hands of close family, are given a pivotal place in the development of Kattaikkuttu's dramatic plots. The characterization of such women characters may be more pronounced and more nuanced than in the literary sources (Ramaswamy 2020). I have referred to this process of interpreting the epic into local, familiar terms as *localization*.[31] By reading the epic as an extended family story, performers are able to bring out hidden tensions and discords that are inherent to most Tamil families – themes to which local audiences can easily relate. It makes Kattaikkuttu's performances topical, relevant and meaningful, in addition to allowing spectators to recognize their own situations and dilemmas acted out on the stage. In the case of Karna Moksam, localization is realized through a number of means. In addition to the introduction of Karna's wife Ponnuruvi, these include the focus on Karna's flawed background, a hidden trait of a previous demonic existence, numerous references to local customs, in particular those related to death, dying and widowhood (which may extend to a real woman having lost a husband in whose honour the play is performed), and finally, the linking of the epic story to the Tamil Saivite bhakti repertoire. Death is portrayed as

the great equalizer – for the same rituals and obligatory small donations are required whether the deceased is a king or a poor, low caste person.

An important theme in the performance, and in understanding the plot of Karna Moksam, is the emphasis on Karna's unknown lineage (de Bruin 1999: 285–8). The fact that Karna is the adopted son of a charioteer is interpreted explicitly in terms of caste. In the 1987 performance, Karna is referred to disparagingly as *vaṇṭikkārar piḷḷai*, 'a cartman's brat'. Karna has to endure repeated slurs on his unknown background not only from his own wife, but also from Drona, Bhīṣma, Salya, Arjuna and the common people of Hastinapura (Hiltebeitel 1988: 397 as quoted in de Bruin 1998: xx). Further localization is achieved by connecting the epic story, on the one hand, with the local Tamil bhakti repertoire and, on the other hand, with Karna's hidden demonic background – a detail that is unexpectedly confirmed by the classical Sanskrit sources. These sources describe Karna's emotional disposition as possessed by the soul of an *asura* (demon). This seems to suggest that the connection between the demonical qualities of a character and his propensity for possession, as acted out in Kattaikkuttu's sacral performances, is an old one that reveals itself perhaps only when the epic narrative is actualized through performance. In the Kattaikkuttu tradition the demonic trait in Karna's character is attributed to a previous existence as the demon Tāṇācuraṇ.[32]

Karna's earlier life as a demon also explains why he, having inherited a life protecting armour-like skin and earrings from this earlier demonic avatar, is invincible in battle until Indra, in order to protect his son Arjuna, obtains this armour from Karna. He does so by exploiting Karna's extraordinary generosity, which makes it impossible for him to refuse a request.[33] Playing into Karna's generosity once more, Krishna, in the disguise of a Brahmin, demands that the gravely wounded Karna lying on the battlefield parts with his *tarumam* (or *puṇṇiyam*). By removing the accumulative result of all charitable deeds that Karna has carried out during his lifetime, Krishna allows

him to die and shed the remnants of his demonic existence and, ultimately, to attain moksam in a future birth. Moved by Karna's extreme generosity, Krishna grants him two boons: firstly, that his mother, Queen Kunti, upon hearing of his death will declare publicly that Karna is her first son and, secondly, that he will be reborn as Ciṟuttoṇṭanāyaṉar. This saint from the Tamil Saivite bhakti repertoire is famous for having sacrificed his own son and offered him as food to Lord Shiva when the latter appeared at his doorstep at a late hour demanding to be fed. As Ciruttontan, Karna thus is able to carry out the last of the thirty-two charitable deeds required to reach moksam, namely that of feeding others. Flashing out the caste issue dramatically, the Kattaikkuttu rendering of the epic narrative states that Karna was unable to fulfil the act of feeding others during his lifetime because nobody wanted to accept food from the hands of a low caste person. Karna's own death, as a victim of the Mahabharata war, and the sacrifice of his son in a next life befit the sacrificial paradigm that Kattaikkuttu performances present (de Bruin 1999: 299–301).

Narrative windows

Many of Kattaikkuttu's Mahabharata plays branch out into additional sub-narratives. Like a set of Russian dolls, the main storyline opens up new dramatic windows that provide us with further background information against which the epic characters and their actions can be read. The story of Karna's birth is such a sub-narrative. Even though it is narrated by Karna himself in a lengthy soliloquy, it allows us an insight into the mind of Karna's mother Kunti when she was coming of age, unable to resist the desire to test one of the boons given to her (which could be interpreted as her sexual awakening) and her bargaining with the Sun God to have her virginity restored. It also helps us understand Karna's lifelong pain of having been rejected by his mother, his humiliation of not knowing his true parentage and his unwavering loyalty to his

friend Duryodhana. Similarly, the story of how Karna acquired his snake-weapon is a narrative within a narrative. Told again by Karna himself as a monologue with the Kattiyakkaran as listener, this flashback features the not-so-nice actions of Krishna and Arjuna when they burned down the Khandava forest. Finally, there is the story of Karna's wife, Ponnuruvi, the daughter of the King of Kaliṅga. Given her Tamilized name, Ponnuruvi in first instance appears to be a folk invention; however, she is also known by the Sanskritized name Cupāṅki (< Śubhāṅki, 'she of the beautiful limbs'). Ponnuruvi's story is narrated in what the performers of the Perunkattur Ponnucami Nataka Manram referred to as the *Kuṭumpakkatai* or *Family Story* (de Bruin 1999: 286–8). On the request of a patron, this episode can replace the (much more popular) public discussion between Karna and Ponnuruvi in which Ponnuruvi accuses Duryodhana to be a man of bad character and Karna defends his friend. The *Family Story* describes how Karna kidnapped Ponnuruvi. During her *svayaṃvara* or self-choice marriage Ponnuruvi ignored the powerful King Duryodhana in favour of a minor prince. This enraged Duryodhana who started a fight with the other royal competitors. Realizing that Duryodhana cannot win, Karna rescues him and kidnaps the prospective bride. Putting them on his chariot he drives them home where Duryodhana refuses to accept the girl as she has been touched by the hands of a low caste (de Bruin 1998: 240–1). This leaves Karna no other option than to marry Ponnuruvi himself. The classical Sanskrit Mahabharata makes no mention of Karna's spouse, in spite of the fact that it is said that Karna's sons die on the battlefield. However, curiously the Śāntiparvan of Vyasa's Mahabharata describes an incident featuring the abduction by Karna and Duryodhana of the daughter of the King of Kalinga during her svayamvara therewith providing credibility to the story of Ponnuruvi (Sukthankar 1927–59, *Rājadharmaparvan* of the Śāntiparavan 12, 4: 1–21; also, de Bruin 1998: xix). While both traditions share the kidnapping incident, it has been elaborated upon and reworked in an extremely localized fashion in the Kattaikkuttu tradition. Alternatively,

one could assume that the fuller narrative of Karna's wife as an epic character has disappeared from the written Sanskrit version. Listening in to Ponnuruvi's background story helps us understand while she feels trapped in a déclassé marriage and why her relationship with Karna and Duryodhana is so strained.

Shifting repertories

To counteract the competition in an emerging rural performance market performers began to emphasize Kattaikkuttu's heroic nature. Among other things this resulted in a greater focus on a Mahabharata-based repertory and a monopolization of Paratam festivals as the exclusive performance context for Kattaikkuttu (de Bruin 1999: 115–17). When I did fieldwork for my research in the late 1980s, the repertory of the Perunkattur Ponnucami Nataka Manram comprised twenty-three plays. All these plays except two were performed in Kattaikkuttu style.[34] Nineteen out of the twenty-three plays were on themes from the Mahabharata, one was an atypical *Rāmāyaṇa* play[35] and three other plays were purana stories.[36] The repertory of Rajagopal's father's and grandfather's company appears to have included about a similar number of plays. However, about half of these plays were performed in Drama style or in a hybrid style mixing elements from Kattaikkuttu and Drama and only half of the plays were on themes from the Mahabharata.

Performing the *Mahābhārata*

Apart from the localization of the epic narrative, what makes Kattaikkuttu's interpretations of the Mahabharata special? Perhaps more so than in the other epic, the Ramayana, Kattaikkuttu's Mahabharata's characters are multifaceted

personages who are not shown as black and white. All of them combine, in varying degrees, aspects of good and bad (also Hawley and Pillai 2021), while some of them (e.g. Krishna and Sakuni) pursue hidden agendas. Duryodhana is not the ultimate villain; nor are Dharmaraja (Yudhisthira), Arjuna or Karna presented as the perfect, ideal heroes. Perhaps Duryodhana could even be said to be the principal anti-hero of Kattaikkuttu's Mahabharata repertory just like Rāvaṇaṇ is in Kampaṇ's Tamil retelling of the Ramayana. Rather than to a flaw in his personality, the Kattaikkuttu tradition seems to attribute Duryodhana's expanding jealousy towards his cousins and Draupadi to a cumulative series of humiliating experiences. Most of Kattaikkuttu's Mahabharata plays open with the darbar of Duryodhana's court in which he is accompanied by some of his brothers, Karna and Sakuni, his maternal uncle. Sakuni pretends to be Duryodhana's trusted advisor but in actuality seeks his death in revenge for the murder of his father and his 103 brothers. On the side of the Pandavas, a cleverly scheming Krishna similarly appears to have interior motives proclaiming he does not want a war, but simultaneously manipulating epic events and characters to orchestrate the battle and its outcome(s).

Battle contests between Kshatriya hero-warriors are central to Kattaikkuttu's interpretation of the Mahabharata. Given the theatre's sacral performance contexts and their anticipated potential to generate sacral power, performances emphasize violent contests between warriors usually resulting in the killing of one of them. The image we get from Kattaikkuttu's heroes is that of consecrated warriors rather than of ideal Kshatriyas depicted in the *Bhagavad-Gita*.[37] In contrast to Arjuna of the Bhagavad-Gita, whom Krishna in this philosophical treaty advises to be emotionally detached from his violent deeds, Kattaikkuttu's warrior-heroes are emotionally fully involved in these battles – ready to kill or be killed.[38] The verbal and physical rallies between Duhsasana and Draupadi in Dice and Disrobing and the latter's attempt to disrobe her are another example of a violent (verbal and physical) battle context in

which Draupadi is the potential sacrificial victim. I have argued that such violent confrontations and bloodshed are strongly associated with a demonic nature of one or both contestants. They often culminate in the occurrence of possession-like states in Kattaikkuttu's actor-singers performing such roles as well as in members of the audience witnessing them. I have also argued that many, if not all Mahabharata characters, have a propensity for the demonic triggered by confrontations of a physical and sometimes verbal nature. Karna's demonic remnant, discussed above, is attested in the Sanskrit version of the epic. Draupadi's demonic propensity is disclosed when she wants to drink Duhsasana's blood upon his killing, in addition to her cannibalistic behaviour found in many local narratives (Hiltebeitel 1988: 290–2). In the case of unredeemable demonic characters, such as Duhsasana, Hiranya and Daksa, their berserker behaviour and states of possession are showcased with verve. However, under the influence of Brahminization/ Sanskritization it has become socially less desirable to acknowledge demonic traits and violent behaviour in more elevated characters, such as Arjuna and Draupadi. Instead, these characters are reinterpreted to fit politically and gender-correct paradigms promoted as part of mainstream, sanitized Hinduism.

As a final observation, I would like to point out that Kattaikkuttu's Mahabharata interpretations allow little scope for loose ends or arbitrary solutions. Performances need to make sense for rural, non-elite audiences; they need to feel emotionally right in terms of local religiosity and the lived reality of the spectators. While Draupadi's polyandry usually is seen as socially problematic, it is explained (away) through invoking her previous birth in which she inadvertently expressed the wish to be married to the same man, the sage Mautkalya, five times. Thus, during her epic life as Draupadi she acquires not one, but five husbands, who are said to represent five different forms of the sage (de Bruin 1999: 114–15). Similarly, when Krishna cuts his finger during a violent encounter with Sisupala in The Royal Sacrifice, Draupadi offers him the

outer-end of her sari to stop the bleeding. Krishna promises
her that whenever she needs it, he will return the favour in
kind. He does so when he replenishes her sarees in Dice and
Disrobing (Hiltebeitel 1988: 226). Duryodhana's desire to
humiliate Draupadi is attributed to the fact that she mocked
him when he made a fool of himself, slipped and fell while
admiring the Pandavas' newly built hall during The Royal
Sacrifice. Krishna's demand for Karna's tarumam while the
latter lies wounded on the battlefield, referred to above, seems
cruel. However, in doing so Krishna paves the way for Karna's
ultimate liberation from the cycle of rebirths, thus providing
closure to his tragic life. Furthermore, it emphasizes Krishna's
profound compassion – an image of the deity that is equally
well known and popular among rural audiences as is his
scheming and dark personality.

Additions to the repertoire

As in Rajagopal's father's and grandfather's time, also today
companies constantly recycle old plays and add new items to
their repertories in response to audience demands. Sticking to
the traditional, all-night Kattaikkuttu format, yet sometimes
lacking in content and topical songs to take the dramatic plot
and its characters forward, these new additions may enhance
the competitiveness of a company vis-à-vis other companies
(de Bruin 1999: 117–22). Some of these new plays feature
Mahabharata characters in narrative situations that cannot
be found in the classical versions of the epic. One such
example is Draupadi Kuravanci in which the epic heroine
Draupadi and her husband Arjuna appear in the disguise of
a Kuratti and Kuravan or members of a low caste of basket
makers and fortune tellers.[39] Another addition is *Aravāṉ
Kaḷappali (Aravan's Battlefield-Sacrifice)*. The play tells
the history of Aravāṉ, one of Arjuna's sons, who is offered
as a pre-war human sacrifice to help the Pandavas secure
victory. Some companies have added *Vēṅkaṭēca Perumāḷ* to

their repertory. This play about Lord Venkateca (Vishnu) in
Tirupati is a favourite fit for performance slots at the end of
the Kattaikkuttu season, which are dedicated to Vishnu. Many
Vanniyar-dominated companies perform *Vanniyar Purāṇam*.
Having the heroic origins of the Vanniyars as its theme, this
play is popular among Vanniyar patrons and spectators as it
reaffirms their (aspired) caste identity as heroic warriors.

Summary

In this chapter I have introduced the concept of an oral reservoir
to explain the coming into being of long-duration multimedia
performance texts assembled in performance without reliance
on a written script. The oral reservoir is porous; it allows
new material to enter (and old material to go out of use), in
addition to facilitating interactions with adjacent performance
and religious traditions. Such interactions create additional
resonances, sensibility and meaning for Kattaikkuttu's rural
audiences, as well as allow novel interpretations of the epic and
its characters. The oral reservoir is stored in the bodyminds
of performers and Kattaikkuttu's regular, rural spectators. It
contains blueprints of performances. I have conceptualized
these as consisting of a framework that performers fill with
multimedia building blocks from a large corpus made available
by the oral reservoir. Curtain entrances prompt a specific song
and movement routine. They represent subdivisions of the
framework and are structured in such a way that they facilitate
the identification of the actor-singer with his/her role. I will
discuss the details of one such curtain entrance in Chapter 3.

Performers fine-tune performances to a specific context
through a dexterous handling of these multimedia building
blocks within the prescribed framework and the conventions
of the theatre. Some of these building blocks are vital to the
production of a performance and cannot be omitted without
affecting the identity of Kattaikkuttu as a genre and the

unfolding of a specific plot. This layer of vital building blocks includes the sung opening and closing routines, the pattus and viruttams of principal royal-divine dramatis personae, including the curtain entrances of main kattai vesams and the entries of principal female characters, and verses that provide information crucial to the development of the plot. Poetic compositions often cue the prose passages that follow them and that are not learned by heart but constructed ad hoc. Song-texts can be stretched, repeated or condensed to fit the demands of a musical meter or melody, render greater dramatic intensity and, as above in the case of Prahlada, showcase a star actor-singer's virtuosity.

Flexibility operates also at the level of the plot. Localization involves the adaptation of the narrative to local cultural patterns and perceptions and includes the (re-)interpretation of epic characters and their relationships.[40] In the case of the play Karna Moksam, localization involved the foregrounding of (customs relating to) death, dying and widowhood and, most importantly, the effects of Karna's unknown descent interpreted in terms of (low/no) caste. Karna's rebirth as a Tamil Saivite saint, after having relinquished the remnants of a previous demonic existence and facilitated by Krishna's compassion, offers non-elite rural spectators hope of individual salvation (moksa). When performed on the occasion of a real death, the play fulfils an important role in preparing a spouse for widowhood and allowing family members to mourn. The performance of *Karna Moksham* makes sense of Karna's tragic life and death on the battlefield – a sense that the classical versions of the epic often lack (de Bruin 1999: 268–316 and de Bruin 1998: xxi).

3

Transmission, interpretation and innovation

Kattaikkuttu performers have a matter-of-fact, workman-like approach to their profession. They know what to do, when and how to do it. Kattaikkuttu's knowledge, comprising its technical and experiential aspects, is inseparable from its *prayoga* (Tamil *pirayōkam*),[1] that is, its application or practice (de Bruin 2023: 82). In this chapter I will take a closer look at the ways in which individual actor-singers acquire and apply this knowledge in order to perform and, ideally, be(come) the character. After discussing the informal training process of a young Kattaikkuttu recruit and the interpretation of a role, I will turn to the Kattaikkuttu Gurukulam. The Gurukulam presents the first attempt at institutionalizing Kattaikkuttu's artistic training process, both with regard to singing/acting and learning to play the three different musical instruments that accompany performances.

Kaṭṭaikkūttu's embodied performance knowledge

Becoming a Kaṭṭaikkūttu performer[2]

Kattaikkuttu's knowledge is tacit and complex. As we have seen, it involves a variety of media that are inextricably

intertwined and grounded in the tradition's oral reservoir. However, Kattaikkuttu does not have a methodological pedagogy through which a student can acquire this knowledge in a systematic and theoretical manner because it has not (yet) been separated from the practitioners, nor has this knowledge been indexed and codified in order to provide newcomers easy access to it. Training and transmission have remained informal, almost casual, from person to person (*parampara*), their validity and effectivity becoming visible only when applied in actual performances.[3]

The most common way to become a Kattaikkuttu performer was, and still is, for a boy to join a professional theatre company. While earlier belonging to a family hereditary involved in Kattaikkuttu, and therefore caste, played an important role (Frasca 1990: 42), this requirement is disappearing quickly now that Kattaikkuttu has opened up to all castes. The decision might not necessarily be the child's choice (in fact, it often is not), nor is it necessarily based on a fair assessment of the child's talent for acting or singing. Failing in formal education, the loss of a parent and poverty are motivations to deposit a boy as young as eight or ten with a professional Kattaikkuttu company. The child-trainee acquires foundational skills in the different aspects of Kattaikkuttu through a constant exposure to all-night performances.[4] By participating in the chorus, he absorbs Kattaikkuttu's typical, open-throated mode of singing and enunciation. He also learns the opening song texts, their musical production and correct sequence, in addition to picking up other selected parts of the repertory. At times he may be allowed to play the hand cymbals that indicate the musical meter. When he has accumulated sufficient skills, he begins participating in performances, often as an assistant of the Kattiyakkaran or in a minor role that may or may not require him to speak or sing. As we shall see below, performing opposite others is an important way of learning the trade. It allows the trainee to copy Kattaikkuttu's different types of body language and energy that define heroic, usually male characters, as well as female and other characters. Exposure to all-night performances helps him develop his memory power,

voice, make-up, kinaesthetic and acting skills. He gets to know the framework underlying all-night plays providing him with a trajectory to apply his newly learned skills. He becomes familiar with the repertory, rituals, management and hierarchy of a professional Kattaikkuttu company. And as Rajagopal recounts from his own experience: participating in all-night performances is a test, not only of a young boy's physical resilience, but also of his ability to ensure his own well-being and negotiate the tensions that pervade a close-knit group of male performers (de Bruin 2020: 4–5).

Training grounds

Formerly, the mobile, processional Terukkuttu discussed in Chapter 1 served as an informal training ground. Not only did the two actors – usually trainees – get the chance to rehearse important tarkkams from the Kattaikkuttu repertory, the Vattiyar would publicly correct them when they made a mistake. Another informal occasion for teaching was when performers walked to their next performance destination. Rajagopal remembers how his father would teach him a new song that was required that same night and that he, therefore, had to memorize instantly (de Bruin 2020: 7). However, the most important training ground for young performers is the stage itself. In Kattaikkuttu's traditional training practice senior performers often act as onstage tutors. Staying in character, they can invite the actor-trainee to react to their actions or provide him with clues what to do, ask or sing next (de Bruin 2020: 8). Finally, performing the character of the Kattiyakkaran for a full season or longer is considered to greatly enable and enhance a novice's training and knowledge. It allows a young actor to familiarize himself with the roles that others play opposite him. It sharpens his alertness, improvisational talent and allows him to use his body in an uninhibited manner (de Bruin 2020: 8–9). There is very little verbalization of what the child-trainee is supposed to do in this informal training process;[5] his basic learning consists of correct copying,

memorizing, onstage application, fine-tuning and internalizing what he has learned into his bodymind. Given the young age of the child-actor and his lack of experience, spectators usually show some leniency when his acting is not perfect – when a crown slips or when he loses his balance while fast spinning. However, once he starts performing a major character, his performance will be judged critically and, when appreciated, the audience will demand to see him in that particular role in future performances (de Bruin 1999: 187). A Kattaikkuttu trainee's knowledge is tested to the full when he embodies for the first time a character on stage. His further performance career is marked by different stages in which he competes with other actors often senior to him, progressing to doing more complex roles and, finally, performing lead roles. However, some actor-singers never reach the stage of performing these principal roles, either because they have problems with their voice, memory, movement, physical stamina or because they lack stage presence or passion for the job.

Being the vēṣam

The foundational unit of a Kattaikkuttu performance is the character (vesam, also *pāttiram* or vessel, de Bruin, forthcoming b).[6] The contours of a well-known vesam are already available in the oral reservoir and, therefore, in an opaque, perhaps not yet penetrable form of knowledge, in the memory or deeper layers of an actor's self or subconsciousness. Her/his coming into being depends on actualization through performance grounded in embodied practice and know-how (de Bruin 2023: 83). Nowadays the term embodiment is used in anthropological and performance studies to highlight the importance of the connection between body and mind in reaction to an earlier Cartesian dualism that separated mind/thinking from body/feeling (Strathern and Stewart 2008: 67). However, the Tamil language does not have an exact equivalent for the concept of embodiment.[7] Rather than embodiment, Kattaikkuttu actors characterized the ideal of fully embodied

acting as *vēṣattil nuḻaiya* or *vēṣattil niṟka/taṅka,* 'to enter or
stay or reside in (a) character' (de Bruin 2019: 70). The idea
that an actor penetrates, hides in or merges with the character,
which could be bidirectional (either from outside/actor into
inside/role or from within the actor when s/he brings character
to the surface) – fits the local cultural context in which the
boundaries of the human body appear to be more permeable
than in a Western perception.[8] Acting in Kattaikkuttu therefore
is not a representation or mimesis nor an attempt at realistic
acting in a Western Stanislavskian sense, but a becoming and
being the vesam. Whether the character one plays is a divine
one, such as Krishna, or a demonic one such as Duhsasana,
acting is about being the character to the fullest extent possible
(de Bruin 2019: 70). When a character emerges into the reality
of the performance, this invites the question of how much of an
actor's self is involved in the creation of the vesam and to which
degree self and vesam merge. An actor's nature and qualities,
that is, the material substance or *kuṇam(s)* with which (s)he
is born, impact on his or her performance in similar ways as
the substance of the physical location impacts on a specific
performance event. When vesam aligns with the kunams of the
actor-singer, it is believed to make a performer particularly apt
to do a specific role. However, some actor-singers, including
Rajagopal, said that they enjoyed performing roles which were
the opposite from how they saw their own personality.

Voice and voicing

Coming from within the body and fuelled by breathing that
supports both singing/speaking and physical movement,
voice is one of the most intimate sensorial experiences for
Kattaikkuttu actors and a faculty many of them worry about
most.[9] As the carrier of music/songs and prose, an actor's
voice, in addition to being distinctively interior and individual,
is pivotal to inhabit a character, take the narrative forward and
create, through the experiential and physical impact of sound
on its environment, epic reality (de Bruin 2019: 70; de Bruin

2023: 83–4). The fact that Kattaikkuttu actor-singers have retained their voices appears to radically change the nature of their acting as compared to other South Indian theatre forms that have delegated singing to a specialist background singer.[10] For Rajagopal, and I believe for many other Kattaikkuttu actor-singers, the voice is an instrument that is crucial to initiate and help them merge with the vesam. For the voice not only produces pitch, volume, timbre and range but, like the Tamil language it uses, has the power to make manifest visual imagery and movement.

Karṇa's curtain entrance

An actor-singer's gradual transition into character starts in the greenroom. It continues when s/he moves from the greenroom into the performance area – in the case of a kattai vesam behind a movable curtain [Figure 5]. Female personages and dress vesams, such as Krishna or Sakuni, enter the performance area without a curtain and for the Kattiyakkaran this device is optional. They announce their arrival in the performance area through a single song the first line of which an actor-singer may initiate in the greenroom before walking or dancing onto the stage. With a few exceptions, this is a general song with many older actor-singers performing a female role opting for a devotional verse unconnected to the story and not providing any personal information about the character herself. Younger performers tend to choose danceable cinema tunes, in particular when they act the role of toli.

Curtain entrances are divided into two parts: During the first part the actor-singer enters behind (or, in Kattaikkuttu jargon, inside) the curtain. Only the performer's head(gear) and feet are visible to the audience. The sung sequence inside the curtain helps ground the actor-singer to find her/his voice, complete her/his ornamentation and facilitates her/his identification with the vesam. The second part reveals the actor-singer being the vesam in his full eminence – a transformation that takes place immediately before or at the moment of the removal of

the curtain. The curtain entrance culminates in a *pōṟṟi viruttam* (a song in praise of a deity), whereafter the performance shifts to the narrative plot. In the scheme below I have outlined the building blocks constituting a curtain entrance (additional songs prior to and after the singing of the porri viruttam may be added):

Structure of a curtain entrance by a kattai vesam and the accompanying actions of the actor-singer, chorus and Kattiyakkaran

general curtain song by chorus (optional)

(potu tiraippāṭṭu)

curtain is brought onstage with actor behind it

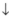

devotional song in praise of a deity

(tirai tūtippāṭṭu)

actor faces musicians; while singing ties ankle bells

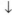

curtain *viruttam*

(tirai viruttam)

provides specific information about the entering character

after 1st stanza of the viruttam, actor-singer performs brief choreography

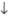

standard panegyric by Kattiyakkaran (optional)

(ending with the word *kāṅka* 'Behold!')

announces arrival of King (using present/future tense);

actor puts on kiritam (big crown) turning briefly to face audience

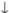

song or rhythmic syllables by actor

(*colkaṭṭu pāṭṭu*)

brief choreography; vesam sits down/stands on actor's bench

CURTAIN IS REMOVED

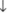

standard panegyric by Kattiyakkaran

(ending with the expression *veku parākku*, 'Your Attention please!')

vesam reveals himself as a momentarily silent tableau

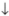

entrance song

(*pravēśappāṭṭu* or *tarpār pāṭṭu*)

signals arrival of the vesam in royal assembly (using past tense)

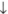

interspersed with dialogue & possibly additional song

establishes identity, ancestry and mood/problem of vesam; physical dance

interaction with the Kattiyakkaran through questions & answers

possibly comic song(s) by Kattiyakkaran to provide actor with breathing space

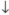

viruttam of praise

(*pōṟṟi viruttam*)

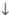

initiates or links up to narrative at moment where it was paused to allow entrance of vesam

For a typical curtain entrance Perunkattur style an actor-singer enters the performance area stage left. Unfolding the curtain across the performance area, the curtain bearers precede the actor-singer following his/her movements when s/he leaves the greenroom to position him/herself back centre stage facing the musicians. To bring the curtain on stage, the chorus may sing a general curtain song.[11] If the character is to wear a kiritam, the performer places the large crown that s/he carried with him/her on the actor's bench. Facing the musicians, the actor-singer proceeds to sing a curtain song in praise of a deity. If not yet put on in the greenroom, the performer uses this song to tie the ankle bells. In the 1987 performance of Karna Moksam, Rajagopal sang a composition written by his father Ponnucami Vattiyar. The curtain song addresses Poṉṉiyammāḷ, the village goddess of his home village Perunkattur asking for her support and protection (de Bruin 1998: 30–1). The curtain song is followed by Karna's curtain viruttam (translated in Chapter 2). It is through this viruttam that the character announces his approach of and entry into the royal assembly, represented by the performance area and the spectators who, like royals, are seated around it. This is the first time that we get to hear specific information about the entering vesam and the context for his appearance. The curtain viruttam may be followed by a standard panegyric (kattiyam) by the Kattiyakkaran. This is the moment when the character puts on the big crown if he is to wear one.[12] Hereto, the performer turns to face the audience placing the crown on his/her head. Turning back s/he ties the crown while the Kattiyakkaran or another assistant tugs in the ends of the cloth covering the backside of the crown or, alternatively, ties it to both sides of the crown's wings. Immediately hereafter, the actor-singer performs a brief choreography behind the curtain. This choreography is set to a series of staccato, articulated, rhythmical syllables (colkattus) – such as *uṭatākka tōtim taka-tāka tōtim tattai* – accompanied by energetic drumming.[13] Moving front centre stage and turning back, the actor-singer approaches the actor's bench using rhythmical steps coinciding with the drumming.

Bouncing up and down and hitting the bench several times
hard with a wooden sword, s/he turns facing the audience and
seats her/himself on it (or stands on it). This is the moment the
curtain is whisked away to reveal the character in his full glory.
Immediately hereafter the Kattiyakkaran announces the arrival
of the King in his court, ending the announcement with the
words: *karṇa makārājaṉukku veku parākku*, 'Your attention
please for Karna Maharaja!' (de Bruin 2023: 83–4).[14]

Fully visible, Karna now sings his entrance song
(*pravēśappāṭṭu* or *tarpār pāṭṭu*). In contrast to the earlier
phase of the curtain entrance during which the character
approached the capa, this song establishes that he has arrived
in the assembly.[15] Depending on the valour of the character,
the choreography accompanying this song may include a
number of fast spins. The vesam formally greets the spectators
by turning to the three sides of the performance area where
they are seated. The entrance sequence ascertains the identity
of the character, his ancestry, mood and specific problem or
dilemma through a song and vacanam sequence that involves
interactions with the Kattiyakkaran [Figure 4]. Rajagopal as
Karna split up his entrance song into four parts. In the first
stanza he identified himself as King Karna reigning over the
country of Anga and revealed that the Sun God is his father.
Having asked the Kattiyakkaran whether he knew why he had
come today in such anger, he sang the second stanza of the
entrance song, in which he describes his arch enemy Arjuna
and his intention to kill him. The stanza ends in a curul – in
this case two lines the words of which are performed at high-
speed providing variation to the rhythmical production of the
song. Both stanzas of Karna's entry song and the curul involve
demanding physical movement and spins in combination with
singing. In the 1987 performance the Kattiyakkaran therefore
stepped in with a comic song to allow the actor-singer some
rest. The third stanza describes Karna's most important
quality: his generosity. This stanza was followed by another
comic song of the Kattiyakkaran. Subsequently, it led into a
somewhat didactic vacanam in which Karna defined when, to

whom and how much to give. This soliloquy cued the final stanza of the entrance song in which Karna claims that his charity is so vast that it can get rid of the poverty of all the poor (de Bruin 1998: 33–7). Karna's curtain entrance included a second song disclosing that he is the first child of Queen Kunti born prior to her marriage – a fact that is known to only four people. Opening up a new narrative window, Karna recounts the story of his birth at a later moment in the performance prompted by his wife's refusal to let him in unless he is able to clearly explain his descent. In the second stanza of this second song, Karna produces the snake-weapon Asvasena and describes in a vacanam how he acquired it – another example of a new narrative window. When the prop Asvasena shows up, the orchestra performs a musical interlude called *makuti* – a melody that snake charmers use to bring the snake out of its basket. The Kattiyakkaran uses this occasion to deflate Karna's royal status in a comic aside saying that kings handle all sorts of weapons – knife, dagger, lance, sword, bow, club, trident and so forth – but that he has never witnessed a king brandishing a snake.[16] The curtain entrance concludes with a porri viruttam set to raga bhairavi (as all viruttams-in-praise are), which bears no relationship to the story. The porri viruttam marks the transition from the curtain entrance to the continuation of the actual story. The Kattiyakkaran now greets Karna formally announcing that His Majesty Duryodhana of Hastinapura has sent him to request Karna's presence. While a tiraippravesam is a solitary affair between the entering character (or group of characters) and the Kattiyakkaran, the following narrative provides the opportunity to engage with other characters through spoken dialogue and sung verse.

Presence and presencing

For Rajagopal the brief musical/choreographic interlude just prior to the removal of the curtain set to rhythmical syllables provides the final stimulus that projects him into character;

he now is the vesam. Seated on the actors' bench, one leg crossed over the other, regulating his breathing, eyes wide open and all his faculties alert, he momentarily presents an iconic image radiating power and aliveness to the audience. His expanded sensorial perceptions open up a fluidity between him, his musicians and the spectators who sense that something is about to happen, that in this moment reality is being created. Rajagopal described this presencing as a state of heightened awareness involving bodily and mental alertness.[17] The intense interweaving of textual-musical and kinetic-visual actions results in an acoustic and visual environment that is typical for Kattaikkuttu – an environment that prompts being the vesam as a full-fledged, mature, alert, named and alive, unique manifestation arising from the oral reservoir, Kattaikkuttu's underlying knowledge source that encompasses and resonates in both the performer and the community. This heightened moment in the performance involves, at an intuitive, enactive level, motor/muscle/breathing actions and stillness (or the absence of voicing). The sensorial amplification bounces off the dramatic environment, therewith composing or constituting it as well as constituting his perception of this environment (de Bruin 2023: 84). For the spectators the heightened dramatic sense translates into something that we could call presence or, in Tamil, *kavarcci*, that is, captivation or attraction (*Tamil Lexicon* 1924–37: 789), indicative of the relationship between the vesam and those who perceive him.[18]

For the actor-singer seeing the audience and being seen by them at the moment at which the curtain is whisked away is an interactive process that draws attention to the power of the eyes. Kattaikkuttu's mask-like make-up emphasizes and contains a performer's eyes, which are instruments *par excellence* to captivate the gaze and minds of the spectators. Conversely, an actor's eyes are believed to be a vulnerable opening into his/her body; it is through the eyes that a spectator's gaze penetrates the performer's internal state – with possible negative effects as in the case of the evil eye (Zarrilli 2000: 93; de Bruin

2006: 127–8). During states of possession, a performer's eyes open up widely, while he may also present enlarged pupils and a stiffening or uncontrolled shaking of the limbs. For an outside observer it is difficult to fathom what a performer experiences at such moments, while he/she often has no memory of what perspired in such a state. Possession can take on different forms and is associated with a (kattai) character's extreme anger. It often is initiated by reviling an opponent, as for instance when Duhsasana confronts Draupadi, a goddess-to-be, in Dice and Disrobing and she returns his insults in kind intensifying his frenzy (Hiltebeitel 1988: 268). Possession also raises the question as to what or who causes it. While this is a topic of debate between scholars (Frasca 1990: 15, 130–2, 91–2; Hiltebeitel 1988: 125–6, 267–81), I have argued that openly demonic characters, such as Duhsasana, are most susceptible to possession. Possession, whether real or acted in fulfilment of audience expectations, occurs at moments of violent confrontation culminating in bloodshed and killing typical of Kattaikkuttu's sacral performance contexts (de Bruin 1999: 129–40).

Interpretation

The score of an individual actor is twofold: firstly, s/he needs to correctly produce the multimedia performance text – a skill s/he has acquired during the informal training process – and, secondly, s/he needs to imagine and interpret the vesam taking into account the specific plot of a play and the performance context. Personal interpretations of a role are particularly exciting to Kattaikkuttu's connoisseurs, who are interested in knowing how a seasoned actor-singer will perform, for instance, Karna in Karna Moksam, Duhsasana in Dice and Disrobing or Hiranya in Hiranya Vilacam. Such a desire is an important reason to extend a performance invitation to a leading actor-singer and his theatre company.

Traditionally, a Kattaikkuttu trainee is not really taught how to act a specific character but may be corrected occasionally when his acting does not befit a character. As a young actor-singer Rajagopal recounts how as Karna he once displayed his skills of performing a *muṭṭi kirikki*. A mutti kirikki is a spin during which the actor goes down onto his knees while continuing to spin; the difficult movement, requiring high speed and balance, is often executed by young, energetic and pliable performers playing to the gallery. A senior actor in Rajagopal's father's company admonished him, telling him to omit this movement because it was inappropriate for Karna, a senior king, to lower himself onto his knees. Interpretation and improvisation usually come with experience and age to seasoned actor-singers who have developed a thorough grip over the multimedia dramatic material enabling them to manipulate and fine-tune it according to their wishes. In addition to being inspired by watching other, senior actors perform well-known vesams, interpretation and characterization are influenced by their individual understanding of song texts and additional background information and experience acquired in the course of their careers. Such background knowledge may come from reading books, in particular the epics and puranas, or listening to the telling of the Mahabharata by professional storytellers (and today also from watching films and television). *Pārata piracaṅkam*s (or *corpoḻivu*s) are daily expositions of Tamil versions of the Mahabharata that are part of the same Paratam festivals that host Kattaikkuttu performances at night (Hiltebeitel 1988: 135–46). Staying in the village for ten or more consecutive nights, Kattaikkuttu performers pick up relevant details listening to such lengthy expositions, which are often broadcasted over a loud-speaker system during the afternoon waking them up from their sleep.

A personal interpretation of a vesam can have different starting points. For Rajagopal interpretation is often grounded in his reading of a poetic verse and the embedding of its words into Kattaikkuttu's distinctive musical-emotional style. Kattaikkuttu's inherent flexibility allows an actor-singer to use

linguistic text creatively without, however, deviating from the authors' given words which, ideally, should not be tinkered with.[19] In the previous chapter we saw how Rajagopal as Karna alternated his entry viruttam with a pattu mode. This allowed him to switch to a higher speed and add atavus to his performance. In a 2001 interview, Rajagopal explained he did so in order to cater to the interests of different segments of his audience. According to him, the younger generation wants speed and action; however, older spectators are interested in understanding the actual wordings and their meaning, something that requires a slower, clear articulation of the text (de Bruin and Rajagopal 2001: Interview with P. Rajagopal 2001). As a further example of personal interpretation, a performer may decide to sing a viruttam in a different raga to bring out an emotionally distinctive mood of the same poetic text or characterize a vesam in a different way. An example of the first instance is the viruttam *aṭi maṅkaiyē itu varaikkum eṉ marmattai collavillai* – 'My Maiden, hitherto I have not disclosed my secret' in the play Karna Moksam (de Bruin 1999: 249).[20] Karna sings this viruttam in answer to his wife's demand to tell her the names of his parents. When sung in raga mokanam, the viruttam creates a heroic and majestic feeling through which the song-text acquires a connotation of 'Who are you to ask me this? See, I am not afraid to tell you my secret (that I am Kunti's illegitimate child)'. However, when sung in kampoti raga, the viruttam reveals Karna's emotions of sorrow and frustration of having been rejected by his mother and his wife and of having to endure constant insults on account of his perceived low caste descent. In the play *Draupadi-the-Kuratti*, situated towards the final year of the Pandavas' forest exile, Draupadi takes on the disguise of a woman of the Kuravar tribe. Unrecognized by them, she tells fortune to the one hundred Kaurava Queens that ends with the prediction that all their husbands will die in an upcoming war. Performing the role of the Kuratti in the play Draupadi Kuravanci demands that an actor-singer balances the Kuratti's socially low status with that of Draupadi's royal, heroic identity and desire for

vengeance. Handling this duality of character, the performer can play with the fact that Draupadi-as-the-Kuratti knows the history of enmity between her five husbands and the Kauravas, including her own experience of dishonour at the hands of Duryodhana and Duhsasana. Pretending to be a lowly tribal woman, she uses this knowledge to tell fortune to the Kaurava Queens, predicting the 'truth' and letting her underlying anger surface from time to time. While the Queens are unaware of the Kuratti's dual identity, the audience is because her transformation into a tribal woman at the hands of Krishna is the subject of an earlier segment of the play. Just prior to exiting the stage at high speed, the Kuratti reveals that her profession is but a disguise (a vesam), yet the Kaurava ladies fail to recognize her true identity:

> I am not a Kuratti with a basket and a winnow;[21]
> this job of telling fortune is but a disguise.
> Be assured that the fate I predict will become true.
> Time is up. If I don't leave now my husband
> will be cross with me. Pay me my grains now
> and I will take my leave. I will leave.
> I will leave.

The Kattaikkuttu Gurukulam

Building a new generation of performers

As a young boy Rajagopal had to forsake formal education because he wanted to become a professional Kattaikkuttu actor like his father. This motivated him later in life to establish the Kattaikkuttu Gurukulam. From 2002 to 2020 the Gurukulam was the flagship programme of the Kattaikkuttu Sangam and the first-of-its-kind residential conservatory where annually fifty children and young people could combine training as a Kattaikkuttu actor or musician with formal education.

Depending on the length of their sojourn, which varied from one to ten years, students acquired foundational or advanced performance skills, in addition to learning one or more all-night plays from the theatre's traditional repertory. Initially training in both acting and music, some students went on to specialize in a musical instrument. A few students continued to develop their skills in both acting and music making. Accommodating a dual curriculum and the necessity to report to donors funding the programme meant that the artistic training of the Gurukulam had to be more time-bound, planned and analytical. As a consequence, the different types of atavus (dance steps) got names while music training became more methodical after we roped in a guest teacher teaching Karnatic vocal with the aim to give the students a basic understanding of the raga system. Such an understanding is important as it allows Kattaikkuttu performers to better respond to questions from outsiders as to what they do musically. In addition to enhancing the status of the art form, the ability to speak about one's art – what one is doing and why – has become increasingly important to attract sponsorship and survive with dignity in a competitive field of the performing arts (de Bruin 2020: 13). Yet, the organic way of teaching and its core elements of sensorial, cognitive and emotional learning through listening, observing, repeating and doing/performing with minimal verbal instructions from the teacher remained intact. Another difference with a traditional training trajectory was that pupils of the Gurukulam moved through the training process as a group. This contributed to a better onstage synchronization between actor-singers and between them and the musicians – an aesthetic aspect appreciated in particular by urban and international audiences (De Bruin 2020: 12). As the principal tutor or Vattiyar, Rajagopal insisted on each student learning all parts of a play before he cast students in specific roles irrespective of their gender. This made it relatively easy to have students change roles when their performance was not up to the mark (or when the voices of young males began changing) – a critical intervention that he exercised

with due diligence. Training together and having access to all roles stimulated collaboration as well as healthy competition, gender awareness and cross-gender performances in which girl students for a change took on typical male kattai roles.[22]

From 2008 onwards the Kattaikkuttu Gurukulam ran its own theatre ensemble, the Kattaikkuttu Young Professionals, consisting of senior students (fourteen years and older) and alumni of the school. For the students it served as a training ground where they could apply the acting and musical skills learned in real-life performance settings and become familiar with a professional theatre company's operation. This first-ever mixed-gender Kattaikkuttu company competed with professional adult companies in the region. Even though only a small number of students ultimately went on to become professional performers, the Gurukulam has delivered a new generation of Kattaikkuttu actor-singers and musicians that now serves existing companies in the region. The Gurukulam had to close its doors in March 2020 as a result of the pandemic and a shortage of funding.

Introducing women performers

The Gurukulam has brought Kattaikkuttu training and onstage performances within reach of rural girls and young women. This is a historic innovation in a theatre that traditionally has been a male prerogative and in a rural society that continues to stigmatize the profession of actress therewith denying rural girls and women an artistic voice.[23] While rural audiences take it for granted that female roles are acted by men, feminist theatre makers and other urban intellectuals have been questioning the exclusion of women from the tradition. Their absence has been attributed to different reasons, including the sacral nature of Kattaikkuttu's performances which would prevent the participation of (menstruating) women, and the fact that women were believed to be unable to perform Kattaikkuttu's physically demanding kattai roles. Professional

male Kattaikkuttu performers foregrounded the difficulty of running a mixed-gender company which, more so than an all-male ensemble, could give rise to frictions and discord between performers in which gender played a role. The myth that women would be unable to perform Kattaikkuttu's powerful kattai roles had been scattered already prior to the establishment of the Gurukulam in 1996/1997 when an all-women's company successfully and multiple times performed the all-night Kattaikkuttu repertoire piece *Bending of the Bow* (Vilvalaippu). The performers were professional actresses from the Drama genre trained by Rajagopal over a period of three months in all aspects of Kattaikkuttu acting. The play featured Draupadi's marriage to Arjuna and the other Pandava brothers and it had women donning all roles, including that of the male kattai vesams and the Kattiyakkaran (Mangai 2015: 127–8).

Performances by the Kattaikkuttu Young Professionals Company have created not only new standards of quality and novelty, they also have set new expectations with regard to the inclusion of women performers. For the most part, rural audiences look forward to and appreciate the presence of women performers in Kattaikkuttu's female and male roles – that is, as long as these women performers are not their own sisters, daughters, wives and mothers. The entry of young women in the theatre and their staying on at critical moments in their young lives has not been an easy process. The first perilous moment at which girls were removed from the Gurukulam (often against their own wishes) by their families was menarche. While parents and other family members tended to look at performances by their prepubescent daughters with adoration and pride, this changed as soon as girls reached puberty. Their new status – often celebrated through a (lavish) ceremony announcing that they were available as potential marriage candidates – required girls to adopt and internalize the culturally prescribed modest behaviour and body language that rural society, and in particular extended families, expect from young women. In such a context, exposing the female body in and through performance to the public (male) gaze,

co-education and mixed-gender performances are contested issues. To perform in public is seen as a source of shame, felt deeply both by the young women performers themselves as well as by their (close) family members.[24] The second critical moment for girls *and* boys was when they successfully passed their 10th or 12th standard school exams. These milestones in formal education confront young people with the choice whether to focus on higher studies and abandon performances altogether or opt for a professional career as a Kattaikkuttu performer. Higher education now has become an acceptable reason for adolescent women to push the age of marriage ahead; continuing to perform in public is not an acceptable reason to do so – in fact, performance is seen as something that makes finding a suitable marriage partner for a young woman, if not impossible, at least highly problematic. The third critical moment for women who would like to become professional performers is marriage: Can a rural woman perform in public after marriage? This is one of the last remaining barriers that is being addressed, and hopefully transcended, by a group of courageous alumni women students of the Kattaikkuttu Gurukulam as I am writing this book.[25] These women performers have been tutored in Kattaikkuttu by Rajagopal for six to ten years; prior to their marriage, they have participated in numerous overnight village performances as well as new productions devised by the Gurukulam playing principal female and male roles. Some of them have been funding their higher studies with money earned through public rural performances with other theatre companies. Now, after marriage and having little children of their own, they want to use the artistic and life skills and experiences they have gained at the Gurukulam to empower a next generation of young girls through their performances and remove the taboo of women on the rural stage.[26] In the case of marginalized performing art forms such as Kattaikkuttu, a woman performer is faced with a double stigma: firstly, as a woman performer and, secondly, as an exponent of Kattaikkuttu, an art form that itself is

stigmatized. In other words, it is the intersectionality of her two identities – being a woman and a professional Kattaikkuttu performer – that reinforces one another and makes the lives and choices that performing women face so complicated (de Bruin 2011: 20).[27]

The advocacy of Rajagopal to open up Kattaikkuttu training and onstage performances to rural girls and young women has shifted the gender balance in Kattaikkuttu. One of his women students from a marginalized background has established her own professional theatre company, while other alumni women students, married and with children, make their initial forays into professional male theatre companies. However, most of these companies continue to employ exclusively male performers. With the closure of the Kattaikkuttu Gurukulam, a safe training ground for women has fallen away. While we hope that the work of the Kattaikkuttu Gurukulam has mitigated somewhat the persisting stigma on women performers, its impact on Kattaikkuttu and the question whether or not women will persevere in the Kattaikkuttu profession will take more time to assess.

Exploring the tradition from within

In addition to Chennai-based playwright and theatre director Na. Muthuswamy, at least three rural practitioners from hereditary Kattaikkuttu backgrounds have written and produced innovative work. In her book *Indian Folk Theatres* Julia Hollander describes the journey of Na. Kannappa Thambiran and his son K. Sambandham of bringing innovation to the Purisai Therukoothu (Kattaikkuttu) tradition in close collaboration with Muthuswamy (Hollander 2007: 169–75). Rajagopal, too, has been writing and directing original work besides contemporizing Kattaikkuttu's traditional repertory, often to accommodate his women students casting them in principal roles previously performed by men. As a prominent actor-singer himself and

a leader of a well-known theatre company (a position he relinquished to devote himself to the Gurukulam), he grounds his work in his own acting experience in order to explore the nature and boundaries of Kattaikkuttu and give shape to his vision of what Kattaikkuttu can be and do.

Creating new work

Realizing that the Mahabharata narrative was daunting to understand and act for his young students, Rajagopal wrote two children's plays: *Māyakkutirai* (*Magic Horse*, 1997)[28] and *Viḷaiyāttiṉ Vilaivu* (*War Games, 1991*). Magic Horse tells the story of two aliens who have lost their *śakti* – in the play understood to be the power of the imagination – to return to where they came from. War Games is about the youth of the Pandavas and the Kauravas and their emerging jealousy which, ultimately, leads to the eighteen-day-long Mahabharata war. Both these short plays became standard pieces in the repertory of the Kattaikkuttu Gurukulam, resulting in multiple performances by subsequent batches of students. In addition to these children's plays, Rajagopal reworked and reinterpreted several traditional, all-night Kattaikkuttu repertory pieces to explore ethical issues, such as in *Abhimanyu* in which he conceptualized the sixteen-year-old hero Abhimanyu as a child soldier, and Dice and Disrobing in which, as we shall see below, he criticizes patriarchy and foregrounds Draupadi's agency. In *Pārkatal* or *Milky Ocean* (2002) he paints a dystopian scenario set at an imaginary moment after the destruction of the world. This parody features two Kattiyakkarans as symbiotic twins and two unnamed groups of survivors who set out to churn the ocean to acquire material possessions. Subsequently, Rajagopal wrote *RāmaRāvaṇā* (2011), a commissioned piece of work and a critical reinterpretation of five scenes from the Ramayana epic in which all roles were performed by young

women performers, and *Karnatic Kattaikkuttu* (2017).[29] In this collaborative production Karnatic concert music and Kattaikkuttu theatre – two Tamil performance traditions that occupy opposite ends of a spectrum that divides the Indian performing arts into classical and folk – share the same stage. Both RamaRavana and Karnatic Kattaikkuttu remained fully grounded in Kattaikkuttu's multimedia vocabulary and presentational style, yet also sought to extend this vocabulary experimenting with different dramaturgies, *mis-en-scène* and incorporating a different musical genre to create richer, more layered, musical and visual experiences and thought-provoking dramatic contents. I have discussed both productions at length elsewhere (de Bruin 2019 and de Bruin 2021).

Condensing traditional repertory pieces and writing new work of a shorter duration, such as Parkatal, RamaRavana and Karnatic Kattaikkuttu, has far-reaching consequences not only for the content but also the aesthetics of a performance. These productions often address urban elite audiences, whose members are unfamiliar with Kattaikkuttu's dramatic form and presentation and who have a much shorter attention span than rural spectators. They take place on fully lighted, (proscenium) stages where everything is visible and audible and the dramatic action needs to be presented to the front instead of to audiences seated on three sides. Consequently, they require the director, dramaturg and performers to pay attention to the direction and excellence of visuals, voice, music, focus, synchronization, liveliness and power in acting, in addition to a conscious planning and rehearsals so as to create (more or less exactly) repeatable performances (de Bruin and Rees 2020: 104). In contrast, in regular overnight performances the framework, internalized by the performers, prompts the process of performance and the use of multimedia building blocks. Such performances tend to develop at a much more leisurely speed that offers greater scope for variation, improvisation, the opening up of new

narrative windows spinning out Mahabharata's intrigues and
background stories and the inclusion of extensive comedy.
As we have seen, the specific configuration of Kattaikkuttu's
overnight performances allows performers to adjust their
performances to the sacral context and wishes of their rural
audiences – something that contributes to their sense of
ownership of the event. In the absence of a director-like figure
such fine-tuning, in addition to being prompted by audience
responses, presupposes knowledge of the specific occasion
(e.g. a Paratam, another religious festival, a funeral). Even
though rural spectators are not unappreciative of shorter-
duration productions on new themes, these may fail to
evoke and channel sacral power as expected from traditional
performances.[30] Therefore, rural patrons prefer to commission
overnight performances featuring well-known epic and
puranic narratives for festival occasions in which these events,
in addition to being entertainment, are considered a visual
sacrifice to the deity.

Portrayal of women characters

An important shift that has taken place in productions of the
Gurukulam directed by Rajagopal and myself has been our
attempt to show women characters with dignity and reduce
or eliminate the onstage violence acted out against them. In
overnight performances by professional companies, it is not
unusual to see women characters being exposed to physical
force at the hands of male characters (and actor-singers)
displaying their male authority. In spite of their royal status
(or perhaps thanks to it), male kattai characters do not shy
away from beating their queens, either punching them with
their hands, hitting them with their wooden sword or a folded
towel, kicking them with their feet or striking them with a
whip that, when it cracks, produces a loud sound. A standard
scene in which such beatings occur is when the wife tries to

convince her husband not to go to battle for fear that he will be killed and, as a consequence, she will become a widow and a social outcast. In general, women contradicting men on the stage invite repercussions. As much as rural spectators identify with Draupadi's suffering and humiliation, both men and women in the audience seem to relish the violence meted out to women characters who are assertive or do not behave as they are culturally expected to.[31]

When Kattaikkuttu's performances touch on the familial roles of women characters as wives, co-wives, sisters, mothers and mothers-in-law, these roles tend to be interpreted within a joint family system. Within this familial frame of reference, women characters are portrayed rather negatively, stereotyped and falling short of the idealized female image inspired by more prestigious Brahminical role models. The Brahminical image emphasizes subservience, dependence through marriage, eternal conjugal fidelity (*karpu*) and female accommodation, even when tested to the extreme as in the case of Nalayini. These prescriptive features contrast not only with female behaviour as it can be observed in everyday life in my rural area of work, but also with deviating – for typically non-Brahminical – female role models that emphasize the martial, militant and blood-thirsty aspects of women characters and female deities. The foremost example of this assertive female role model is Draupadi herself in whose case heroic, ferocious and vengeful aspects of her character are triggered by the humiliation she has undergone at the hands of Duhsasana and Duryodhana.

In the next section I highlight the confrontation between Duhsasana and Draupadi in Rajagopal's adaptation of the all-night play Pakatai Tukil (Dice and Disrobing).[32] I have singled out this play, which is considered the *pièce de resistance* of the Kattaikkuttu repertory, as an example of innovation from within the tradition. Additionally, by incorporating sequences of the performed text in translation I hope to convey something of the potency of the original Tamil text.

Pakaṭai Tukil[33]

Between 2013 and 2016, we adapted Dice and Disrobing
for the Kattaikkuttu Young Professionals Company. The aim
of the reworked play was to reshape Draupadi's role – now
performed by a young woman – by endowing her with greater
onstage resistance, verbally, visually and kinaesthetically,
and greater agency. Equally important was that we wanted
to stimulate our regular rural audiences – women, men and
children – to engage with issues of gender, gender violence
and justice at an experiential-affective level, rather than
taking the theatre's conventional acting format and gender
stereotyping for granted. Marginalized rural spectators often
feel and, in actual practice are, excluded from the rational
bourgeois feminist debates because these are framed in alien
discursive, analytical/abstract and/or persuasive terms (de
Bruin 2019: 55).

At the centre of Dice and Disrobing is the almost rape of
Draupadi, the polyandrous wife of the five Pandavas. The
violence meted out to Draupadi includes being pulled by the
hair into an assembly of kings, a failed attempt to publicly
disrobe her and, finally, the ambivalent order to place her on
the lap of the principal aggressor, Duryodhana. The notorious
hair-pulling scene is usually enacted matter-of-factly in a
conventional performance, with an emphasis on a realistic
presentation of violence. Draupadi appears on stage behind
the hand-held curtain symbolizing the boundary between
the royal women's apartments and the outside world. The
antagonist Duhsasana cuts away the curtain with his sword and
barges into this private, feminine space. He grabs Draupadi's
long, unbound hair – in actual practice, a black cord that
substitutes for it as convention has it that Duhsasana should
not touch Draupadi physically.[34] Pulling her head towards
him, he forces her to bend forward, facedown, restraining her
in a stranglehold that creates a visual image of submission
and suffering. Moving Draupadi into the performance arena
with mounting violence, Duhsasana swirls her around and

then throws her to the ground, rolling her over and over in the dust. In contrast to the visual imagery of male domination and female subjection this creates, Draupadi's traditional sung text is explicit, forceful and sometimes sarcastic. Yet, its semantic forcefulness often is suppressed and diluted visually, perhaps because the male actor-singers struggle to reconcile Draupadi's assertiveness with the stereotyped role model of the ideal, modest, subjugated woman/goddess or, as we found out during the rehearsals, because of the atypical rhythm to which parts of the hair-pulling sequence are set.

The hair-pulling scene[35]

We enter the performance after Dharmaraja (Yudhisthira) has lost his possessions, country, younger brothers, himself and, finally, their common wife Draupadi, in a fraudulent game of

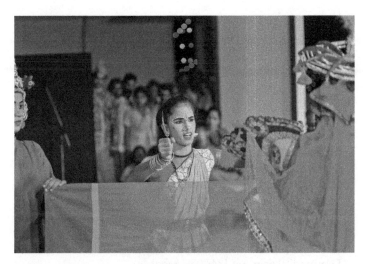

FIGURE 8 *Draupadī (S. Tamilarasi).* Disrobing of Draupadi *excerpt as part of* Karnatic Kattaikkuttu, *Kattaikkuttu Sangam's Performing Arts Festival, Punjarasantankal, 14 August 2018. (Photo by PeeVee © 2018 Kattaikkuttu Sangam.)*

dice. Duryodhana orders first the Kattiyakkaran and then his younger brother Duhsasana to fetch Draupadi and bring her to the royal assembly. She refuses, according to tradition, because she has her period and is not supposed to enter a public space.[36] And she wants to know why she is being summoned:

Draupadi's song

Foolish Brother-in-law, who calls me
without respect – as if drunk:
You say that your older brother, a crowned monarch,
wants you to bring me to his famed assembly.
Tell me why?

Draupadi Foolish Brother-in-law, why does your older brother summon me to come to the court of illustrious kings?

Duhsasana's song

The famous son of Dharma[37] got engrossed in a game of dice.
First, he lost his land and cities.
Then he lost himself and his younger brothers.
Finally, he lost you: Come and see the spectacle for yourself!

Duhsasana *[Sarcastically]* What should I say? Dharma proposed to play a game of dice. We told him that it was not a good idea. Nevertheless, he played and lost everything.[38] First he staked his country and cities, then his younger brothers, himself and in the very end he staked you. Having lost everything, he's sitting there downcast. Come and have a look for yourself!

Draupadi's viruttam [*Mukari raga*]

If the king could bring himself
to stake me in a game of dice,
wouldn't he have the presence of mind
to invite me personally?

Who are you
and who is this older brother of yours
to summon me to the assembly?
Please leave without further delay

Draupadi I will come only when invited by the person who has a right to call me. Who are you, or for that matter, that older brother of yours, to do so? There's no need for talk. Get marching! Get marching! Get marching!

Duhsasana's viruttam

Marching I came, to tame you this very moment
and bring you in front of my older brother,
destroying the pride of those kings in public!
Get real, woman! Why stick to this smugness? Get up and come![39]

Duhsasana What is bound to happen can't be stopped. I'll break your arrogance! I'll haul you right in front of my older brother. Get going!

Draupadi's song

'Get going', you bray, 'to the noble assembly
that hosted this dirty game of dice.'
Would that be right for a woman like me?
Get out of my sight!

Kattiyakkaran [to Duhsasana] She tells you to piss off!

The actor-singer in the role of Draupadi audibly and visually marks her extremely impolite expression, 'Get out (of my sight)!' (pōṭā), commented upon by the Kattiyakkaran, by vigorously lashing out at Duhsasana through a stylized arm/hand gesture across the curtain now folded into half. This prompts him to retreat into a corner. Duhsasana responds by driving Draupadi menacingly into the opposite corner of the performance area. The brief sequence has both actors move

diagonally across the stage in a tight and fast choreography and in close proximity yet separated by the curtain. As an innovation in our production the curtain was held by two female curtain bearers, who functioned at the same time as chorus repeating Draupadi's sung lines.[40] Draupadi's partial visibility opened up the possibility for eye contact between her and Duhsasana galvanizing the verbal insults hurled back and force between them, including Duhsasana's insinuation that she should not shy away from the 'love' of the hundred cousins as she already has sexual relationships with five men.

In contrast to conventional performances, in Rajagopal's dramaturgy Draupadi resists being dragged by the hair once the curtain has been removed. She digs in her heels and throws in her full weight. Her resistance takes Duhsasana by surprise and enables Draupadi to momentarily free herself from his grip. She ducks and runs to escape. The distance that this creates between the two opponents and their encircling movements and eye

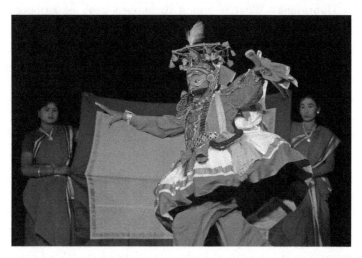

FIGURE 9 *Duḥśāsana (M. Greenkumar) in front of the curtain held by two women performers in P. Rajagopal's* Dice and Disrobing. *Kattaikkuttu Sangam's Performing Arts Festival, Punjarasantankal, 13 March 2013. (Photo by A. Prathap © 2013 Kattaikkuttu Sangam.)*

contact augment the sense of immanent violence. Duhsasana manages to seize her by the hair again. His tight hold of Draupadi has the two performers move closely together, facing each other. Calling him a sinner (*pāvi*), Draupadi commands Duhsasana to let go of her hair or pay with his life for his misbehaviour. The syncopated, terse rhythm of the choreography in an unusual tirupatai talam in five counts pre-empts – perhaps purposefully within this loaded sacral context – a full-blown physical confrontation between the two. Calling her cry for help a 'performance (*nāṭṭiyam*)', Duhsasana orders Draupadi to let go of her pride. He invokes her 'pretentiousness' and her (unfeminine) 'arrogance' (*kervam*) to legitimize his gendered violence and his right to destroy her chastity (*māṇam*):

Duhsasana's song

Walk, woman who deceives the entire world
crying 'O my Lord, O my Lord!'
A nice performance, spoken well!
Now let go of your pride!

Stubborn you remain,
speaking pretentiously,
crying out for help in vain as
I am dragging you along!

Dragging Draupadi with him Duhsasana drops her at the feet of his mother Gāndharī where Draupadi sings a long lament addressing her as *māmi* (mother-in-law) and seeking Gandhari's protection. In regular performances Gandhari harshly shoves Draupadi into the hands of her violent son Duhsasana, exclaiming that looking after one-hundred daughters-in-law is already enough trouble.[41] In our reinterpretation, we tried to endow Gandhari with greater empathy towards Draupadi. Thus, she tells her daughter-in-law that she has nothing to fear as she herself will come to the assembly to 'see' (remember that Gandhari blind-folded herself when she got married to

FIGURE 10 *Draupadī (S. Tamilarasi) ducks and runs to free herself temporarily from Duḥśāsana's grip (K. Radhakrishnan). All-night performance of P. Rajagopal's Dice and Disrobing, Marutam Village, 24 September 2016. (Photo by A.R. Sumanth Kumar © 2016 Kattaikkuttu Sangam.)*

the blind Dhritarashtra) what perspires there. Another round of hair-pulling follows that is even more intense and in which Duhsasana goes all the way to make it clear that he will tame Draupadi who, having been lost in the game of dice, now is the property of the Kauravas:

Duhsasana's song

Will I leave without dragging you along
to confront you with Duryodhana and my younger brothers?
These poor Pandavas have become vagrants –
slaves who have to beg for a measure of rice.

Draupadi's song

Proclaiming your laws,
eager to show off your cleverness,

will a black crow become white
even when it bathes three times a day?
Get out of here, Beast of prey!

Duhsasana's song

What! You talk without thinking!
I will toss you, destroying your modesty,
entangling your legs
so that you no longer know
what is front and what is back.

Draupadi's song

Aiyayoo, curse you!
How can you allow this injustice, God?
How can this mad man touch the hair (bun)
which my husbands adorned with millions of flowers?

Duhsasana's song

They lost you in the game of dice.
They saw you reduced to a slave.
There's no use to wriggle like a worm now:
You have become the property of the house.

Draupadī's question

At the end of this sequence Duhsasana deposits Draupadi at
the feet of Duryodhana sitting in state amidst the assembled
royals, including his father Dhritarashtra, Gandhari, Bhisma,
Vidura, Karna and his younger brothers. Draupadi laments
and berates her enslaved husbands for their passivity. As in a
typical contemporary 'rape script', they are made to watch the
violation of their wife – their inability to protect her becoming
a symbol of their emasculation. A further innovation at this
moment in the production was the dramatization of Draupadi's
vaḻakku, the question through which she appeals to the elders
in an attempt to mitigate her own situation. She wants to

know the truth, that is, whether Dharmaraja lost (him) self
first, or whether she was lost after he lost himself. Her question
is embedded in a viruttam provided by the traditional play
script, followed by a poetic, spoken verse that Rajagopal
borrowed from Villiputtur's Tamil Paratam.[42] Draupadi's
question remains unanswered for it is a *praśna*, a kind of
riddle that cannot be solved because it invokes a range of other
questions, such as what constitutes self and did Dharmaraja
have a right to stake his wife before or, even more problematic,
after he lost himself.[43] In Rajagopal's staging, this scene has
been further embodied and contextualized to foreground
the sustained silence that meets Draupadi's question, giving
rise to a growing feeling of unease and apprehension among
royalty and spectators. Her lone female presence in front of the
assembled royal statesmen and her enslaved husbands stands
out starkly. After a long pause, Vikarna, the youngest of the
Kauravas, gets up to voice his opinion:

Vikarna's viruttam

Don't we feel the same disgrace
that consumes the Five?
Does not everyone want to keep a wife
in comfort and happiness?

Such derogatory speech
about a woman whose chastity
supersedes that of the famous Arundhati,
does not befit a king

Vikarna Listen, great people of this assembly! The honour
of the five Pandavas has been put to shame. But what
has happened to us? Don't we feel ashamed to disgrace
womanhood by calling Draupadi, who cannot even be
compared to the famous Arundhati, a slave and a whore in
this regal court? Is this the royal dharma? Is this justice?

In addition to a demand for justice or truth (*niyāyam*), the
idea of manam resonates throughout the entire scene. While

Draupadi's manam – her female integrity and chastity – is at stake, Vikarna questions the assembled royalty about *their* manam, that is, their male honour. How can the Kauravas allow the public humiliation of a woman? Don't they have the same feeling of honour that the Pandavas have? Vikarna is removed from the court on the excuse that he is too young to know what is wrong and what is right.

Draupadī's disrobing

The disrobing scene happens towards the end of the all-night performance before dawn breaks. In our performance Draupadi stands on a platform stage right, holding a plate with burning camphor in front of her. She is partly hidden by the raised curtain folded in half. Duhsasana reaches under the screen and starts to tug at the lower end of her sari. At this moment when her nakedness is about to be revealed, she surrenders to Krishna, who supplies her with an infinite succession of saris. The song text states that Draupadi 'forgets (her)self' and, possibly, that she enters a different realm of consciousness where she is oblivious to shame and other norms conditioning female propriety. Within the local, sacral performance context, the moment when Draupadi forgets (her) self and surrenders to Krishna seeking his help, signals her transformation into the village goddess Draupadi Amman. Her bhakti contrasts with Duhsasana's almost-possession in which he, too, has no longer a hold over self. The violation of Draupadi's physical and mental integrity unshackles a menacing, sacral power and results in an alarming condition of female 'un-containment'. It often elicits strong, affective responses in the performers as well as among Kattaikkuttu's rural audiences, including instances of possession and spectators wanting to intervene in the dramatic action on stage (de Bruin 2023: 88).

Regular all-night Kattaikkuttu performances of Dice and Disrobing end here. Rajagopal has composed an innovative last scene based on a combination of oral and written literary

sources circulating in the oral reservoir, in which Draupadi plays a final game of dice directly opposing Duryodhana. Staking the only thing she still owns – her chastity (manam) – she wins this decisive game that allows the Pandavas to go into their thirteen years of exile as free people. As a result of this added final scene, the play ends with a strong, victorious Draupadi standing on a slightly elevated dais. It is this last image, so very different from that of the conventional subjugated woman lost in a game of dice and molested by her own relatives, which rural spectators take home.[44] The dais symbolically implies her transition from a worldly wife to a vengeful goddess, a change that is acknowledged by the elders in the assembly and by Duryodhana's blind father Dhritarashtra. In a moving verse the latter tries to undo Draupadi's terrible curse that she will not tie her hair again before she has drenched it in Duryodhana's blood and combed it with a bone taken from his chest. Realizing Draupadi's merciless power, Dhritarashtra pleads with her to forgive the Kauravas, because 'they were children who did not know what they were doing'. But his change of mind comes too late and the stage has been set for future revenge.

Validation and aesthetics

Kaṭṭaikkūttu's enduring stigma

I began this book by referring to the twentieth-century discourse of contempt that pervades writings about the recent history of the Tamil stage. Members of the urban upper- and middle-class and caste elite blamed the deterioration – perceived and real – of popular Tamil theatre on a lack of education, artistry and moral integrity of its subaltern performers. They failed to take into account Kattaikkuttu's historical roots in a feudal village context in which to perform was both a caste-based right and an obligation. For hereditary Kattaikkuttu performers, the physicality of their performances, in combination with their handling of sacral power during (acted) acts of bloodletting

and killing, was emblematic of their low caste status. Rural patrons expected performers to put in their full physical effort in return for a meagre and, in the case of the processional Terukkuttu, uncertain remuneration. The obligatory nature of the labour of performance, its association with a low caste status and Kattaikkuttu's categorization as a folk theatre – a term that has problematic connotations in the wider field of the Indian performing arts – constitute part of the profound, internalized social stigma that young performers inherit (de Bruin, forthcoming a).

Stigma, and coping with what Erving Goffman has called a 'spoiled identity' (Goffman 1963), is a complex phenomenon. It affects not only Kattaikkuttu's status and validation as a legitimate expression of Tamil culture, but also individual experiences of what it means to be a Kattaikkuttu performer.[45] Kattaikkuttu's stigma socially marks and devalues professional performers as a group, in addition to affecting their sense of self and personhood. While the theatre has dissociated itself from the feudal mamul system, at least at an economic level, the social implications of Kattaikkuttu as a form of physical labour or ulaippu involving subservience and impurity, linger on. The endurance of Kattaikkuttu's multifaceted stigma is revealed by the fact that most hereditary performers, including Rajagopal's own father, discouraged their sons from following in their footsteps and becoming professional performers. Today the abhorrence of physical exertion as an indicator of low caste is an important motivation for some of Rajagopal's talented, young male students, who are educated and have performed at a professional level when they were training under him, to opt for white collar jobs instead of a career in the theatre (de Bruin, forthcoming a).

Aesthetics and quality

Members of the urban arts establishment often feel that Kattaikkuttu has nothing much to offer in terms of aesthetic

satisfaction and meaningful value (de Bruin 2019: 55). It certainly is true that Kattaikkuttu's aesthetics differ from those that govern highly codified, classical performing art forms, such as Karnatic concert music, Bharata Natyam, Kathakali and Kutiyattam. Kattaikkuttu's aesthetics have been shaped by the theatre's open-air, sacral performance contexts and the fact that performers needed to fine-tune their performances to the demands of their patrons. Village religious festivals, where most Kattaikkuttu performances take place, lie outside the purview of the educated middle and upper class and caste elites and the cultural bureaucracy. Such performance contexts are layered and messy and can be violent and heated. They blur the dividing lines between actors, spectators and deities, and between the worlds of everyday life, ritual and theatre. They often involve non-Brahminical sacral-religious practices, including blood sacrifice, self-mutilation and possession. And in spite of the fact that these material and experiential contexts are integral to the contemporary religiosity of a vast section of the subaltern rural majority in Tamil Nadu, members of these urban bourgeois elites regard such rites and performances as superstitious and not in alignment with India's project of modernity.

As I have illustrated, the production of Kattaikkuttu's long duration performance events requires practical knowledge of the framework underlying overnight performances, in addition to having access to the vast corpus of multimedia building blocks and the conventions for their use. I have argued that the ways in which performers operationalize this framework individually and collectively accounts for Kattaikkuttu's flexibility. This flexibility is sometimes mistaken for a lack of artistic expertise and discipline by those unfamiliar with Kattaikkuttu's performance practice (de Bruin 2019: 55–6). Being a subaltern theatre form, Kattaikkuttu emphasizes flexibility in response to the demands and aesthetic expectations of its patrons and audiences instead of freezing the performance in a fixed, standardized (and supposedly more sophisticated) aesthetic end-product in which the audience has

little say in, or ownership over, the performance. Kattaikkuttu's inherent flexibility is both an artistic and, given the (hereditary) performers' low caste background, a social coping mechanism. Flexibility was, and continues to be, crucial to the theatre's resilience and survival within a competitive performance market. By not acknowledging the theatre's inherent flexibility or devaluing it consciously or unconsciously as a sign of folk aesthetics and a lack of artistic discipline, the urban arts establishment reveals its own ignorance of the existence of an indigenous theatrical knowledge system that is grounded in orality and that surfaces only in and through the praxis of performing. This unique epistemological system is part and parcel of the intangible heritage of the Tamil culture and deserves our further academic and practical attention (de Bruin 2023: 89–91); also, Hollander 2007: 169).

Parallel to contempt for and ignorance of Kattaikkuttu, a few urban-based contemporary playwrights, directors, theatre makers and performers from outside the tradition have recognized Kattaikkuttu's theatrical power and complexity. In the Introduction I have referred to the work of Tamil playwright and director Na. Muthuswamy and Koothu-p-pattarai, the theatre ensemble he established. More recently, well-known French theatre director Ariane Mnouchkine has used Kattaikkuttu extensively in her 2016 production *Une Chambre en Inde*. In a personal conversation Mnouchkine told me that she was completely carried away by Kattaikkuttu's dramatic power and vitality when she accidently happened to attend an all-night performance. This experience rekindled her idea of what theatre is and could or should do. In her own words, Kattaikkuttu 'does not question the role of theatre in the world. It just is or does unquestioningly' (de Bruin 2017). Such urban-rural and cross-cultural exchanges provide Kattaikkuttu with greater visibility and recognition. However, juxtaposed to the indigenous discourse of contempt, they also raise the question as to what Kattaikkuttu means for whom and what the state of contemporary Kattaikkuttu is.[46]

In my conversations with performers many of them expressed
dissatisfaction with the standard of today's performances.[47]
This is not something new. In the 1980s Purisai Kannappa
Thambiran Vattiyar began developing new work as a 'reaction
against a vulgar style of Therukoothu performances that had
recently become the norm due to the increased popularity
and accessibility of television and film dramas' (Hollander
2007: 171). I vividly remember my failed attempt as a novice
student of Kattaikkuttu to interview the late Neyyadu V.
Kannan in 1987. I was shocked by the strong sentiment of
disgust (veṟuppu) he expressed for the profession. As a famous
Vattiyar from a hereditary lineage of performers, Mr Kannan
no longer wanted to be associated with Kattaikkuttu in his
old age and did not want to speak about it at all. Dissatisfied
by the quality of performance – and possibly in search of an
(imaginary) opposite actor-singer who could match his talent –
another well-known performer, Kunnattur P. Ponnusami
Vattiyar, began switching companies towards the end of his
career before suffering a stroke that left him bedridden. More
recently, actor-singer C. Sitaraman described Kattaikkuttu to
me as having lost its glory (cīr keṭṭaṭu).[48]

Several performers blamed the lack of performance quality
on a lesser coherence in today's theatre ensembles and a want
of discipline within the fraternity, in addition to insufficient
training of novices lacking exposure to well-trained senior
performers who knew the craft. Alcohol abuse was another
much heard explanation for performers' inability to sustain
and deliver quality performances.[49] Some performers
attributed Kattaikkuttu's deterioration to kali yuga, the world
age in which decay and conflict get the upper hand.[50] While the
feeling that everything was better in the olden days may be of
all times – and perhaps is a pretext to cope with rapid change
and living with uncertainty – the opinions of the performers
referred to above mirror the denigratory discourse of contempt
prevalent among members of the urban arts establishment.[51]
Having heard and often personally experienced this discourse,
many of Kattaikkuttu's rural practitioners, in particular those

from a hereditary background, appear to have internalized its negative and humiliating effects as part of their own stigmatized professional and social identity. As a consequence, Kattaikkuttu professionals often feel disempowered to intervene and improve the quality of performance, also within their own company. Their felt lack of agency is enhanced by the current condition in which many theatre companies work with a minimum of performers, or are incomplete, in their attempt to share the total remuneration with as few performers as possible. This makes it difficult to continuously deliver high standard performances. Additionally, the coherence of a company is undermined when one or more lead performers invest in the ensemble as financers. In doing so they take home the interest on loans they have extended to their colleagues performing secondary roles and receiving a much smaller share of the total remuneration. Another oft-heard complaint, in particular from non-Vanniyar performers, is that caste at times overrules considerations of quality of performance, in particular when rural patrons give preference to companies owned or dominated by Vanniyars. Vanniyar patrons may also insist that the role of Arjuna in Arjuna's Penance, in particular the off-stage episode of this play in which Arjuna climbs a huge pole symbolizing Mount Kailasa, is performed by a Vanniyar. Though not new either, such demands appear on the rise (de Bruin 1999: 151–4). Caste (with a vengeance) appears to have taken preference over talent also in the case of two alumni students of the Gurukulam, one a Dalit and the other a Vanniyar by caste. They parted company when both laid claims to performing the aforementioned role of Arjuna. Not in agreement over who would perform this role, the family of the Dalit actor-singer organized his debut performance during which he climbed the pole.[52] With no dearth in the demand for performances and with a Vanniyar caste identity being played out as a selection criterion to commission a theatre company, there appears to be insufficient incentive for Kattaikkuttu performers to look seriously at the standard of their own performances.

Younger performers trained at the Gurukulam and now
working in professional companies criticized the colloquial
speech of both senior performers and their peers. They judged
the language used to be unbefitting to Kattaikkuttu's royal-
divine characters. They also criticized occurrences of physical
and at times (gendered) violence, sleazy comedy, sexual and
misogynistic conduct invoking easy laughter meant to rope in
the attention of young men. Such strategies might backfire as
they do not meet with the approval of all patrons and spectators
and might damage the reputation of a company, in particular
when such a company includes representatives of the first
generation of women performers. They also spoke about the
mismatch between them and a regular company's musicians
who, even though being senior and more experienced, were
insufficiently trained. In addition to creating problems of pitch
and friction with regard to the correct rendition of ragas,
the fact that a mridangam-player did not or could not play a
tirmanam prevented actor-singers trained at the Gurukulam
from properly completing their dance movements.[53] Actor-
singer and company owner C. Sitaraman (a newcomer himself)
cited insufficient or no training and ignorance of Kattaikkuttu's
performance conventions of newcomers in the theatre as a
reason for the erosion of performance quality and company
discipline:

> They do not follow the set practice that this particular
> viruttam should be sung like this and that pattu like that.
> There are (unwritten) rules to it (*vitimurai*) Take for
> instance the role of Krishna as Aṇṇaṉ (P. Rajagopal)
> performs it. At his age he combines his singing with that
> kind of energy and body language that makes us wonder
> whether we could do the same when we are that age. I
> do not know into which direction our current artists are
> taking the theatre but I fear (for the worst). I am afraid
> they will shift gears and even change the character of
> Kuttu.[54]

Yet other performers expressed their willingness to learn, but said they never had had the opportunity because of a lack of qualified teachers and foundational training opportunities such as those offered by the Gurukulam.[55] Given the frequency of performances at the height of the Kattaikkuttu season, training during the daytime is virtually impossible because performers have to sleep. The only time that training on a regular basis can take place is during the theatre's low season.

In spite of the criticism of performers reflected above, a fair assessment of the standard of today's Kattaikkuttu performances as compared to earlier ones is extremely delicate and difficult, if not impossible. Given Kattaikkuttu's wide geographical spread and stylistic differences, such an assessment, in addition to being entirely subjective, would be a gross generalization. Furthermore, judging the artistic quality of a performance is always based on a collaborative assessment of performers, patrons and spectators; what counts for someone as a good performance or a good theatre company may be judged to be below standard by well-trained experienced performers such as C. Sitaraman referred to above. Quality of performance emerges when performers are able to establish through their performance an intangible, emotive rapport with their audiences. In addition to adequate training in all aspects of Kattaikkuttu that enables talented performers to establish such a rapport, practical criteria, for instance the available performance space, its natural acoustics and the patrons' hospitality, in addition to a performer's physical condition, play a role in delivering quality in performance.

For Rajagopal, and for me too, Kattaikkuttu's quality is closely related to the theatre's scope, that is, what Kattaikkuttu can be and not necessarily what it is at a particular moment in time. Based on my own experiences, I can vouch for the fact that knowledgeable rural spectators, who are Kattaikkuttu's traditional connoisseurs par excellence, are extremely critical and able to recognize high-standard performances. This was evident in the case of the Young Professionals Company.

During its active existence this company received many more invitations to perform than it could take. It also fetched much higher prices than other professional companies. This was not only because of the presence of young women performers, which was a unique selling point of the company. The fact that all young performers had received a foundational training and gelled together well enhanced the quality of performance. Additionally, having access to a corpus of well-trained students of the Gurukulam and its alumni, the Young Professionals Company was able to showcase a fuller cast onstage. Most importantly in the opinion of some rural patrons of the company, it was Rajagopal's binding role as tutor and director keeping a close eye on the overall delivery of the show that guaranteed quality of performance.[56] In the absence of such a supervising role, collaboration and quality may easily dwindle. Rural connoisseurs then may decide to commission another company or, when they are unable to locate a good quality ensemble, refrain from organizing a performance altogether.

With the gradual disappearance of a generation of hereditary teachers and senior performers familiar with the theatre craft and its conventions, it seems likely that gaps are opening up in Kattaikkuttu's oral transmission. In my area of work, these gaps have been filled to some extent by young performers who received their training at the Kattaikkuttu Gurukulam. While I believe that this training has attempted to transmit Kattaikkuttu's knowledge and conventions of the Perunkattur performance style to the fullest extent possible, there is no guarantee that alumni students will continue to follow this stylistic praxis and discipline, in addition to becoming role models and teachers for a next generation of performers. Another reason for concern is the impact of performers' indebtedness on the standard of performance. As we have seen in Chapter 1, Kattaikkuttu's economic base has changed radically. As part of the commercialization of the theatre, financers providing performers with loans have entered the informal rural performance market. With the loan amount increasing over the years, quite a large number

of performers in my area of work are no longer able – or feel no longer obliged – to repay the principal loan amount. Earlier, performers used to exchange one company for another at the end of the theatre season. Nowadays, indebtedness prevents a free movement of performers between companies. As a consequence, Kattaikkuttu's performance knowledge no longer freely circulates and becomes inaccessible to a larger corpus of (aspirant) performers. This in turn impacts on the informal training process in which exposure to seasoned senior performers is essential, and, ultimately, on the quality of performance.

Lastly, while performers' individual mobility has increased, this appears to have reduced intimate prior and post-performance discussions and evaluations. In Rajagopal's father's time performers used to walk to their performance destinations; in the second half of the twentieth-century actors and musicians travelled to performances using Tamil Nadu's well-developed public transport system (bus and train). As a sign of their improved economic status, nowadays most performers own a two-wheeler on which they pack their luggage to go to their performance locations. Shared time between performers to meet informally – and to transmit aspects of the theatre's knowledge while walking to a performance destination or assembling at the bus station while waiting for the single bus that will bring them to a remote village – has almost disappeared. The only time performers now meet prior to the performance, allowing them to connect – other than on a mobile phone – is during the pre-performance meal customarily offered by their village patrons, and even this opportunity is sometimes skipped by (leading) performers reaching (just) in time for the overnight performance to start.

If Kattaikkuttu is to retain its popularity among the rural population, it seems essential to me that performers critically reflect on their own practice and rural patrons on the kind of theatre they wish to commission. Such reflection should result in action, for instance through (re-) instituting formal or informal training facilities and reconfirming company

discipline and collaboration for those who wish to make Kattaikkuttu their profession, while ensuring that these facilities are open to all social groups and genders. A corpus of well-trained performers is pivotal when it comes to creating and performing innovative productions. Such innovative plays enable professional Kattaikkuttu practitioners to move outside their regular rural performance contexts into the urban and global performing arts scene. Unaware of the negative social stigma locally associated with Kattaikkuttu, new audiences will watch and experience this rich, exuberant theatre tradition with an open mind. This will provide the Kattaikkuttu art form with greater visibility and standing and, hopefully, the performers with greater recognition and additional sources of income.

NOTES

Introduction

1 Frasca 1990: 25; Aṟivunambi 1986; Swaminathan 1991; Hiltebeitel 1988. Different spellings of these names are in use as the transliteration of Tamil has not been standardized.

2 Literally 'ancient stories', a genre of Indian narratives about a wide range of topics, including legends and other traditional lore.

3 Susan Seizer signals the omission of Special Drama from the history of the Tamil stage (Seizer [2005] 2007: 47); additionally, the contribution of women performers to the development of Tamil theatre is neglected in these narrations, too; see de Bruin 2011: 15–18; Mangai 2022: 1–15.

4 Junoon 2019.

5 Judge and well-known theatre person E. Krishna Iyer and N. Shyamala exposed Terukkuttu to urban audiences – probably for the first time – through a series of so-called village theatre festivals held in Tanjavur, Madras and Coimbatore in 1956, 1957 and 1961 and organized by the Tamiḻnāṭu Caṅkīta Nāṭaka Caṅkam. From the twenty-eight groups selected, the only group which came up to Kirusnayyar's expectations was that of Mr Raghava Thampiran from the village of Purisai. The hereditary Purisai performers remain one of the most well-known exponents of Kattaikkuttu (de Bruin 1999: 9–12, and fn 5).

6 My coining of the term *field of the performing arts* is inspired by Bourdieu's concept of *field of cultural production* (Bourdieu 1983: 311–56; Bourdieu 1993: 125; also, Kapferer 1997: 19–20 as quoted in de Bruin 1999: 7 and fn 3).

7 The classical-folk binary overlaps with Robert Redfield's famous distinction between the Great Tradition and Little Traditions.

Inspired by Redfield's work, anthropologist Milton Singer further investigated this distinction with specific reference to the South Indian cultural context (Singer 1972).

8 See Ravikumār 2021 for an example of Terukkuttu/Kattaikkuttu being used to convey a message about road safety.

9 Other training facilities in Kattaikkuttu/Terukkuttu have been established elsewhere: Purisai Therukoothu Payirchi Palli in the village of Purisai (Tiruvannamalai District) run by the Purisai Doraisami Kannapa Thambiran Parambarai Therukoothu Mandram (www.purisaikoothu.org); Krishnagiri Terukkuttu Payirchi Sangam in Krishnagiri and Kalari Koothu Palli in Erwadi Village, Salem District (de Bruin 2016: fn 14). These training schools represent different styles of Kattaikkuttu. The Purisai Doraisami Kannapa Thambiran Parambarai Therukoothu Mandram runs its own annual performance festival and so does the Kattaikkuttu Sangam.

10 Entry for Terukkūttu (தெருக்கூத்து) in *Tamil Lexicon* reads: (1) Dramatic performance or dance in a street. (2) That which is a public disgrace (*Tamil Lexicon* p. 2037); on the negative connotation of the term Terukkuttu see also Frasca 1990: 25–6 and Frasca 1998: 41, fn 17.

11 My area of work roughly includes the Kanchipuram, Tiruvannamalai, Vellore and Tiruvallur Districts of Tamil Nadu.

12 Palaṉi and Muttukantaṉ 2011: 9–11; Ramaswamy 2021: 34–5.

13 The only concrete documents we have are a few palm leaf manuscripts and the handwritten notebooks of performers, which they guard as part of their professional secrets. Photographs of actual performances, such as the one of Rajagopal's father's company reproduced in this book, are rare. Detailed archival research may throw up further data, but such research was not my primary aim.

14 Also known as Special Drama, Company Drama and Icai Nāṭakam or Mēṭai Nāṭakam depending on the region.

15 See also Bal on writing history in the context of documentaries, not as a record, but as a memory (Bal 2021: 2).

16 With regard to the Special Drama genre in the South of Tamil Nadu, Susan Seizer observes that Special Drama artists are believed to lack 'culture' and 'propriety' (*muṟai*) while their

social mobility onstage and offstage is seen as excessive and a threat to the social order (Seizer 2005: 32–5).

17 This is not to deny the existence of radical plays influenced by the political Dravidian movement, which interrogated and fiercely attacked religion, caste and social ills. More recently, modern theatre productions have examined gender and gender equity, in addition to providing new interpretations of traditional epic and Tamil stories (e.g. Richman 1991: 193–4 with special reference to the *Keemayanam*, a Dravida Kaḻakam persiflage of the Ramayana story inspired by E.V. Ramasami's reading of the epic; also, Inquilap 2021 and de Bruin 2021).

18 Saravanan 2005; Raj 2012; Chatterjee 2013; PTV 2016; Ramana 2019; *The Lede* 2019; News18 Buzz 2021; The Hindu 2022; 30Stades.com 2022.

19 Palaṇi and Muttukantaṉ (2011) provide a selective overview of 106 Terukkuttu performers, their caste, teacher(s) and earnings (which since have gone up).

20 That is, Kattaikkuttu.

21 Aparna Dharwadker terms productions, in which urban theatre makers collaborate with folk artists and use a folk idiom, *urban folk* (Dharwadker [2005] 2008: 318–51). Such collaborations display their own internal power dynamics, appropriation of folk-art idioms being one of them. Theatre directors sometimes take it for granted that they can use a folk theatre's vocabulary without further training and/or restrictions to enhance their modern theatre production. This does not always do justice to the integrity of the folk form as performed and transmitted in its traditional context. In March 2022, the National School of Drama (Bangalore Centre) invited P. Rajagopal and his student S. Tamilarasi to teach Kattaikkuttu's movement vocabulary to its actor-students. The students were working on an adaptation into Kannada of the Kalidasa satire *Mālavikāgnimitram*. In addition to Kattaikkuttu's movements, the production also used elements from two Karnataka-based theatre forms, Yakshagana and Dodatta. For Rajagopal, movement in Kattaikkuttu is intimately related to voice. Not having access to the energy generated by the use of voice and in the absence of Kattaikkuttu's instrumental music, the students found it difficult to do justice to Kattaikkuttu's kirikki or spin which demands high energy

and high speed. They could execute the movement only in slow motion (personal communication S. Tamilarasi, 20 March 2022).

22 Kristen Rudisill has researched the Sabha Natakam. According to her, many of the Sabha natakams were rather shallow, and at times amateurish, reality shows with plots that played out stereotyped characters conversing in their typical Brahmin dialect. The purpose of these plays was perhaps not so much fostering good taste, but rather counteracting the negative image and appeasing the hurt sentiments of the Brahmin community in the light of Tamil Nadu's virulent anti-Brahmin politics (Rudisill 2022: 55 and *passim*).

23 Since the onset of the pandemic this gap has been widening. Many live performance forms as well as the teaching of the performing arts went online. The translation of Kattaikkuttu's live performances into a digital format presents a challenge, while connectivity remains a hurdle to online access and work.

24 Hollander quotes M. Natesh, son of the late playwright Na. Muthuswamy, and an urban theatre designer. Natesh describes in vivid terms his experience of a Paratam festival, a context that features a cycle of all-night Kattaikkuttu performances, as strange and intoxicating, 'giving you an unbelievable high' … 'This excruciating *Padu Kalam* exercise (that is the killing of Duryodhana on the battlefield of Kurukṣetra acted out in the centre of the village) in scorching heat makes me think that these people are a totally different lot, and that I don't have any connection with them' (Hollander 2007: 163–6).

Chapter 1

1 Kattaikkuttu's material aspects deserve a separate study. For a detailed account of the make-up and costumes, see Frasca 1990: 112–32; de Bruin 2006: 112–17.

2 An exception is the Goddess Kali. She appears in the Mahabharata play The Royal Sacrifice wearing a large crown signalling her divine status, shoulder ornaments and a breast ornament, while her red make-up includes white fangs as an indication of her demonic nature.

3 Other styles of Kattaikkuttu found in the Vilupuram, Krishnagiri and Dharmapuri Districts feature an additional triangular shaped crown decorated with crows' feathers referred to as *cūramuṭi*.

4 Alternatively, fig wood (*atti*) can be used to make kattai ornaments.

5 A woman of the Kuravar tribe.

6 As compared to my fieldwork area where kattai attire was the dominant way of costuming for royal, male characters, tires vesams occupied a prominent place in the performance style of theatre companies in the Salem District. Their dresses were much more elaborate and heroic with enlarged shoulder parts and collars substituting apparently for the shoulder ornaments worn by kattai characters.

7 Karnatic singing is part of a complex form of art music that has been analysed, systematized, politicized, urbanized and modernized over the past 200 years. During this time, new instruments, sound technologies and performance venues were adopted, contributing to the concert format as we know it today. This format has shaped a new modern aesthetics of musical performance and reception (Weidman 2006; Pesch [1999] 2009 as quoted in de Bruin 2019: 59).

8 Other Kattaikkuttu styles may use different pitches, both lower and higher.

9 Nowadays contemporary urban audiences are no longer accustomed to hearing a high-pitched male voice and may experience its sound as strange and unsophisticated. Yet, singing in a higher pitch was part of the practice of Karnatic vocal prior to the introduction of microphones during the first half of the twentieth century (Terada 1997: 927).

10 As an innovation in the tradition, the repertory company of the Kattaikkuttu Gurukulam started employing two Kattiyakkarans to enhance the comic element in performance, in particular its non-verbal, visual aspects.

11 Susan Seizer has done ground-breaking work in documenting and analysing comedy in the Special Drama genre in the Madurai area (Seizer 2005).

12 This and the following two sections are based on the illustrated discussion of Kattaikkuttu's performance spaces found in de Bruin and Rees 2020: 93–6.

13 The title given to an experienced actor and teacher, from
 Sanskrit *upādhyāya*, 'teacher'.

14 In older times it seems that British administrators, in addition
 to *kāmpaṉitārikaḷ* or members of the East India Company, were
 part of the enumeration.

15 According to Julia Hollander an actor's proclivity towards
 trance/possession and his ability to transfer it to members of
 the audience contributes to his star status and is valued even
 more than his physical or verbal prowess (Hollander 2007:
 157). Possession-like states are extremely personal experiences.
 Performers' opinions with regard to the desirability of
 possession differed. Rajagopal, for instance, believes that a state
 of full possession may be acted, but a performer should never
 lose control over self.

16 To get an idea the heightened atmosphere during Paratam
 festivals, see, for instance, the visual footage from Sasikanth
 Ananthachari's documentary footage *Vanavasam* (Ananthachari
 2021); also Muthukumaraswamy 2018.

17 After this date performers, who are orally bound to work in
 a theatre company for one season, are free to join a different
 company. However, with the emergence of a commercialized
 performance market, traditional conventions such as waiting
 for the 'fifth Saturday' are being eroded. Nowadays performers
 are contracted to work in the same or another company much
 earlier on in the season, usually through providing them with
 a token amount, and increasingly with a real lump sum or
 'advance' – a phenomenon to which I will return below.

18 For a rough overview of the potential occasions for
 performances throughout the year, see de Bruin 1999: 53, fn 29.

19 Both these castes have Tamil- and Telugu-speaking divisions
 whose members usually do not intermarry.

20 The principal occupation of Vannars was laundering soiled
 linen and, nowadays, ironing clothes. Pantarams or Tampirāṉs
 (Thambirans) are a composite caste. They include a section
 of itinerant mendicants or Jaṅkamars with connections to the
 heterodox Paṇṭāram Vīracaiva (Virasaiva or Lingayat) religious
 movement. The traditional occupation of Pantarams appears
 to have been making flower garlands used in temples and other

ritual services (de Bruin 1999: 74–5; Hollander 2007: 141). At times, Pantarams also serve as priests in non-Brahmin temples.

21 It was not unusual to hear older performers comment that the labour of performance should end with them: their children should not suffer what they had experienced (de Bruin and Rajagopal 2001: Interview with Drama actress M. Shanmugavalli).

22 The lowest of the four varnas.

23 Being a vote bank to reckon with, this claim was translated politically into the foundation of the Pattali Makkal Katchi (PMK) in 1989, a Tamil political party representing the interests of the Vanniyars. This was followed in 2006 by the launch of Makkal TV with a Vanniyar support base. According to the TV channel's website its primary objective is to promote 'the Tamil culture and society in their truest form' (https://www.youtube.com/channel/UCoxhw7GkSURr8G46SN-d7Iw/about accessed on 30 August 2021). Makkal TV broadcasts every evening edited versions of all-night Kattaikkuttu (Therukoothu) performances by companies from all over Tamil Nadu (for recent episodes see https://www.youtube.com/channel/UCoxhw7GkSURr8G46SN-d7Iw/search?query=therukoothu accessed on 30 August 2021). In doing so it has not only created a novel media niche for Kattaikkuttu, it is also documenting Kattaikkuttu – even though many episodes are heavily (and sometimes arbitrary) edited – and its variety of styles. In the absence of any consistent documentation of Kattaikkuttu by the arts establishment, this documentation can be an important source of reference for future scholarship.

24 Interview with Siruvanchippattu C. Sitaraman, Punjarasantankal, 09 February 2021; Pillanthankal M. Arumugam expressed a similar attraction to the theatre even though nobody in his family had any hereditary link to the Kattaikkuttu profession, personal communication M. Arumugam, Punjarasantankal, 15 February 2021.

25 Interview with K. Guru, Punjarasantankal, 15 February 2021.

26 Three children – a girl and two boys – of this Dalit kin group joined the Kattaikkuttu Gurukulam when the school was established in 2002.

27 On the royal patronage of the Devadasis see, e.g., Soneji 2012: 163–4); for Kathakali's royal patronage and the theatre's origin in Kerala's indigenous martial art tradition where they were trained to actualize vira (heroism) on the battlefield in order to protect their king, see Zarrilli 2000: 18–22.

28 These are numerically small castes positioned at the bottom of the caste hierarchy, just above the Scheduled Castes or Dalits (with Pantarams slightly higher than Vannars in the caste hierarchy).

29 With reference to the famous 'Slater studies' (villages that were surveyed by the Madras University economist Gilbert Slater and his students in 1916 and which were subsequently resurveyed in the 1930s, 1960s and the 1980s), John Harriss, J. Jeyaranjan and K. Nagaraj observe a practice similar to the mamul system in a village in North Arcot in the early 1970s (Harriss et al. 2010: 56; also, Harriss 1982).

30 While I have been able to trace the involvement of Vannars in Kattaikkuttu to the mamul system and I have found this to be the case for rural Devadāsīs I interviewed too (de Bruin 2007), I cannot confirm this for the Pantaram performers with whom I could not liaison sufficiently to discuss the sensitive issue of caste and the (historical) experience of caste.

31 These festivals are also known as *kūḻ ūṟṟi tiruviḻā* as the goddess will be offered large quantities of *kūḻ* or ragi gruel by each household (Harriss 1982: 48). The Vannars held the right-cum-obligation to decorate the karakam, invite the Goddess into it by praising her through songs (*varṇittal*) and carrying the karakam in procession (de Bruin 1999: 69).

32 Rajagopal dramatized the performance of a traditional Terukkuttu in his 1994 all-night play *Veṟiyāṭṭam allatu Tantira Kuṟatti* (*Possession or the Gypsy's Ruse*) as his response to the urban critique of naming the theatre Kattaikkuttu.

33 The Terukkuttu appears to have been the male counterpart of the Sadir or Sadirkaccheri, which was a prerogative of rural female dancer-singers belonging to the Devadasi community.

34 It is a point of debate whether Kattaikkuttu evolved out of the processional Terukkuttu enactments and related ritual practices or the mobile 'off-stage' performances or whether the off-stage performances were, perhaps, degenerate forms

of fully fledged Kattaikkuttu performances, as Alf Hiltebeitel
seems to suggest (de Bruin 1999: 83). Terukkuttu appears to
have been the prerogative of Vannars. Purisai K. Sambandham
in a conversation with P. Rajagopal said that his ancestors were
unfamiliar with the practice of mobile Terukkuttu. Possibly
the involvement of Pantarams in Kattaikkuttu has followed
a somewhat different trajectory, as the ancestors of today's
performers are said to have been involved earlier in leather
puppetry (Swaminathan 1992: 28 in conversation with the late
Mr Kannappa Thambiran, a well-known senior representative of
the Purisai style of Kattaikkuttu).

35 This argument has been further developed in de Bruin,
forthcoming a.

36 Vilupuram District and Pondicherry/Cuddalore areas.

37 Betel leaves and areca nuts are traditionally exchanged to seal an
agreement or accompany a gift.

38 Harris et al. find that members of the highest, land-owning castes
moved away from villages to the cities selling off their lands and,
after India's Independence, were disowned under the provisions of
the land ceiling act (Harriss et al. 2010: 56). They also observe that
the presence of hereditary service and artisan castes in villages (to
which hereditary performers belonged) has dwindled considerably.

39 https://en.wikipedia.org/wiki/Vanniyar accessed on 16 January 2022.

40 On the rural Devadasi tradition, see de Bruin 2007. In contrast
to Devadasis attached to higher status male deities of Agamic
temples, rural girls were dedicated to local goddesses or
kirāmatēvatā. In addition to women from the rural Devadasi
tradition, performers – both women and men – from an
itinerant, nomadic background found employment in local
Drama companies. They referred to themselves as *nāṭakakkārar*
and belonged to various castes and tribal groups at the bottom
of the social hierarchy, such as Tommaram (Dommara), Nōkkar,
Jāti piḷḷai and Putupputuppai, whose members traditionally were
involved in circus-like acts, record dance as well as begging.
They also included a number of performers from intercaste
backgrounds (de Bruin 2001: 77–8). The contribution of the
natakakkarar has been obliviated from the narratives of the
history of Tamil theatre.

41 The exchange and recycling of dramatic material between Kattaikkuttu and Drama was a two-way process. Drama in northern Tamil Nadu abandoned ticket sales and adopted the economic practice of receiving a lump sum as performance remuneration from Kattaikkuttu performers (de Bruin 2001: 73). Conversely, Kattaikkuttu copied the practice of providing loans to members of a theatrical ensemble ('advance') in order to enlist them for a next theatre season from the commercial Drama.

42 Personal communication P. Rajagopal, 28 February 2022.

43 Other plays that were part of the repertory were *Nīli Nāṭakam*, about a woman turning into a demon (*pēy*) in her next life to avenge the man who murdered her in her previous life (for a summary of *Nīli Nāṭakam* based on a printed chapbook see Umamaheshwari 2018: 60–73 and passim), *Purūrava Rājā Nāṭakam* or the story of the mythical King Purūravas who fell in love with the apsara Urvashi (an (incomplete) version of this play can be found in Jagannathan 1950: 53–111), *Kaṟkōṭṭai Iḷavaraci* which probably is an adaptation of Alexandre Dumas' 1844 adventure-novel *Le Comte de Monte-Cristo*, *Pakta Cētā* about an untouchable cobbler called Chetha/ Cētaṉ and a historical play *Kaṇṭi Rājā Nāṭakam* about the last king of Kandy in Sri Lanka. The repertory of Ponnucami's Perunkattur Company included a number of plays inspired by the Mahabharata, which are no longer performed and which did not become part of the cycle of Kattaikkuttu Mahabharata episodes performed nowadays at Paratam festivals. Examples of such obsolete plays are *Naḷacakravartti Nāṭakam* featuring the well-known story of Nala and Damayanti, *Vatsalā Kalyāṇam* about Vatsalā who is in love with Abhimanyu but forced to marry Duryodhana's son, *Parimalaikanti Nāṭakam*, a play about the great-grandmother of the Pandava and Kaurava princes, Parimalaikanti or Satyavatī or Matsyagandhā – 'she who smells like fish' – who is adopted by of a fisherman and later marries King Shantanu on the condition that her children will inherit the throne, therewith denying the right to Shantanu's son, Bhīṣma, *Pulēntiran Kaḷavu* or *Pulēntiran's Deceit* about the exploits of Arjuna's and Queen Alli's son Pulēntiraṉ, the cast of which poses in the 1930s photograph of Rajagopal's father's company [Figure 6].

44 Seizer ([2005] 2007: 43–7) on Swamikal. Another example of
 the mixing and/or interchangeability of performances styles is
 the play *Hiranya Nāṭakam*, performed as community theatre in
 twelve villages around Tanjavur. According to Sundar Kaali, who
 researched this tradition, the play can be performed either in the
 kuttu or in the *icai natakam* mode (Kaali 2006: 90).

45 According to P.K. Bhupati, a professional mridangam player
 in a Drama company in North Tamil Nadu, such a company
 would stay at a specific location for a number of days, at times
 putting up a tent (just like a Circus company and the early Tamil
 film), charging tickets for its shows. When performances on the
 basis of tickets sales were abandoned, Drama performers began
 to perform on the occasion of village religious festivals, which
 previously were the prerogative of Kattaikkuttu performers
 (Interview with the late P.K. Bhupati, Kanchipuram, 31 October
 1998).

46 Alternatively, Sakuni may be shown as a dress vesam.

47 De Bruin and Rajagopal 2001: Interview with Rajagopal.

48 However, Kattaikkuttu performances in and around Gingee in
 the Vilupuram District provided greater scope to female roles.

49 Personal information, A. Kailasam and other members of the
 executive board of the Kattaikkuttu Sangam.

50 Based on my brief research, carried out on behalf of the
 Kattaikkuttu Sangam in 2007, as an input for an India Theatre
 Forum discussion that intended to evaluate the feasibility of
 using micro-finance to support performers.

Chapter 2

1 Rajagopal donated these palm-leaf manuscripts to the Indira
 Gandhi National Centre for the Arts in New Delhi.

2 Frasca gives a number between two hundred and three hundred
 plays (Frasca 1990: 57; also, Perumal 1981: 148, 221–45);
 Hiltebeitel thinks this estimate should be doubled (Hiltebeitel
 1988: 153).

3 Kumarasami was himself a Kattaikkuttu actor and a Pantaram by caste; Ramasami from the village of Konametai near Perunkattur and a Kīḻampi Vēḷāḷar by caste was not a performer, but knew the tradition well. For a list of authors of the repertory of the Perunkattur Ponnucami Nataka Manram in the period 1987–90 see de Bruin 1999: Appendix IV.

4 Ebeling 2010: 16 and passim with regard to classical Tamil literature of the nineteenth century; Venkatachalapathy 2012: 131–2.

5 I use *indigenous* as a qualifier to indicate that Kattaikkuttu's knowledge is always specific and owned by a local group of stakeholders and, therefore, that it reflects the world as they see it.

6 However, Kathakali and Yakshagana have retained an introduction by two young performers equivalent to the Palar vesams.

7 For an example of a song and dialogue sequence between the Kattiyakkaran and Ponnuruvi's maid see de Bruin 1998: 78–81.

8 Such a disclaimer, called *avaiyaṭakkam*, is also a feature of traditional Tamil poetry (Ebeling 2010 [2013]: 74).

9 On the role of the towel as a status marker, and the significance of how it is worn by (rural) Tamil men, see Seizer 2005: 257–8.

10 Older performances apparently showed the Kattiyakkaran as a representative of the people. He would enter the performance area, not stage left from inside the greenroom, but from the side of the audience, ostensibly in search of a job. The stage manager or Cūstiratāri (Sūtradhāra) – a character that since has disappeared from the Kattaikkuttu stage – would offer him the part of comedian (Vikaṭaṉ) as his troupe happened to be without one (de Bruin 1999: 210–11). With the emergence of a rural performance market and the commercialization and professionalization of Kattaikkuttu, the role of the Sutradhara and the comedian appears to have collapsed into one in order to minimize the number of performers in a company.

11 Krishna 2020 for a rendering of a *kantārttam* by P. Rajagopal.

12 In other styles, members of the chorus may respond with exclamations and encouragements instead of repeating the sung line of the lead singer (de Bruin 1999: 231).

13 For an example of a viruttam sung by P. Rajagopal see Rees 2018a.

14 For an explanation of a curul see page 70; for a rendering by P. Rajagopal, see Rees 2013a.

15 The | indicates a rhythmical stopgap in the rendition.

16 The snake serves as couch on which Vishnu reclines.

17 With a history dating back more than two millennia.

18 Played by T.P. Durai from Thiruppanangadu Village near Vembakkam, Tiruvannamalai District.

19 Both *jalam* and *puṣpam* are Sanskrit loan words that have Tamil equivalents. In general, Kattaikkuttu's language has retained a number of Sanskrit words and sounds and appears to have escaped the politically motivated cleansing of the language of its Sanskrit vocabulary and sounds.

20 The Tamil text can be found in de Bruin 1998: 14–15.

21 The most well-known Tamil literary version of the Mahabharata epic.

22 In the Gingee-Vilupuram area, the natai melam by female characters is particularly pronounced.

23 For more examples of musical building blocks see de Bruin 1999: 232–3.

24 See Rees 2013b, from 01:40:51 onwards.

25 In contrast, in Kathakali the make-up is done by professional make-up artists.

26 De Bruin 2006: 112–17; also, Frasca 1990: 112–32 for a description of the make-up and its significance.

27 *ampāḷ nāṉē uṉ pātattai nampiṉēṉ,* 'Mother, I trust (worship) your feet'.

28 Rajagopal cited the example of Na. Ramalingam, a hereditary actor from a Vanniyar family (and caste) lineage, personal communication 6 November 2021.

29 *Tivya parimaḷa jekaṉamōkaṉamuḷḷa – tēvi poṉṉuruvi vantāḷ oyyaramāka,* 'the Lady Ponnuruvi has arrived in style – celestial, fragrant and bewitching'. In the performance on which my English translation of Karna Moksam is based, the actor-singer Mr M. Masilamani in the role of Ponnuruvi sang a general

entry song devoted to the goddess Kāmākṣī instead of this song. While having a great voice, this elderly actor may have felt uncomfortable with the dance sequences that the composition of the traditional song demanded and with the skill and speed with which younger actors execute such choreographies.

30 In the recorded version of Karna Moksam, Karna acknowledges the diverse authorship of the Mahabharata: 'Besides Vyāsa's *Mahabharata* there is Villi's *Pāratam*, Nallāppiḷḷai's *Pāratam* and Cēntaṉār's *Pāratam* – four authors in all. All these authorities differ from each other in certain respects ... that shows the strength of each author' (de Bruin 1998: 64–5; also, de Bruin 1998: xviii and fn 18).

31 De Bruin 1999: 284–301; also, Hiltebeitel 1988: 131 with regard to the Draupadi Cult in which the Mahabharata is localized and transposed to fit narrative, dramatic and ritual modes.

32 For the references to Sanskrit text see de Bruin 1999: 295–7.

33 The story of Karṇa's demonic past forms part of the background information of experienced Kaṭṭaikkūttu performers. It can be found in de Bruin 1999: 295.

34 Nalayini Carittiram (*The Life of Nalayini*) and *Subhadrā Kalyāṇam* (*Subhadra's Marriage*).

35 *Mayilrāvaṇaṉ caṇṭai* (*Mayilravana's Battle*).

36 Hiranya Vilacam, *Takkaṉ Yākam* (*Dakṣa's Sacrifice*) and *Aiyappaṉ Nāṭakam*.

37 Kattaikkuttu performances do not feature, or even refer to, the *Bhagavad-Gita*, which is part of the Sanskrit Mahabharata. In this famous philosophical dialogue Krishna advises the ideal Kshatriya-hero Arjuna to detach himself emotionally from the violent deeds he is about to carry out. While in the Sanskrit version Arjuna is reluctant to go to war, Karna Moksam offers a reverse situation. In this instance it is Krishna, acting as Arjuna's charioteer, who refuses to drive the chariot on the pretext that he is afraid of Karna's snake-weapon. Arjuna, on the other hand, is bent on fighting and fulfilling his vow of killing Karna (de Bruin 1999: 297–8).

38 A similar sacrificial paradigm, marked by bloodletting and killing, appears at work in Kathakali, in spite of the higher caste status of its performers and patrons (Zarrilli 2000: 130–2).

39 Rajagopal added Draupadi Kuravanci to his company's
 repertory in 1976.

40 In the words of Alf Hiltebeitel Kattaikkuttu performers and
 audiences view the Mahabharata in terms of 'a royal family
 feud among *paṅkāḷis* (co-sharers) over the rights of inheritance'
 (Hiltebeitel 1988: 398).

Chapter 3

1 *Prayoga* (from the Sanskrit verb *pra-yuj*, to yoke or join or
 harness) means 'joining together, connection, application,
 employment, practice, experiment' (*Monier-Williams* [1899]
 1976: 688).

2 This section is based on an essay with the same title (de Bruin
 2020).

3 This is not an unusual situation; for a discussion of the
 transmission of India's classical theatre form Kutiyattam, see
 the interview with Margi Madhu Chakyar and Dr Indu G. in
 Richman and Bharucha 2021: 227–36.

4 See also Frasca 1990: 42–7 on the training process.

5 See also Coldiron 2018: 6 with regard to the transmission of
 embodied knowledge in Balinese Topéng.

6 An actor is sometimes referred to as *vēṣatāri* or the doer or
 carrier of the vesam. Other words to refer to actors are *naṭikar*
 or the colloquial *āṭṭakkārar*; in formal contexts, the term
 kalaiñar (artist) may be used.

7 Nor does Bengali, another Indian language, possess a term for
 embodiment (personal communication Titas Dutta, 22 June
 2022).

8 Many Asian traditions focused on artistic, medical or spiritual
 practices or a combination thereof do not assume a sharp
 distinction between the body and the mind (Kasulis et al. 1993:
 xv).

9 Being located in the body, the voice is susceptible to heat and
 cold, two concepts that derive from traditional health systems

and ideas about the functioning of the body. As a consequence, the voice is also susceptible to influences on one's bodily balance and well-being of diet, weather, the impact of playing a particular role and the lack of sleep as the result of continuous performances during the theatre's high season.

10 The separation between voiced language and visual language allows the onstage actor to direct his breathing towards energizing an elaborate codified gestural and facial language. Phillip Zarrilli describes how separating out this visual language from the (voiced) performance text allows the Kathakali performer to temporarily step out of the character when he visually narrates, and let us as spectators see, for instance, a mountain (Zarrilli 2000: 87).

11 The oral reservoir offers several of such songs from which the chorus can choose. In my translation of Karna Moksam (de Bruin 1998) three different *potu tiraippāṭṭus* or general curtain songs can be found on pages 12–13 (entry of Duryodhana), pages 178–9 (entry of Salya) and pages 186–7 (entry of Arjuna).

12 In contrast, the small crown or cikarek is put on and tied fixed already in the greenroom.

13 Alternatively, the actor may sing a brief song with rhyming sounds to approach the actor's bench.

14 Karna's name can be substituted by that of another king.

15 Though not a hard and fast rule, Rajagopal distinguished between the use of a present tense inside the curtain to indicate that the character is approaching the royal assembly and, after the removal of the curtain, a past tense to signal the character's arrival (de Bruin 1999: 32–3; 196). Some scholars have argued that the entry sequence of a character is marked by a shift from third-person to first-person narration, in which the latter would indicate that full identification of the actor with the character he is to perform has been achieved (Frasca 1990: 7, 10).

16 As a sceptical interlocutor, the Kattiyakkaran also questions Karna as to how he knows all this: Can a snake speak? Yes, says Karṇa, 'it can because every living being has its own language called *nayaṉa pāṣai* or language of the eyes' (de Bruin 1998: 42–3).

17 அனைத்தையும் ஒருங்கிணைத்து, 'integrating and concentrating everything together, as in a knot' as described in a song Rajagopal wrote for the experimental production *Karnatic Kattaikkuttu*.

18 With regard to Balinese Topeng, Coldiron speaks of *ilmu*, the power to enrapture audiences. According to her ilmu is a form of embodied knowledge that includes a spiritual component. 'Without ilmu, a performer may be very good, even excellent, but she or he will not be able to embody the spiritual power necessary to strongly affect those watching' (Coldiron 2018: 12).

19 Kattaikkuttu's characteristic movement vocabulary is another important source of inspiration. Exposure to other movement styles stimulated a young woman performer to further develop her own movement vocabulary. S. Tamilarasi, an alumna of the Kattaikkuttu Gurukulam, also was responsible for designing a new choreography representing the battlefield of Kurukshetra for the collaborative production *Karnatic Kattaikkuttu*, see Rees 2018b.

20 Rees 2018a for this viruttam performed by P. Rajagopal.

21 The trademarks of the Kuratti. In the performance, she has a small basket-like construction tied on her head which she makes spin around from time to time. People in the audience donate small coins into this basket. For a video recording of the entry of the Kuratti played by S. Tamilarasi *Kuravanci*, Rees 2013b.

22 As a novelty, the Gurukulam offered its students a range of artistic workshops in addition to their daily Kattaikkuttu training. Some of the skills learned during these workshops, in particular with regard to the use of voice and the creation of comedy, directly impacted on the performances of the Gurukulam students. Comedy was developed through a long-standing artistic relationship with Scola Teatro Dimitri (now Accademia Teatro Dimitri) in Switzerland and the late Clown Dimitri. During a voice training workshop by Tom Bogdan of Bennington College, USA, the students learned to sing work by Meredith Monk. All Gurukulam students also profited from storytelling workshops in English by professional storyteller Craig Jenkins (CJ) from the UK, which greatly enhanced their ability to express themselves in English.

23 On the profound stigma of women performers on the Tamil
 stage and the equation of women performers with prostitutes
 see, e.g., de Bruin 2011: 15–33, Seizer 2005: 4 and *passim*;
 on the family pressure experienced by Kattaikkuttu women
 performers to get married and take up conventional roles, see
 Gopalakrishna 2022: 2.

24 Personal communication A. Bharathi, alumna Gurukulam
 student, 15 August 2021.

25 The 2021 production *Tavam* records the constraints faced by
 women who want to make Kattaikkuttu their profession after
 marriage. *Tavam* has been produced both as a live performance
 (2021) and as a film (2022) in collaboration with Indian film
 maker Sandhya Kumar. For the live performance see Rajagopal
 and de Bruin 2021.

26 A number of women scholars have written about what Lata
 Singh has called the 'women's question in theatre' in India (Singh
 2009), investigating why a professional engagement with theatre
 supposedly spoils a woman's identity and destroys her respect in
 patriarchal societies the world over (e.g. Singh 2009; Bruckner,
 de Bruin and Moser 2011; Rege 2002; Seizer 2005; Mangai
 2015; Mangai 2022; Davis 1991; Goodman and De Gay [1998]
 2003).

27 The term intersectionality was coined by Kimberlé Crenshaw
 who used it to illustrate the double whammy of being black and
 being a woman in a racist, white world (Crenshaw 1991).

28 An English translation of the play text of Mayakkutirai has
 been published as part of the children's book *Aiyappan and the
 Magic Horse*, describing the life of a child at the Kattaikkuttu
 Gurukulam (Rajagopal et al. 2005); for the Tamil text see
 Rajagopal 2005. The Tamil play text of Mayakkutirai was
 translated into Kannada.

29 Parkatal, RamaRavana and *Viṭuttal*, Rajagopal's adaptation in
 Tamil of a Rabindranath Tagore play, were published in 2014
 (Rajagopal 2014).

30 When P. Rajagopal's original play RamaRavana featured in
 the 2011 Performing Arts Festival of the Kattaikkuttu Sangam,
 the performance received appreciation from rural spectators.
 However, after the performance they requested Rajagopal to

develop the production into an all-night performance so that they could commission it for their own temple festivals (de Bruin 2021: 184).

31 Susan Seizer has brilliantly captured the mechanisms at work that elicit both violence and laughter in her graphic description of the 'Aṭipiṭi' scene in the Special Drama genre. While this scene is set in the world of everyday life (and not in the world of epic reality) and is acted out by the Buffoon (as the husband) and the Dancer (as the assertive wife), it gives a pretty good idea of the audience's reactions to seeing gendered violence being acted out on the stage (Seizer 2005: 250–7).

32 The play is also known under the Sanskritized name *Draupadī Vastrāpakaraṇam*.

33 Parts of this section were presented at a conference at Wurzburg University in 2017 and a conference of the International Research Center Interweaving of Performance Cultures, Berlin, 2018. See also de Bruin 2023: 86–9. For a further discussion of Pakatai Tukil (wrongly referred to as *Pakatai Tuyil*) performed by the Perunkattur Ponnucami Nataka Manram in 1981, see also Frasca 1998. This essay contains what the author calls a 'telescoped' English translation of the performance of this play in which P. Rajagopal played the role of Duhsasana. Frasca's discussion provides a historical background against which the current reworked version of the play directed by Rajagopal and performed by his students can be read.

34 For possible explanations see Hiltebeitel 1988: 235.

35 For a video recording by the Kattaikkuttu Young Professionals Company with S. Tamilarasi as Draupadi and K. Radhakrishnan as Duhsasana, Rees 2017.

36 Though there is no mentioning of the fact that Draupadi is menstruating, this is generally known by the performers and spectators and indicated by the fact that the performer embodying Draupadi wears his/her hair loose.

37 Yudhisthira.

38 Duhsasana's version of what has happened is a form of 'fake news' as in reality it were the Kauravas who, knowing that Yudhisthira was addicted to gambling, laid a trap inviting him over and making him play a fraudulent game of dice 'just for the fun of it'.

39 Tamil *vārāy,* 'Come *(impolite)*!'.

40 Many companies in my area of work, including the Kattaikkuttu
Young Professionals Company, employed a double pair of
Draupadi-Duhsasana, a phenomenon I did not observe during
my fieldwork in the 1980s and 1990s. I was told that the
rotation of the two Duhsasana-Draupadi pairs is a recent
innovation, copied from companies performing further north of
my area of work (personal information A. Kailasam who used to
perform with a Kattaikkuttu company based in Timojippali in
Chittoor District, Andhra Pradesh).

41 The relationship between mother-in-law and daughter-in-law
is notoriously problematic in local Tamil culture. Relationships
between female characters in Kattaikkuttu's Mahabharata
renderings are often marked by antagonism, jealousy and
inequality – as a result of senior and junior positions within
the extended family – and the women are notably lacking in
solidarity for each other's predicament (de Bruin 1999: 202).

42 **Draupadi's viruttam**

tuṉṉiya capaiyiluḷḷa toḷumperiyōrē kēḷīr

eṉṉaimuṇtōṟṟapiṉpu eḻilaivartōṟṟittārā

maṉṉavarmiṉṉētōṟṟu maṟṟeṉṉaitōṟṟittārā

naṉṉilainaṭukkaṇṭōrkaḷ ñāyamāyppēcuvīrē

'Listen respected elders assembled in this court: "Did he lose me
before losing the famous five, or did he lose them and then lose
me?" Tell me the truth, impartially, that what you saw!'

Draupadi's vacanam (following Villiputtur (1934),
cūtuppōrcarukkam: *ceyyuḷ 235*)

maṉṟōṟṟaṉaṉ veñcūtākil vaḻakkārkoṇmiṉmaṉṉavaiyiṉ

muṉṟōṟṟaṉaṉō veṉṉaiyum tāṉ muṉṉēyicaintu taṉaittōṟṟa

piṉṟōṟṟaṉaṉō kariyāka periyōruṇmai pēcuka

'Did the king who indulged in gambling in this court lose
me first (or) did he first stake and lose himself? Tell me the
truth, respected elders!' Here Draupadi refers to Dharmaraja
(Yudhisthira) as *taṉṉai,* a neutral term which translates both
as *himself* or as *self*. Taken at a more literally level, therefore,
her question can also be read as: 'What did he lose first, self or
me?'. With reference to Vyasa's Mahabharata, Alf Hiltebeitel

has pointed out this detail, also present in the Sanskrit text, and discussed the importance of Draupadi's game-changing question (or *valakku*), and the possibility of Dharmaraja having lost self in the game of dice, see Hiltebeitel 2001, 242 and *passim*. The vacanam, taken from Villiputtur, frames Draupadi's question in a highly literary, complex Tamil. It can be replaced by a simpler version that is somewhat easier to reproduce for a performer: taṉṉai tōṟṟa piṉ tārattai tōṟṟārā allatu tārattai tōṟṟa pin taṉṉai tōṟṟārā itil kaṇṇir kaṇṭatai niyāyamāy pēcavēṇṭum periyōrkaḷē, which can be translated as 'What did he lose first, (him)self or (his) wife? Respected elders, tell me please whether that what you saw with your own eyes is (morally) right?'.

43 In his translation of the play Frasca refers to the valakku as Draupadi arguing, first with the Kattiyakkaran, and thereafter when she has been dragged into the royal assembly with Duryodhana demanding to know whether she was wagered before or after Yudhisthira/Dharmaraja lost himself, Frasca 1998: 28–31.

44 Our intervention in the tradition has had further-reaching, unexpected effects as many theatre companies in the neighbourhood have added Draupadi's final game of dice that she wins to their performances of Dice and Disrobing.

45 For a discussion of one such experience, see de Bruin, forthcoming a.

46 Another famous theatre director who produced his own version of the Mahabharata was the late Peter Brook. Alf Hiltebeitel has described how Kattaikkuttu was one of his theatrical sources of information on the epic and its Indian ways of performance. Using, and often appropriating, such performance traditions outside their original contexts has not been unproblematic and has its own dynamics which can be quite disturbing, as Hiltebeitel and others have shown (Hiltebeitel 1992; Bharucha 1988; de Bruin 2017).

47 Most recently senior actor-singer Thiruppanangadu P. Durai expressed his dismay during an Executive Board meeting of the Kattaikkuttu Sangam. He said that performers are getting good rates for their performances after the Covid-19 pandemic (according to Mr Durai around Rs. 25,000 per show), but that the quality of performances leaves much to be desired

and stands in no relation to the payment received (personal communication T.P. Durai, 5 June 2022).

48 Interview with C. Sitaraman, Punjarasantankal, 9 February 2021.

49 Interviews with senior actor-singers A. Kailasam and B. Saravanan (both hereditary performers), 16 February 2021 and junior actor K. Guru, 15 February 2021.

50 Interviews with A. Kailasam and B. Saravanan, Punjarasantankal, 16 February 2021. Today mukavinai player Umaiyalpuram K. Elumalai is working for different companies across styles because there is an acute lack of good mukavinai players; switching companies during the Kattaikkuttu season seems to have become quite acceptable.

51 With reference to Tamasha, Julia Hollander writes that some of its expert performers were 'perpetually dissatisfied with what is happening in the present', lamenting the death of their authentic art form (Hollander 2007: 186).

52 Based on personal information, Punjarasantankal, 23 August 2021; given the sensitivity of the issue I have refrained from giving the names of the performers.

53 Based on conversations with alumni Kattaikkuttu students S. Haribabu, S. Ajai, P. Sasikumar, P. Moorthy, A. Bharathi, K. Venda, R. Mahalakshmi and M. Doraisami during 2021 and 2022.

54 Interview with C. Sitaraman, Punjarasantankal, 9 February 2021. The interview took place during the rehearsals for the Kattaikkuttu Sangam's production of *Kiruṣṇaṉ tūtu* (*Krishna's Embassy*) in which P. Rajagopal played Krishna and C. Sitaraman Dharmaraja. A similar complaint was voiced by a younger generation actor-singer (trained at the Gurukulam) who said that some performers had started singing the curtain viruttam after (instead of prior to) the removal of the curtain therewith overturning the (theatrical) logic of the curtain entry. Personal communication P. Moorthy, Punjarasantankal, 9 July 2021.

55 Personal communication K. Guru, Punjarasantankal, 15 February 2021; also, actor-singer N. Ramamoorthy, who

participated in a workshop of the Kattaikkuttu Sangam to learn
the atavus for a female character, 31 January 2021.

56 Personal communication Mr Vajra Mudaliar, Aiyankarkulam,
after witnessing an all-night performance of the Kattaikkuttu
Young Professionals Company at Thiruppanangadu Colony,
2 August 2015.

REFERENCES

30Stades.com (2022), 'Therukoothu: Tamil Nadu's Street Theatre Fading into Oblivion'. https://30stades.com/2022/03/27/ therukoothu-tamil-nadu-street-folk-theatre-fading-into-oblivion-rural-performing-art/ (accessed on 04 November 2022).

Ahuja, Chaman (2007), 'Therukkoothu Is Doubly Blessed', *The Hindu*, 04 March.

Ananthachari, Sashikanth (2021), *Vanavasam*. https://vimeo. com/478295316 (accessed on 22 February 2021).

Aṟivunambi, A. (1986), *Tamiḻakattil Terukkūttu*, Kāraikkuṭi: Amutaṉ Nūlakam.

Bal, M. (2021), 'Aesthetic for Documentaries', *Academia Letters*, Article 4283. https://doi.org/10.20935/AL4283 (accessed on 01 May 2022).

Beck, Brenda (1981), 'The Goddess and the Demon: A Local South Indian Festival and Its Wider Context', *Puruśārtha* 5: 83–136.

Bharucha, Rustom (1988), 'Peter Brook's "Mahabharata": A View from India', *Economic and Political Weekly* 23 (32) (Aug 6): 1642–7.

Blackburn, Stuart (1988), *Singing of Birth and Death: Texts in Performance*, Philadelphia: University of Pennsylvania Press.

Bourdieu, Pierre (1983), 'The Field of Cultural Production, or the Economic World Revisited', *Poetics* 12: 311–56.

Bourdieu, Pierre (1993), *The Field of Cultural Production: Essays on Art and Literature*, edited and introduced by Randal Johnson, New York: Colombia University Press.

Brook, Peter ([1968] 1996), *The Empty Space. A Book about the Theatre: Deadly, Holy, Rough, Immediate*, New York: Touchstone.

Brubaker, Richard L. 'Barbers, Washermen, and Other Priests: Servants of the South Indian Village and Its Goddess', *History of Religions* 19 (2): 128–52.

Brückner, Heidrun, Hanne M. de Bruin and Heike Moser (eds) (2011), *Between Fame and Shame: Performing Women – Women Performers in India*, 11–35, Wiesbaden: Harrasowitz Verlag.

de Bruin, Hanne M. (1998), *Karṇa Mōkṣam or Karna's Death: A Play by Pukalentippulavar,* translated by Hanne M. de Bruin, Publications du Département d'Indologie 87, Pondicherry: Institut français de Pondichéry.

de Bruin, Hanne M. (1999), *Kaṭṭaikkūttu: The Flexibility of a South Indian Theatre Tradition,* Gonda Indological Series Vol. VII, Groningen: Egbert Forsten.

de Bruin, Hanne M. (2000), 'Naming a Theatre in Tamil Nadu', *Asian Theatre Journal* 17 (1) (Spring): 98–122.

de Bruin, Hanne M. (ed.) (2001), *Seagull Theatre Quarterly* 3: *'Hybrid Theatres in India'*, Calcutta (India): The Seagull Foundation for the Arts.

de Bruin, Hanne M. (2006), 'Donning the Vēṣam in Kaṭṭaikkūttu', in Shulman, David and Deborah Thiagarajan (eds), *Masked Ritual and Performance in South India: Dance, Healing, and Possession,* 107–34, Ann Arbor: Centers for South and Southeast Asian Studies, The University of Michigan.

de Bruin, Hanne M. (2007), 'Devadāsīs and Village Goddesses of North Tamil Nadu', in Brückner, Heidrun, Elisabeth Schömbucher and Phillip B. Zarrilli (eds), *The Power of Performance: Actors, Audiences and Observers of Cultural Performances in India,* 53–83, New Delhi: Manohar.

de Bruin, Hanne M. (2011), Contextualizing Women and Performance in India: An Introductory Essay', in Brückner, Heidrun, Hanne M. de Bruin and Heike Moser (eds), *Between Fame and Shame: Performing Women – Women Performers in India,* 11–35, Wiesbaden: Harrasowitz Verlag.

de Bruin, Hanne M. (2016), 'Kaṭṭaikkūttu', *Kalakshetra Journal* 4, Chennai: Kalakshetra Foundation Publications: 73–104.

de Bruin, Hanne M. (2017). 'Kattaikkuttu and the World', in *Textures: Online platform for Interweaving Performance Cultures* (June 19). https://www.textures-archiv. geisteswissenschaften.fu-berlin.de/index.html%3Fp=4745.html (accessed on 23 August 2020).

de Bruin, Hanne M. (2019), 'Karnatic Meets Kattaikkuttu: Notes on an Unusual Cultural Conversation', *The Drama Review* 63 (3) (Fall 2019) (T243): 50–73.

de Bruin, Hanne M. (2020), 'Becoming a Kattaikkuttu Performer: Transmission and Training in a Traditional, Subaltern Theatre Form of South India', in Sarangapani, P.M. and R. Pappu

(eds), *Handbook of Education Systems in South* Asia, *Global Education Systems*, Singapore: Springer. https://doi. org/10.1007/978-981-13-3309-5_4-1.

de Bruin, Hanne M. (2021), 'The Making of RāmaRāvaṇā: Reflections on Gender, Music, and Staging', in Richman, Paula and Rustom Bharucha (eds), *Performing the Ramayana Tradition: Enactments, Interpretations, and Arguments*, 161–85. New York: Oxford University Press.

de Bruin, Hanne M. (2023), 'Kattaikkuttu as Practice-Based Knowledge', in Fischer-Lichte, Erika, Torsten Jost, Astrid Schenka and Milos Kosic (eds), *Performance Cultures as Epistemic Cultures*: Vol. I, 79–97. London: Routledge.

de Bruin, Hanne M. (forthcoming a), 'Uḻaippu: Performance as Labour in a Tamil Theatre Tradition', in Morcom, Anna and Neelam Raina (eds), *Creative Economies of Culture in South Asia: Craftspeople and Performers*. London: Routledge.

de Bruin, Hanne M. (forthcoming b), 'Vēṣam', in Fischer-Lichte, Erika Torsten Jost and Astrid Schenka (eds), *The Routledge Companion for Performance-Related Concepts in Non-European Languages*, London and New York: Routledge.

de Bruin, Hanne M. and Clara Brakel-Papenhuyzen (1992), 'The Death of Karna: Two Sides of a Story', *Asian Theatre Journal* 9 (1) (Spring): 38–70.

de Bruin, Hanne M. and P. Rajagopal (2001), *In Their Own Words: The Unheard History of the Rural Tamil Stage as Told by Four of Its Professional Exponents* (DVD). Leiden (The Netherlands): International Institute for Asian Studies [ISBN 90-74917-25-9; NUGI 086].

de Bruin, Hanne M. and Sue Rees (2020), 'Kaṭṭaikkūttu's Performance Spaces', *Performance Research* 25 (6–7): 89–107. DOI: 10.1080/13528165.2020.1903708.

Canning, Charlotte M. and Thomas Postlewait (eds) (2010), *Representing the Past: Essays in Performance Historiography*, Iowa City: University of Iowa Press.

Chatterjee, Partha (1993). *The Nation and Its Fragments: Colonial and Post-Colonial Histories*. Princeton, New Jersey: Princeton University Press.

Chatterjee, Pyush (2013), 'Reviving Ancient Tamil Art Forms', *The New Indian Express*, 01 August. http://newindianexpress.com/ cities/chennai/Reviving-ancient-Tamil-art-forms/2013/08/01/ article1711560.ece (accessed on 03 August 2013).

Cherian, Anita (2007), 'Imagining a National Theatre: The First Drama Seminar Report', *Sangeet Natak* 16 (2): 15–49.

Cherian, Anita (2009), 'Institutional Manoeuvres, Nationalizing Performance, Delineating Genre: Reading the Sangeet Natak Akademi Reports 1953–1959', *Third Frame: Literature, Culture and Society* 2 (3): 32–60.

Clifford, James (1986), 'On Ethnographic Allegory', in Clifford, James and George E. Marcus (eds), *Writing Culture: The Poetics and Politics of Ethnography*, 98–121, Berkely, Los Angeles, London: University of California Press.

Coldiron, Margaret (2018), 'The Conundrum of Transmitting Embodied Knowledge for Intercultural Performance: A Case Study', *Indian Theatre Journal*, 2 (1–2), 5–18, Bristol: Intellect. https://doi.org/10.1386/itj.2.1-2.5_1 (accessed 26 May 2022).

Crenshaw, K. (1991), 'Mapping the Margins: Intersectionality, Identity Politics, and Violence against Women of Color', *Stanford Law Review*, 43 (6): 1241–99, https://doi.org/10.2307/1229039 (accessed on 24 May 2022).

Daniel, Valentine ([1984] 1987), *Fluid Signs: Being a Person the Tamil Way*, Berkely and Los Angeles: University of California Press.

Davis, Tracy C. (1991), *Actresses as Working Women: Their Social Identity in Victorian Culture.* London, New York: Routledge.

Dharwadker, Aparna Bhargava ([2005] (2008), *Theatres of Independence: Drama, Theory, and Urban Performance in India since 1947.* New Delhi: Oxford University Press.

Ebeling, Sacha (2010), *Colonizing the Realm of Words: The Transformation of Tamil Literature in Nineteenth-Century South India*, New York: SUNY Press.

Frasca, Richard Armando (1990), *The Theater of the Mahābhārata: Terukkūttu Performances in South India*, Honolulu: University of Hawaii Press.

Frasca, Richard Armando (1998), 'The Dice Game and the Disrobing (Pakaṭai Tuyil): A Terukkūttu Performance', introduced and translated by Richard A. Frasca. *Asian Theatre Journal* 15 (1) (Spring): 1–44.

Ganesh, Kamala (2018), 'For Brahmins, by Brahmins: How (and Why) Carnatic Music Became such an Elite Preoccupation', *Scroll* (Jan 20) https://scroll.in/magazine/865046/for-brahmins-by-brahmins-how-and-why-carnatic-music-became-such-an-elite-preoccupation (accessed on 15 June 2022).

Goffman, Erving (1963), *Stigma: Notes on the Management of Spoiled Identity*. Hoboken, New Jersey, USA: Prentice-Hall.

Goodman, Lizbeth and Jane de Gay (eds) ([1998] 2003), *The Routledge Reader in Gender and Performance*, London, New York: Routledge.

Gopalakrishna, Maitri (2022), 'Practicing in an Expanded Paradigm: Case Examples and Ethical Anchors for Creative Arts Therapists Working in Community-Based Social Justice Contexts', *The Arts in Psychotherapy* 80 (September) 101921, 1–9, https://doi.org/10.1016/j.aip.2022.101921 (accessed on 02 June 2022).

Gopalakrishnan, E.R. (2014), 'The Early Days', *Sruti*, 18 March. https://www.sruti.com/index.php?route=archives/interview_details&intid=67 (accessed on 24 April 2021).

Gopalratnam, V.C. ([1956] 1981), 'Tamil Drama', in *Indian Drama*, 119–26. New Delhi: Ministry of Information and Broadcasting.

Hansen, Kathryn (2021), 'Tamil Drama in Colonial Madras: The Parsi Theatre Connection', *South Asian History and Culture* 12 (1), 19–38, https://doi.org/10.1080/19472498.2020.1816414 (accessed on 28 December 2021).

Harriss, John (1982), *Capitalism and Peasant Farming: Agrarian Structure and Ideology in Northern Tamil Nadu*, Bombay: Oxford University Press.

Harriss, John, J. Jeyaranjan and K. Nagaraj (2010), 'Land, Labour and Caste Politics in Rural Tamil Nadu in the 20th Century: Iruvelpattu (1916–2008)', *Economic & Political Weekly* 45 (31) (July 31): 47–61.

Hawley, Nell Saphiro and Sohini Sarah Pillai (eds) (2021), *Many Mahābhāratas*, New York: SUNY Press.

Hiltebeitel, Alf (1988), *The Cult of Draupadī: Vol. 1 Mythologies: From Gingee to Kurukṣetra*, Chicago and London: The University of Chicago Press.

Hiltebeitel, Alf (1992), 'Transmitting "Mahabharatas": Another Look at Peter Brook', *The Drama Review* 36 (3) (Autumn): 131–59.

Hiltebeitel, Alf (2001), *Rethinking the Mahābhārata: A Reader's Guide to the Education of the Dharma King*, Chicago and London: The University of Chicago Press.

Hollander, Julia (2007), *Indian Folk Theatres*, London and New York: Routledge.

Inquilap (2021), *Avvai*, translated into English by A. Mangai, New Delhi: Sahitya Akademi.

Jagannathan, Kee. Vaa. (ed.) (1950), *Three Tamil Operas. A. Madana Sundara Prasada Santana Vilasam. 2. Pandya Keli Vilasa Natakam. 3. Pururava Natakam*, Madras: The National Art Press (Saraswati Mahal Series 16).

Jayashree, C. H. (1989). 'Agrestic Slavery in Mirasi-tenures of Tamil Nadu during 19th Century', in *Proceedings of the Indian History Congress* 50: 580–7. http://www.jstor.org/stable/44146101 (accessed on 16 March 2023).

Junoon Salons (2019), *Kattaikkuttu Sangam's Mahabharata in Action*, Mumbai, 13 November.

Kaali, Sundar (2006), 'Masquerading Death: Aspects of Ritual Masking in the Community Theatres of Tanjavur', in Shulman, David and Deborah Thiagarajan (eds), *Masked Ritual and Performance in South India: Dance, Healing, and Possession*, 89–106, Ann Arbor: The University of Michigan.

Kapferer, Bruce (1997), *The Feast of the Sorcerer: Practices of Consciousness and Power*, Chicago and London: The University of Chicago Press.

Kapur, Anuradha (1993), 'The Representation of Gods and Heroes: Parsi Mythological Drama of the Early Twentieth Century', *Journal of Arts and Ideas* (New Delhi) 23–24 (January): 85–107.

Karthikeyan, Aparna (2019), *Nine Rupees an Hour: Disappearing Livelihoods of Tamil Nadu*, Chennai: Context.

Kasulis, Thomas P., Roger T. Ames and Wimal Dissanayake (eds) (1993), *Self as Body in Asian Theory and Practice*, Albany: SUNY Press.

Kersenboom, Saskia (1995), *Word, Sound, Image: The Life of the Tamil Text*, Oxford: Berg Publishers.

Krishna, T.M. (2020), *The Artiste*, episode 2. https://www.youtube.com/watch?v=fyOUmrQfmOM (accessed on 24 May 2022).

Mangai, A. (2015), *Acting Up: Gender and Theatre in India, 1979 Onwards*, New Delhi: Left Word.

Mangai, A. (2022), 'The Legacy of Balamani Ammal in Tamil Theatre: Affirming a History Lost in the Conjunction between Social Respectability and Historiography of Arts', *Economic and Political Weekly* 57 (22) (28 May), https://www.epw.in/journal/2022/22/review-womens-studies/legacy-balamani-ammal-tamil-theatre.html (accessed on 28 May 2022).

Monier-Williams, Monier Sir ([1899] 1976), *A Sanskrit-English Dictionary: Etymologically and Philologically Arranged with Special Reference to Cognate Indo-European Languages*, Oxford: At the Clarendon Press.

Muthukumaraswamy, M.D. (2018), 'Padukalam: The Enactment of the Final Battle of Kurukshetra', *Sahapedia*. https://www.sahapedia.org/padukalam-the-enactment-of-the-final-battle-of-kurukshetra (accessed on 10 Nov 2022).

News 18 Buzz (2021), 'Tamil Artists Trying to Revive "Theru Koothu" in Bid to Preserve Traditional Art of Street Play' (13 February). https://www.news18.com/news/buzz/tamil-artists-trying-to-revive-theru-koothu-in-bid-to-preserve-traditional-art-of-street-play-3424703.html (accessed on 15 February 2021).

Ong, Walter J. ([1982] 1985), *Orality and Literacy: The Technologizing of the Word*, London and New York: Methuen.

Palaṇi, Kō. and Ci. Muttukantaṇ (2011), *Terukkūttuk kalaiñarkaḷ kaḷañciyam*, Chennai: Bodhivanam.

Pandian, A. (2009), *Crooked Stalks: Cultivating Virtue in South India*, Durham and London: Duke University Press.

Perumal, A.N. (1981), *Tamil Drama, Origin and Development*, Madras: International Institute of Tamil Studies.

Pesch, Ludwig ([1999] 2009), *The Illustrated Companion to South Indian Classical Music*, 2nd ed., Delhi: Oxford University Press.

PTV (Puthiyathalaimurai TV) (2016), 'Therukuthu Ancient Tamil Folk Art Is at Verge of Disappearance' (23 May). https://youtu.be/uNtQ9r2oIA0 (accessed 16 April 2018).

Raj, T. V. Antony (2012), 'Theru Koothu — The Dying Folk Art of Tamilnadu, India', *Tvraj.com* (3 July). https://tvraj.com/2012/07/03/theru-koothu-the-dying-folk-art-of-tamilnadu-india/ (accessed on 05 July 2012).

Rajagopal, P. [Po Rājakōpāl] (2005), *Māyakkutirai*. Chennai: Tulika Publishers.

Rajagopal, P. [Po Rājakōpāl] (2014), *Pārkaṭal, Viṭuttal, RāmaRāvaṇā: muṇṟu kūttup piratikaḷ* [Parkatal, Vituttal, RamaRavana: Three Plays by P. Rajagopal]. Nagercoil: Kalachuvadu Publications.

Rajagopal, P., Evelien Pullens and Hanne M. de Bruin (2005), *Aiyappan and the Magic Horse*, Chennai: Tulika Publishers.

Rajagopal, P. and Hanne M. de Bruin (2021), *Tavam*, https://youtu.be/-cTMvNjoTic (accessed on 01 March 2022).

Raman, Srilata (2019), 'Useless Words: The Obsolescence of the Nikaṇṭus in the Tamil Literary Tradition', *Working Papers of the Chicago Tamil Forum* 6 (23–25 May), Version 6. 1.2019. http://chicagotamilforum.uchicago.edu/workshops/2019/ ewExternalFiles/Raman%2C%20S_Useless%20Words%20 %28CTF%202019%29.pdf (accessed on 28 December 2020).

Ramana, Dharshini (2019), 'Dying Art of Therukoothu', *The Asian Age*, 13 August, https://www.asianage.com/life/art/130819/dying-art-of-therukoothu.html (accessed on 8 June 2022).

Ramaswamy (Irāmacuāmi), Mu. (2021), 'Kūttiṉ urumāṟṟattil uyirppāṉa iṉṉoru "putiya" kūttu – kaṭṭaikkūttuc caṅkattiṉ "tavam" (a) cātaṉaip peṇkaḷ!', *Kaṉaiyāḻi* 56 (8 November), 34–9.

Ramaswamy, Vijaya (2020), 'Different Strokes: Women in the Tamil Mahabharatas', *The Wire* (26 January). https://thewire.in/ women/tamil-mahabharatas-women (accessed on 24 Oct 2021).

Ravikumār, Jōti (2021), 'Terukkūttu nāṭakam mūlamāka ōcūril cālaip pātukāppu viḷippuṇarvu' *Hindu Tamil e-newspaper*, 21 January. https://www.hindutamil.in/news/tamilnadu/624178-road-safety-awareness-in-hosur-through-streetplay.html?utm_source=site&utm_medium=search&utm_campaign=search (accessed on 8 June 2022).

Rees, Sue (2013a), Curuḷ song from *The Royal Sacrifice* sung by P. Rajagopal, recorded by Sue Rees, https://youtu.be/ zmYpR6VUurQ (accessed on 24 May 2022).

Rees, Sue (2013b), *Kuṟavañci* (part 1) performed by students of the Kattaikkuttu Gurukulam, recorded by Sue Rees, Maantankal Village (16th–17th January), https://youtu.be/ARrexai-PSg accessed on 24 May 2022.

Rees, Sue (2017), P. Rajagopal's *Dice and Disrobing* (part 2) (26 January) performed by the Kattaikkuttu Young Professionals Company, recorded by Sue Rees, Punjarasantankal Village, 26 January, https://youtu.be/A3WCknviOus (accessed on 24 May 2022).

Rees, Sue (2018a), Viruttam from the All-night Play *Karṇa Mōkṣam* sung by P. Rajagopal, recorded by Sue Rees, https://youtu.be/ qNGJJ52NIhQ (accessed on 24 May 2022).

Rees, Sue (2018b), Edit of War Dance Choreographed by S. Tamilarasi, *Karnatic Kattaikkuttu*, Serendipity Festival, Goa, 20 December, https://youtu.be/WnmLCgbKw_E (accessed on 16 May 2022).

Rege, Sharmila (2002), 'Conceptualizing Popular Culture: "Lavani" and "Powda" in Maharashtra', *Economic and Political Weekly* 37 (11) (16 March), 1038–47.

Richman, Paula (ed) (1991), *Many Rāmāyaṇas: The Diversity of a Narrative Tradition in South Asia*, Berkeley, Los Angeles, Oxford: University of California Press.

Richman, Paula and Rustom Bharucha (eds) (2021), *Performing the Ramayana Tradition*, New York: Oxford University Press.

Rudisill, Kirsten (2022), *Honeymoon Couples and Jurassic Babies: Identity and Play in Chennai's Post-Independence Sabha Theater*, New York: SUNY Press.

Saravanan, T. (2005), 'Hoping to Bring a Dying Art Back to Life', *The Hindu. Life Madurai.* 26 May.

Seizer, Susan ([2005] 2007), *Stigmas of the Tamil Stage: An Ethnography of Special Drama Artists in South India*, Calcutta: Seagull Books.

Singer, Milton (1972), *When a Great Tradition Modernizes: An Anthropological Approach to Indian Civilization*, New York: Praeger Publishers.

Singh, Lata (2009), *Theatre in Colonial India: Playhouse of Power*, New Delhi: Oxford University Press.

Smirnitskaya, Anna (2019), 'Diglossia and Tamil Varieties in Chennai', *Acta Linguistica Petropolitana*, XIV. DOI:10.30842/ alp2306573714317 (accessed on 28 April 2021).

Soneji, Davesh (2012), *Unfinished Gestures: Devadasis, Memory, and Modernity on South India*, New Delhi: Permanent Black.

Srinivasan, Perundevi (2010), 'The Creative Modern and the Myths of the Goddess Mariyamman', in Dimitrova, Diana (ed.), *Religion in Literature and Film in South Asia*, 83–91, London: Palgrave Macmillan.

Strathern, Andrew and Pamela J. Stewart (2008), 'Embodiment Theory in Performance and Performativity', *Journal of Ritual Studies* 22 (1): 67–71, http://www.jstor.org/stable/44368783 (accessed on 21 January 2022).

Sukthankar, Vishnu S. (ed.) (1927–59), *The Mahābhārata for the First Time Critically Edited*. Poona: Bhandarkar Oriental Research Institute.

Swaminathan, Venkat (1991), '*Therukoothu: Theatre of the Mahabharata*', New Delhi: Sangeet Natak Nos 101–102 (July–December): 47–65.

Swaminathan, Venkat (1992), 'Interview with Purisai Kannappa Thampiran', *Sangeet Natak* (New Delhi) 105–6: 36–53.

Swaminathan, Mina and Hanne M. de Bruin (1992), '"Folk" Theatre on the Threshold: A Kattaikkuttu Festival', *Frontline* (Madras) 9 (6): 100–3.

Tamil Lexicon ([1924 –36] 1982), 6 vols. and supplement. Madras: University of Madras.

Taylor, Diana ([2003] 2007), *The Archive and the Repertoire: Performing Cultural Memory in the Americas*, Durham, North Carolina, USA: Duke University Press.

Terada, Yoshitaka (1997), 'Effects of Nostalgia: The Discourse of Decline in Periya Mēḷam Music of South India', *Bulletin of the National Museum of Ethnology* 21 (4): 921–39.

The Hindu (Pondicherry edition) (2022), 'The Revival of the Ancient Art of Kattaikoothu' (06 May), https://www.thehindu.com/news/cities/puducherry/the-revival-of-the-ancient-art-of-kattaikoothu/article65388515.ece (accessed on 08 May 2022).

The Lede: Independent Journalism (2019), 'The Dying Art of Therukoothu', https://youtu.be/bbJqXCEmXwM (accessed on 18 October 2022).

Umamaheshwari, R. (2018), *From Possession to Freedom: The Journey of Nīli-Nīlakeci*, New Delhi: Zubaan Publishers.

Venkatachalapathy, A.R. (2012), *The Province of the Book: Scholars, Scribes, and Scribblers in Colonial Tamilnadu*, New Delhi: Permanent Black.

Villipputtūrāḻvār Makāpāratam with an introduction by Āṟumukanāvalar (reprint 1934). Chennai: Vittiyānupālanuyantiracālai.

Weidman, Amanda J. (2006), *Singing the Classical, Voicing the Modern: The Post-Colonial Politics of Music in South India*, Durham: Duke University Press.

Zarrilli, Phillip B. (2000), *Kathakali Dance-Drama: Where Gods and Demons Come to Play*, London: Routledge.

INDEX